IMAGES
of America

GREEKS IN
SAN FRANCISCO

IMAGES
of America

GREEKS IN SAN FRANCISCO

Greek Historical Society of
the San Francisco Bay Area

ARCADIA
PUBLISHING

Published by Arcadia Publishing
Charleston, South Carolina

Library of Congress Control Number: 2016932928

For all general information, please contact Arcadia Publishing:
Telephone 843-853-2070
Fax 843-853-0044
E-mail sales@arcadiapublishing.com
For customer service and orders:
Toll-Free 1-888-313-2665

Visit us on the Internet at www.arcadiapublishing.com

This book is dedicated to the Greek immigrants who left their families and their homeland, seeking a better life in the "land of opportunity." We honor their courage, hard work, and sacrifice, and their devotion to their families, community, and new homeland.

CONTENTS

ACKNOWLEDGMENTS

The idea for a book chronicling the history of San Francisco's Greek community became a reality through the dedication and hard work of the Arcadia Book Publication committee of the Greek Historical Society of the San Francisco Bay Area: John D. Bardis, Sophia Pethenos Fonti, Patricia Georgiou, Jim Lucas, Eleftheria Lula Tamaras Ossipoff, Carol Varellas-Pool, Joan Marina Peponis Rinde, George Samoulides, Dorothy Couch Vasiloudis, John Basil Vlahos, Cynthia Soteria Zamboukos, and Mary James Zamboukos.

Content for this book is based on extensive research from numerous books, publications, early church records, and other manuscripts. We are grateful to the staff at the San Francisco History Center at the San Francisco Public Library for their assistance with our special research needs. Particularly valuable sources included The Autobiography of Alexander John Kosta (1924); George Daskarolis's San Francisco's Greek Colony: The Evolution of an Ethnic Community (1995); Christopher of San Francisco, by George Dorsey (1962); and Jewel City Art From San Francisco's Panama-Pacific International Exposition, James A. Ganz, editor (2015). A complete bibliography of source materials can be found on the Greek Historical Society of the San Francisco Bay Area website, www.sanfranciscogreeks.com.

We wish to acknowledge our title manager at Arcadia Publishing, Henry Clougherty, for his prompt attention to every question we had and for his guidance throughout the process, as well as our editors Tina Petrakis and Dr. Sophia Papageorgiou for their skilled preparation of the manuscript. We wish to thank His Eminence Metropolitan Gerasimos of the Greek Orthodox Metropolis of San Francisco; Fr. Stephen Kyriacou, Dean of Annunciation Cathedral, San Francisco; and Fr. Niko Bekris, pastor, Resurrection Greek Orthodox Church, Castro Valley, California for their unwavering support of the Greek Historical Society of the San Francisco Bay Area since its inception. Finally, our special thanks go to the many people who shared their precious photographs and personal family histories with us, enabling us to remember and honor those who came before us, and without whom, this book could not have been written. Support for this book was made possible by a grant from the Elios Charitable Foundation and a donation from San Francisco's Archbishop Riordan High School.

INTRODUCTION

The history of the Greek community in San Francisco is inextricably linked to the history of the city of San Francisco and reflects the pioneering spirit of California. From the earliest days of San Francisco, the Greek community contributed to the city's growth and distinct charm with their industry, culture, religion, business acumen, community involvement, and political impact.

Prior to the 1880s, a small number of Greeks, primarily miners and sailors, lived in the San Francisco area. Greek immigration to California increased in the late 1880s, and by the beginning of the 20th century, the *San Francisco Call Bulletin* newspaper estimated that 2,000 Greeks were living in the San Francisco Bay Area. The Eastern Orthodox faith has had a presence in San Francisco dating back to 1857, and the first Russian Orthodox church was founded in 1868. Prior to the establishment of their own parish, Greeks worshipped at the Russian church.

Members of the community founded the Hellenic Mutual Benevolent Society, the first known Greek organization, in July 1888. The society took an active role in establishing a Greek Orthodox church, organized community events, and coordinated local response efforts to tragic events occurring in Greece. In 1902, this organization initiated meetings to establish a Greek Orthodox church in San Francisco. Trustees were elected, a priest from Greece was hired, and by the spring of 1903, the community purchased land at Seventh and Cleveland Streets for $6,000. Construction began, and Fr. Constantine Tsapralis arrived and celebrated the first divine liturgy on Christmas Day, 1903. Holy Trinity Greek Orthodox Church was incorporated on March 23, 1904, making it the oldest Greek Orthodox church west of Chicago and the eighth oldest church within the present-day Greek Orthodox Archdiocese of America. Holy Trinity served as the religious headquarters for the Greek Orthodox faithful across the Western region, and its priests ministered to the needs of Orthodox Christians throughout the West. On April 18, 1906, the church, along with much of San Francisco, was destroyed by earthquake and fire. Work began on a second church in the fall of 1906. The new church was completed in 1907, and a Greek language school, the first west of Chicago, was opened in 1912.

The Greek Orthodox community in San Francisco experienced its first major schism in 1908, leading to the founding of a second Orthodox church, St. John Prodromos, on Rincon Hill (Stanley/Sterling Place). A faction led by Ioannis Kapsimalis (former parish council president and Greek consul), disagreeing over parish council elections and the handling of money, established its own church. It built offices and the Alexander the Great Meeting Hall. Father Tsapralis was hired to serve as the priest of St. John Prodromos, and Fr. Stefanos Macaronis was retained by Holy Trinity. By December 1909, the factions had resolved their differences, the St. John Prodromos property was sold to Holy Trinity for $5, Father Tsapralis was rehired by Holy Trinity, and Father Macaronis moved to a parish in Oregon. From 1910 until Holy Trinity was raised in 1922 to install a meeting hall, the Rincon Hill property served as the offices and meeting hall for the Greek community. It was sold in 1936 to the State of California to make way for the San Francisco–Oakland Bay Bridge.

The rate of immigration from Europe reached enormous proportions between 1900 and 1914. By the 1920s, the number of Greeks grew fivefold, from 2,000 to 10,000. During this time, the Greek community settled in the area south of Market Street, around Third Street. By 1925, the majority of businesses in this area (58 percent) were Greek owned, especially between Folsom and Harrison Streets. Today, the Hellenic Heritage Plaque at the corner of Third and Folsom Streets, commissioned by the Hellenic American Professional Society, pays tribute to these pioneering Greek immigrants.

The close-knit relationship between San Francisco's Greek residents and their church was challenging to maintain during the early part of the 20th century, given the community's growth. The community's expansion accelerated with the return of hundreds of volunteers at the conclusion of the Balkan Wars. A growing number of parishioners voiced their concerns that the community's progress was not keeping pace with its growth. Furthermore, the community was divided over politics in Greece—those who supported the liberal prime minister Eleftherios Venizelos and those who were loyal to King Constantine I. The Venizelists met to discuss building a second church, and in June 1921, they purchased all the lots facing Pierce Street from Hayes to Fell Streets. This new church was named Agia (Saint) Sophia, with Fr. Philaretos Ioannides hired as the first priest. He was followed by Fr. Pythagoras Caravellas, a Harvard-educated doctor who gave up his medical career for the priesthood.

With the advent of a second church, Greek community life shifted to St. Sophia, which became the cathedral church for the San Francisco Diocese. Fr. Kallistos Papageorgopoulos became the first bishop of San Francisco in August 1927 and utilized St. Sophia as the San Francisco Diocese office. As the Greek community continued to grow, the St. Sophia parish sought to be closer to the core of San Francisco's Greeks. Parishioners voted to purchase the Valencia Street Theater for $47,743 in April 1928 and started using it as a church in 1929.

Once the Great Depression hit, the St. Sophia community had an increasingly difficult time paying its debts, and it declared bankruptcy in 1935. Bank of America purchased St. Sophia in a foreclosure sale in December 1935, charging the community $100 per month in rent. The St. Sophia community purchased the property back from Bank of America in December 1937, largely due to the efforts of Chris Katon, and it was renamed United Greek Orthodox Community of San Francisco, the Annunciation.

Meanwhile, Fr. Basil Lokis arrived at Holy Trinity in May 1936 and found a divided Greek community. Father Lokis believed strongly that the two church communities should merge, and he started a campaign to unite the Annunciation and Holy Trinity parishes. This led to litigation, and the court ordered each parish to vote on the proposed merger. Holy Trinity voted against the merger, with Annunciation for it. Holy Trinity lost many parishioners and for several years was an independent parish. Its membership numbers would remain low until the arrival of Fr. George Paulson (Pavlogou), its first American-born priest, in 1949. Father Paulson revitalized the parish ministries, and membership grew.

During World War II, the Greek community served its new country bravely and organized Greek war relief efforts, and Annunciation, through the use of a weekly radio hour, informed the community of local and international events. Annunciation's choir performed live radio concerts that were very popular.

Fr. Anthony Kosturos, a native San Franciscan who grew up at Annunciation Cathedral, was assigned to Holy Trinity in 1955. He would serve there until his death in 2004. His dedication and devotion to the Greek Orthodox Church, his parish, and the community at large earned him the respect of politicians and luminaries and the love of the Greek community.

On September 5, 1957, at a lively public auction administered by the City and County of San Francisco, the Holy Trinity community's winning bid of $44,300 procured 8.5 acres on Brotherhood Way to build a new church. Construction of the new Holy Trinity commenced on November 13, 1961, with completion in October 1963, and the first divine liturgy was held on January 26, 1964.

In 1962, Annunciation was named the cathedral for the Metropolis of San Francisco, and the parish acquired an adjacent apartment building as investment property. A major renovation of the sanctuary, auditorium, and classrooms was completed, and when the Bausch and Lomb Optical Company building became available, it was purchased by the cathedral, effectively giving the community 47,000 square feet of land.

Six priests who originally served in San Francisco parishes were later elevated to the episcopacy. St. Sophia/Annunciation Cathedral's Fr. Philaretos Ioannides became the first bishop of Chicago in 1922, served as the absentee bishop of San Francisco until 1927, and was later metropolitan

of Syros. Fr. Kallistos Papageorgopoulos became the first bishop of San Francisco on August 7, 1927. Fr. Athenagoras Kavadas became the bishop of Boston, with Fr. Irenaeos Kassimatis named bishop of South America. Fr. Polykeftos Finfinis became the bishop of Pittsburgh, and Fr. Meletios Tripodakis was elevated to bishop of San Francisco.

Earthquakes have played a significant role in the history of San Francisco's Greek community. Since the beginning of the 20th century, the Greek community has had two churches destroyed by violent earthquakes. The 1906 earthquake and fire destroyed the first Holy Trinity building along with much of San Francisco, but this resilient community rallied and rebuilt. The 1989 Loma Prieta Earthquake devastated Annunciation Cathedral, and it was demolished. In the spirit of the early immigrants, Fr. Stephen Kyriacou rallied and ministered to his flock in the adjacent Bausch and Lomb Building until a new church facility was built.

Given changes in the neighborhood, some parishioners wanted Annunciation Cathedral to relocate, but in 1991, the parishioners voted to rebuild on the same site, and in 1992, the parish assembly voted to start phase I of the master plan, which included a 300-seat chapel, a multipurpose hall, a kitchen, classrooms, and the cathedral offices at a cost of $4.6 million. Under Father Stephen's leadership, ground breaking for phase I occurred on November 22, 1992. On October 9, 2013, Annunciation Cathedral signed a contract with McNely Construction to build the cathedral and underground parking at a cost of $10.7 million, the interior space and appointments expected to cost an additional $2.3 million. When completed, it will serve as the cathedral church of the Metropolis of San Francisco, which covers seven Western states—Alaska, Arizona, California, Hawaii, Nevada, Oregon, and Washington. The community was issued a building permit on October 17, 2013, the 24th anniversary of the Loma Prieta Earthquake. The new Annunciation Cathedral is under construction, with anticipated occupancy in 2018.

The architecture, design, and iconography of the Greek Orthodox church are revered globally. In 2008, Holy Trinity engaged iconographer Robert Andrews to create the Pantokrator mosaic. At a cost of $1.7 million, the Pantokrator mosaic features the largest mosaic face of Christ in the Western Hemisphere, measuring 23 feet from the top of the forehead to the chin, comprised of an estimated 1.4 million individual hand-cut glass mosaic tiles, installed 75 feet above the church floor.

The Greek ideals of community and philanthropy are clearly evident in many fraternal and benevolent organizations. On November 16, 1929, Alexandra Apostolides, a member of St. Sophia Cathedral and a graduate of the University of California, Berkeley (UC Berkeley), established the Daughters of Penelope, EOS Chapter No. 1, a women's organization promoting Hellenism, education, philanthropy, civic responsibility, and family and individual excellence in San Francisco, with 25 charter members. In 1931, Apostolides became the organization's first grand president. Within 10 years, she had established 96 chapters across the United States, and she continued to have a profound impact on Greek women throughout her life.

Greeks are news enthusiasts and avid readers. These characteristics are reflected in the three Greek-language newspapers published in San Francisco: *Eirinikos*, *Prometheus*, and the *California*. Anastasios Mountanos, the publisher of the *California*, became a well-known figure among Greeks as a community leader and businessman and was honored by the Greek government for his service to the community. Most Greek San Franciscans remember going to Mountanos's store as children for their Greek-language schoolbooks and festive Greek costumes. Alexander Pavellas, the cofounder of *Eirinikos* and *Prometheus*, served as acting Greek consul during the 1910s. Frank P. Agnost founded the *Hellenic Journal*, a Western newspaper that was dedicated to covering news from Greece and Greek American communities, in April 1975. In 2001, Agnost retired and passed the torch to the present *Hellenic Journal* staff and board of directors, who updated the paper to its current format. The *Hellenic Journal* continues Agnost's vision of connecting and informing the Greek American community by offering its publication to the churches of the West, at special events, and in Greek stores.

Greek Americans have also contributed to San Francisco politically. In 1956, George Christopher was the first Greek American elected as mayor of San Francisco. Mayor Christopher had humble

beginnings: he immigrated with his parents in 1910 and settled near Third Street. Through his leadership, the city and the Greek community thrived. In 1993, former mayor Christopher donated the professional basketball court of the George and Tula Christopher Center at Holy Trinity. The center, with its multifunctional design, is utilized by the parish, fraternal organizations, dance groups, and athletic teams, including the Bay Area Orthodox Youth Athletic Association.

Art Agnos was elected the 39th mayor of San Francisco in 1987, the second Greek American to hold that position. He led the city through the recovery of the Loma Prieta Earthquake, and his decision to tear down the double-decker freeway along the city's Embarcadero opened up San Francisco's waterfront. After serving as mayor of San Francisco, he served as regional head of the US Department of Housing and Urban Development from 1993 to 2001.

The Greek American community continues to thrive in the San Francisco Bay Area. There are approximately 27,000 individuals of Greek descent and 10 parishes in the area. The government of Greece is represented by the Greek consulate of San Francisco. Greek youth dance groups have flourished and grown into an annual Folk Dance Festival attended by thousands. Many parishes have Greek language classes and host Greek food festivals. Annunciation Cathedral hosts San Francisco's only Greek festival, attended by thousands annually. Notably, in 1981, the Modern Greek Studies Chair at San Francisco State University was established "to promote the study of the modern Greek language, literature, history and culture in relation to its earlier Hellenic and Byzantine civilizations." This center is a testament to the legacy of Greeks in San Francisco.

One

EARLY YEARS

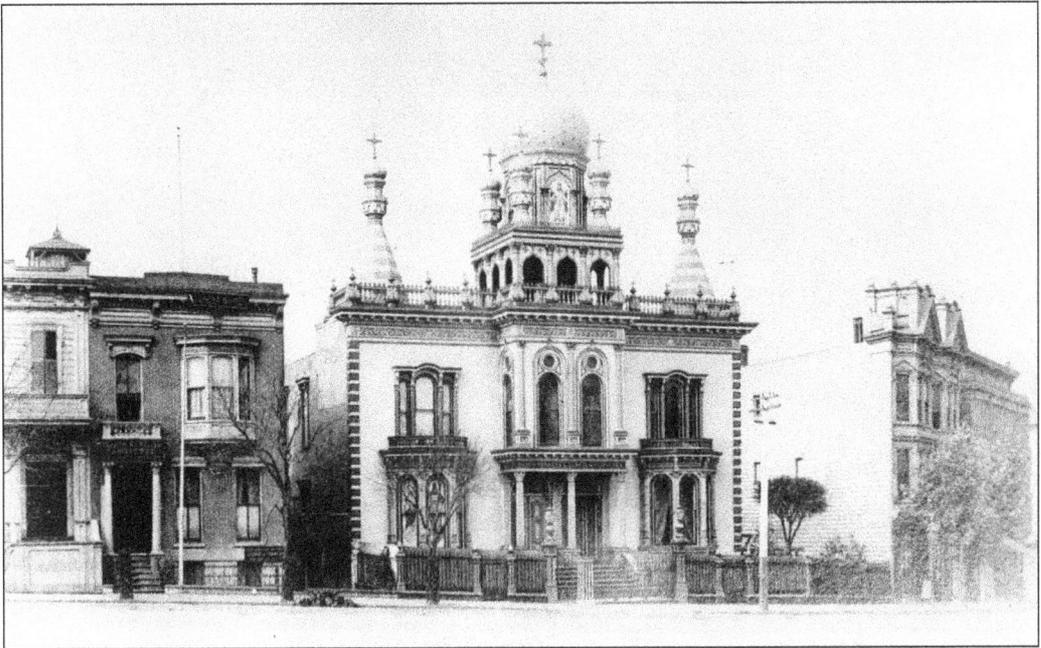

Early Greek immigrants attended Trinity Cathedral of the Holy Orthodox Church, located at 1715 Powell Street, known as the "Greco-Russian Church," prior to the establishment of Holy Trinity in 1904. The September 6, 1889, *San Francisco Chronicle* noted, "Although called the Russian Church, it is, strictly speaking, the 'Greek' Church. It includes few Russians, most of its congregation being Greeks or Slavonians." (Courtesy of the San Francisco History Room, San Francisco Public Library.)

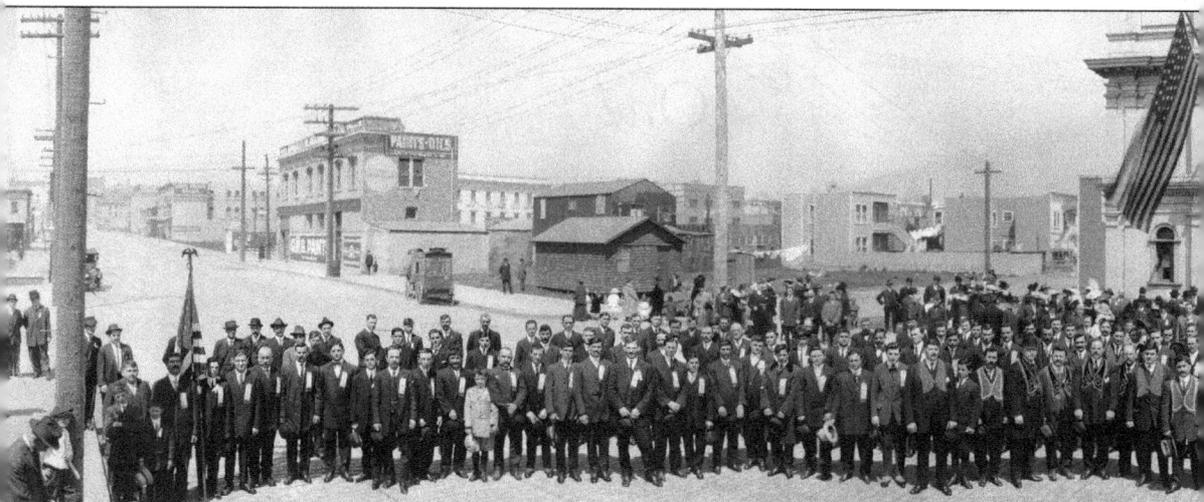

The Hellenic Mutual Benevolent Society, founded in 1891, was the first official Greek organization in San Francisco. Its members were instrumental in the establishment of Holy Trinity Church, the oldest Greek Orthodox church west of the Mississippi River. Members are pictured here at

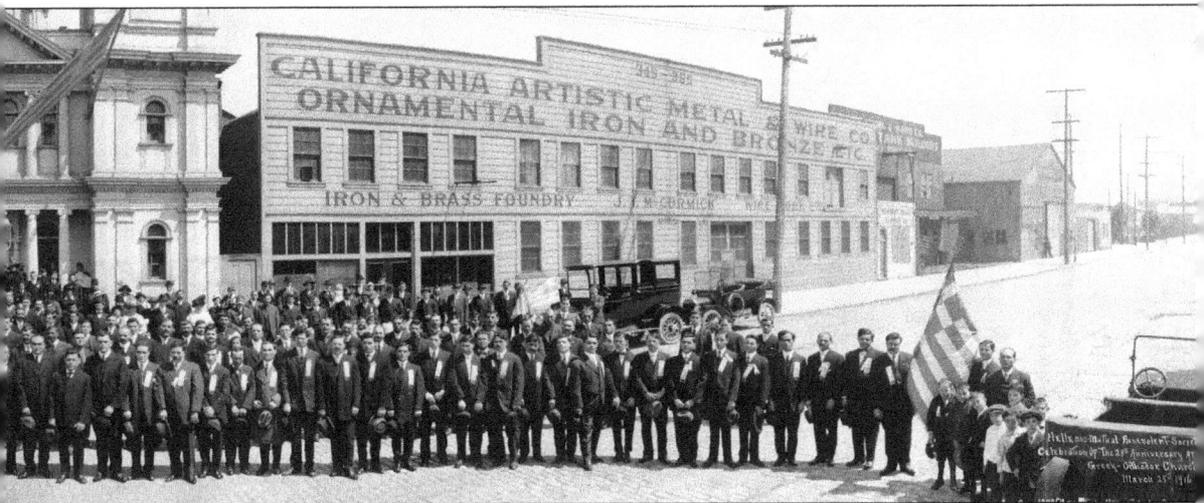

the society's 25th anniversary on March 25, 1916, in front of the old Holy Trinity Church at 345 Seventh Street. (Courtesy of the Greek Historical Society of the San Francisco Bay Area.)

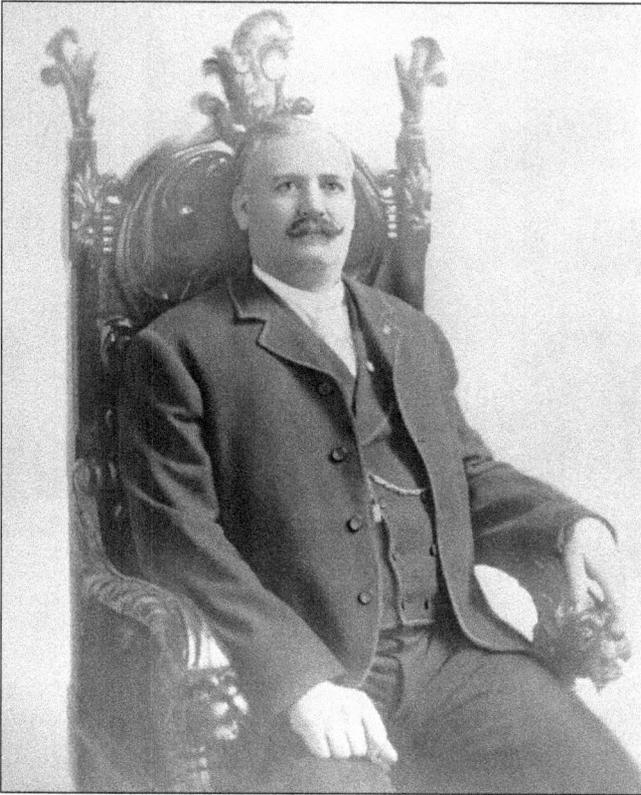

Alexander Kosta (about 1905) arrived in San Francisco from Galaxidion, Greece in the 1880s. He started the Baltimore Oyster House, served on the board of many Greek organizations, and led the community to build Holy Trinity Greek Orthodox Church, the oldest Greek Orthodox church west of the Mississippi River. His autobiography provides the only written account on the founding of Holy Trinity. (Courtesy of Peter B. George.)

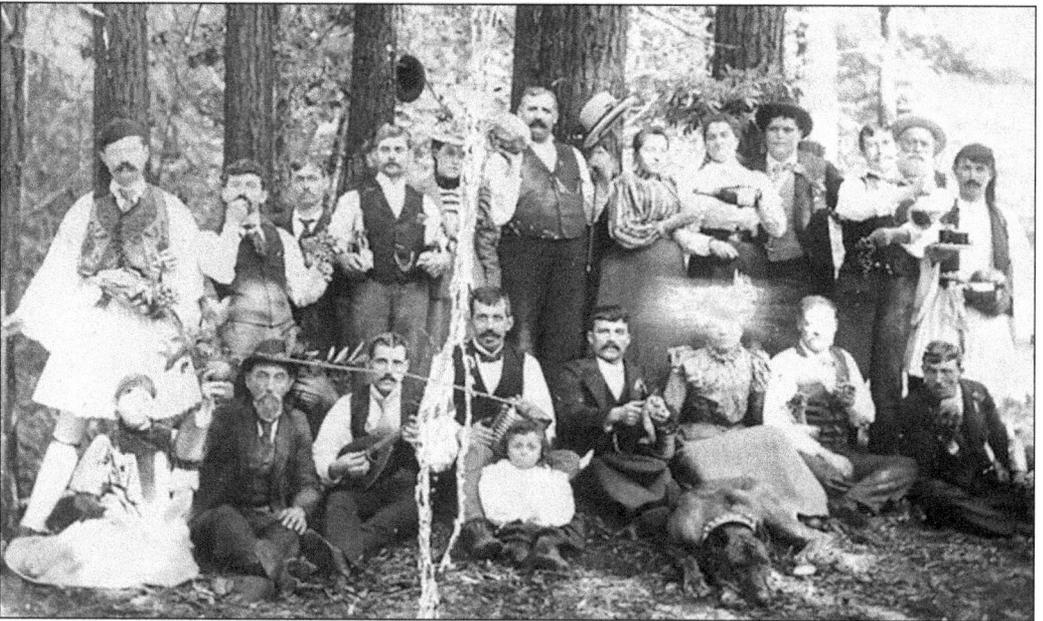

Early 1890s picnic organized by the founder of the Greek Mutual Benevolent Society, Alexander Kosta, where the early immigrants enjoyed the fellowship of friends and family, Greek music, singing, and dancing. Picnics continued to be hosted by churches and many Greek American organizations for the next 100 years. (Courtesy of Peter B. George.)

14

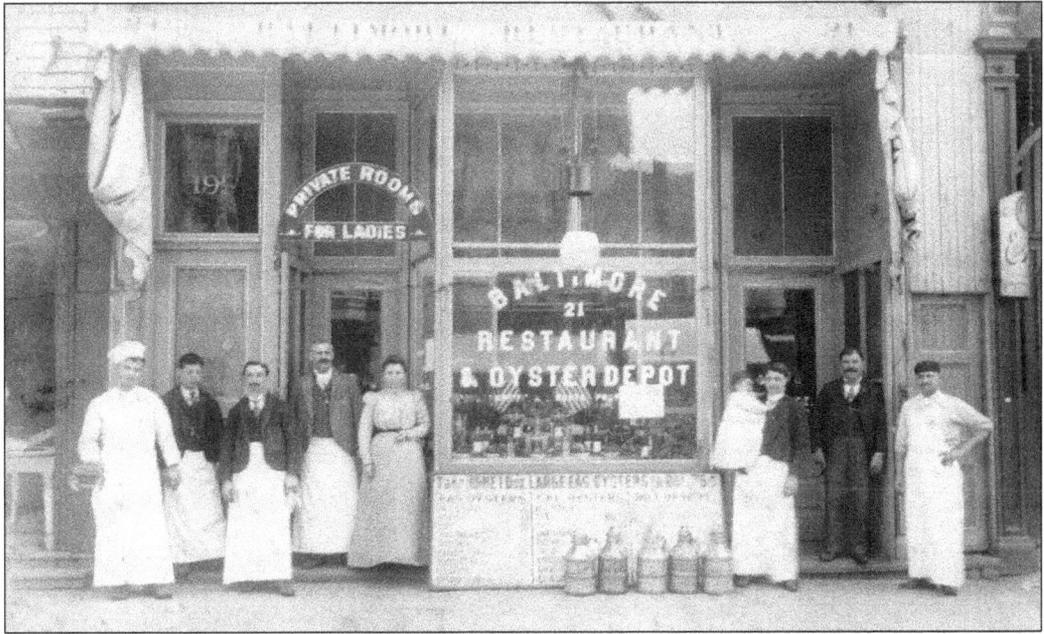

The Baltimore Oyster House was Alexander Kosta's first and most successful restaurant. In this 1900 photograph, Kosta is standing at the front door with his wife, Katherine. His cousin John Stratos, far right, is holding a baby, Kosta's daughter Chrissie (Chrisafo). The restaurant was destroyed in the 1906 earthquake and fire. (Courtesy of Peter B. George.)

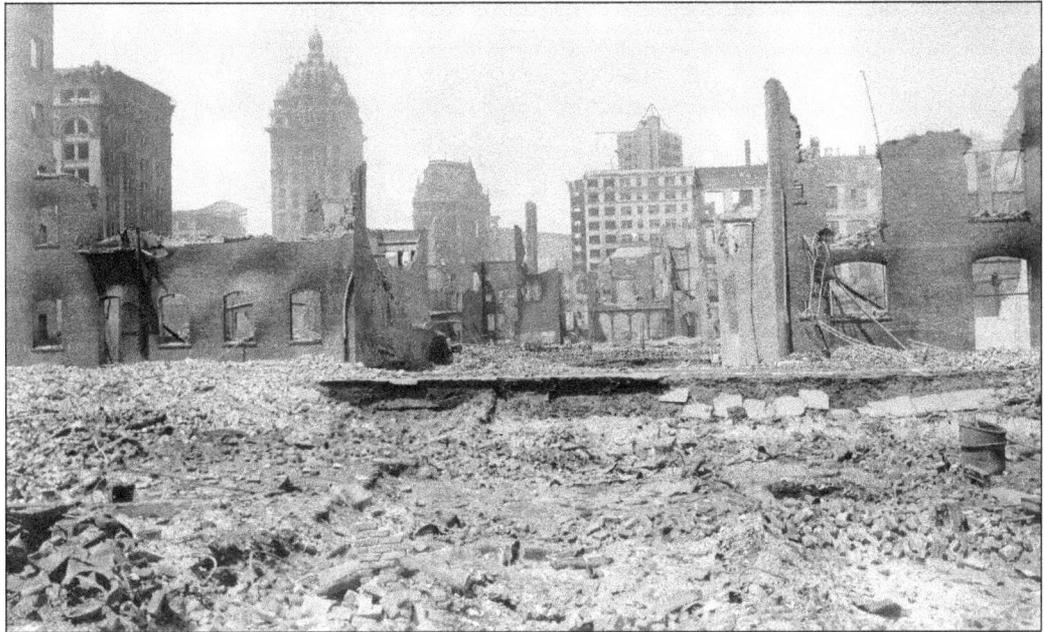

At 5:12 a.m. on Wednesday, April 18, 1906, an earthquake measuring 7.8 on the Richter scale and lasting 45 seconds wreaked devastation on San Francisco. Four days of fires followed, destroying 80 percent of the city. This photograph, looking south of Market Street, captures the sheer magnitude of the destruction, which included the first Holy Trinity Greek Orthodox Church. (Courtesy of the San Francisco History Room, San Francisco Public Library.)

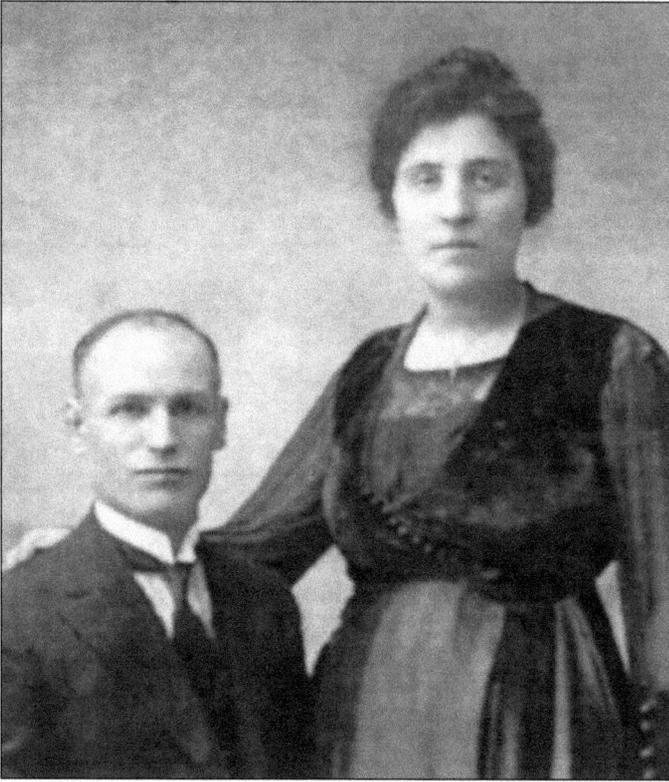

Harry Kockos, a native of Kalavrita, Greece, was one of hundreds of Greek immigrants who came to San Francisco after the 1906 earthquake and fire to rebuild the city's rail lines. He opened a successful grocery store, followed by a wholesale grocery business, and invested in real estate. His business ventures made him a millionaire. He is pictured here with his wife, Panagiota. (Courtesy of the Amanda Antipa estate.)

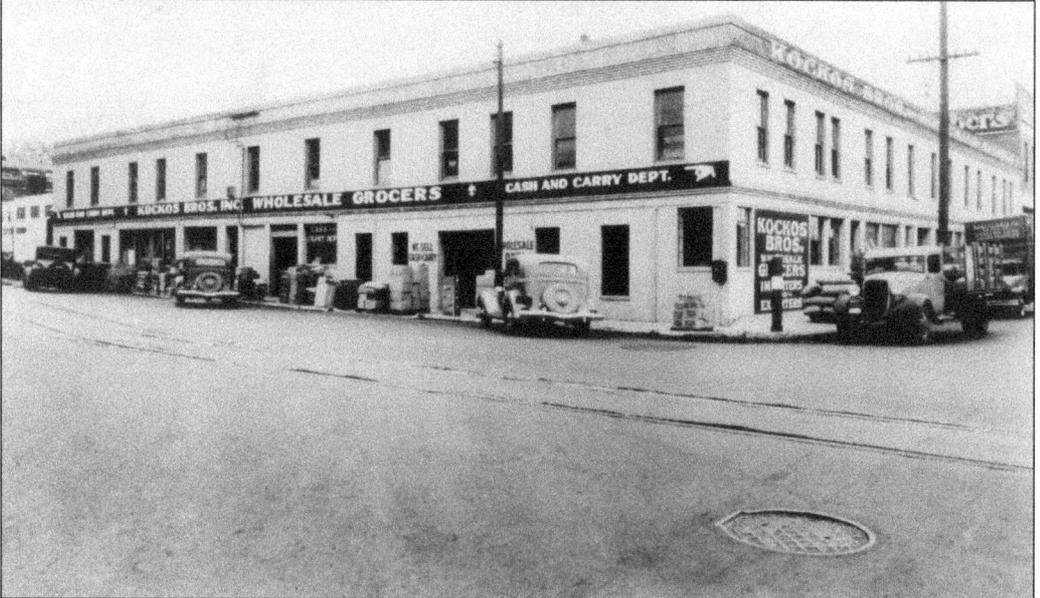

In his autobiography, Harry Kockos chronicled his journey to America. He left Patras, arriving in Boston in 1903. Traveling by train to Chicago, he found employment with the railroad, laying track in Kalispell, Montana. He worked loading lumber onto boats in Portland, Oregon, and for a bakery in Salt Lake City, before opening Kockos Bros. Inc. Wholesale Grocers at 701 Davis Street in San Francisco. (Courtesy of the Amanda Antipa estate.)

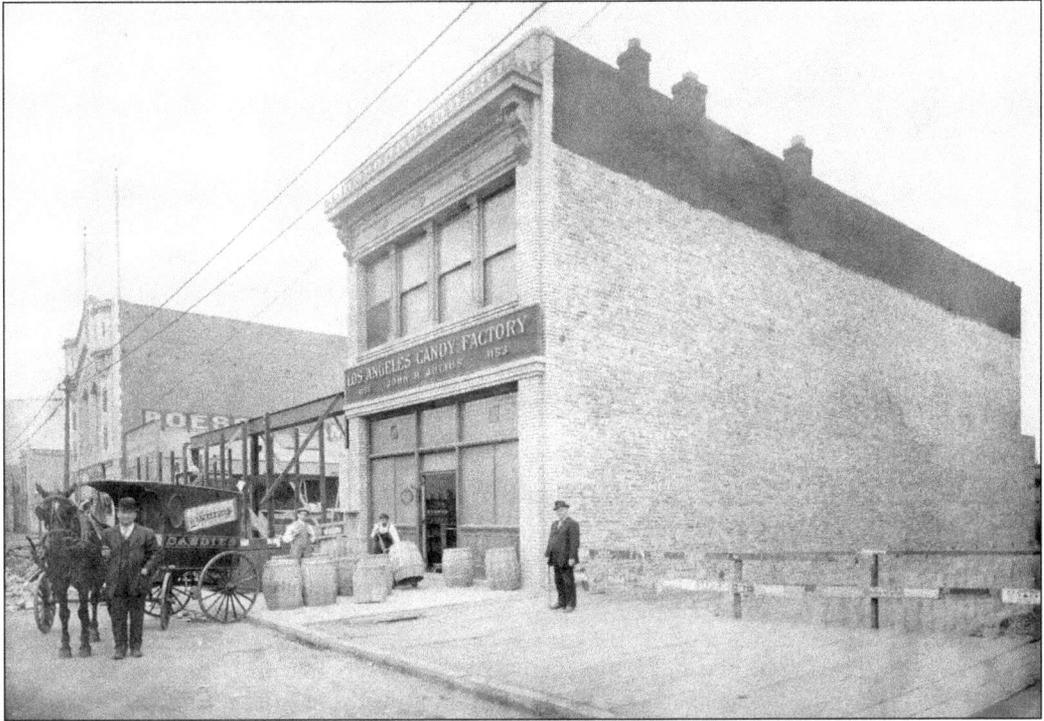

John Julius came to the United States from Haraka, Laconia, Greece. He started the Los Angeles Candy Factory at 1151–1153 Mission Street. The building survived the 1906 earthquake and fire and exists to this day. Julius perished in the 1918 influenza pandemic and is buried at Olivet Cemetery. (Courtesy of Peter B. George.)

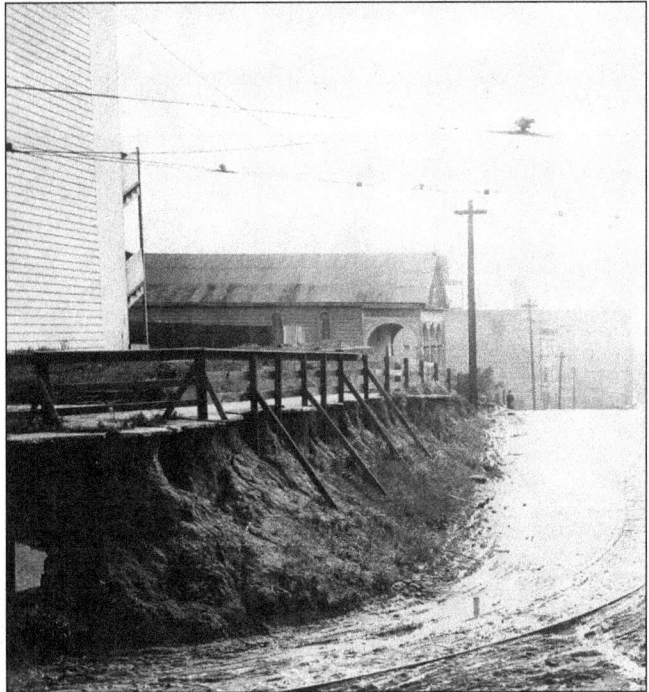

In 1908, a disagreement at Holy Trinity led to the establishment of St. John Prodromos Church and Alexander the Great Meeting Hall on Stanley/Sterling Place (center). In 1909, the churches settled their differences, and St. John Prodromos closed. Until Holy Trinity was elevated to install a meeting hall in 1922, this property housed the offices and meeting hall for the community. (Courtesy of the San Francisco History Room, San Francisco Public Library.)

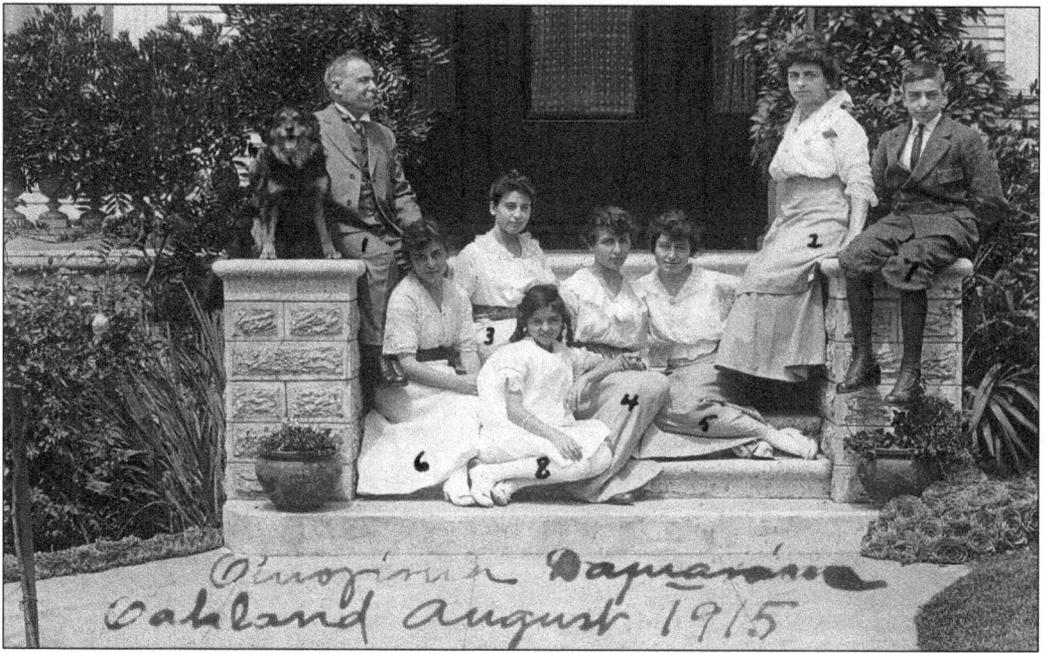

Nicholas Damianakis, the "Peanut King," arrived in San Francisco in December 1889 from Romania via Central America. He started a fruit stand business and, after the 1906 earthquake, opened a peanut factory on Clay Street. He sold roasted peanuts, hard candies, peanut butter, and chocolate-covered nuts and raisins. The California Peanut Company became one of the largest Greek-owned businesses in Northern California. Damianakis is pictured here with his family. He was married at Trinity Cathedral of Holy Orthodox Church. (Courtesy of Peter and Paula Anast.)

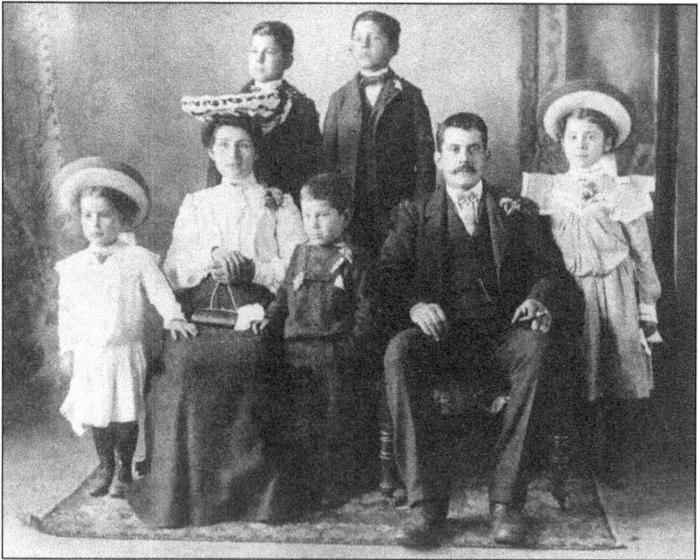

Panagiotis Georgopoulos (pictured here in 1903) and his wife, Spiridoula Hlebakos, came from Kyparissia, Greece. They immigrated to the United States through Castle Clinton in New York City. Panagiotis opened several grocery stores, including the Green Grocery Market. He was one of the founders of Holy Trinity. They are pictured with their children, from left to right, (first row) Elisavet, Demetrios, and Stavroula; (second row) Basil and George. (Courtesy of Peter B. George.)

Two

THIRD STREET

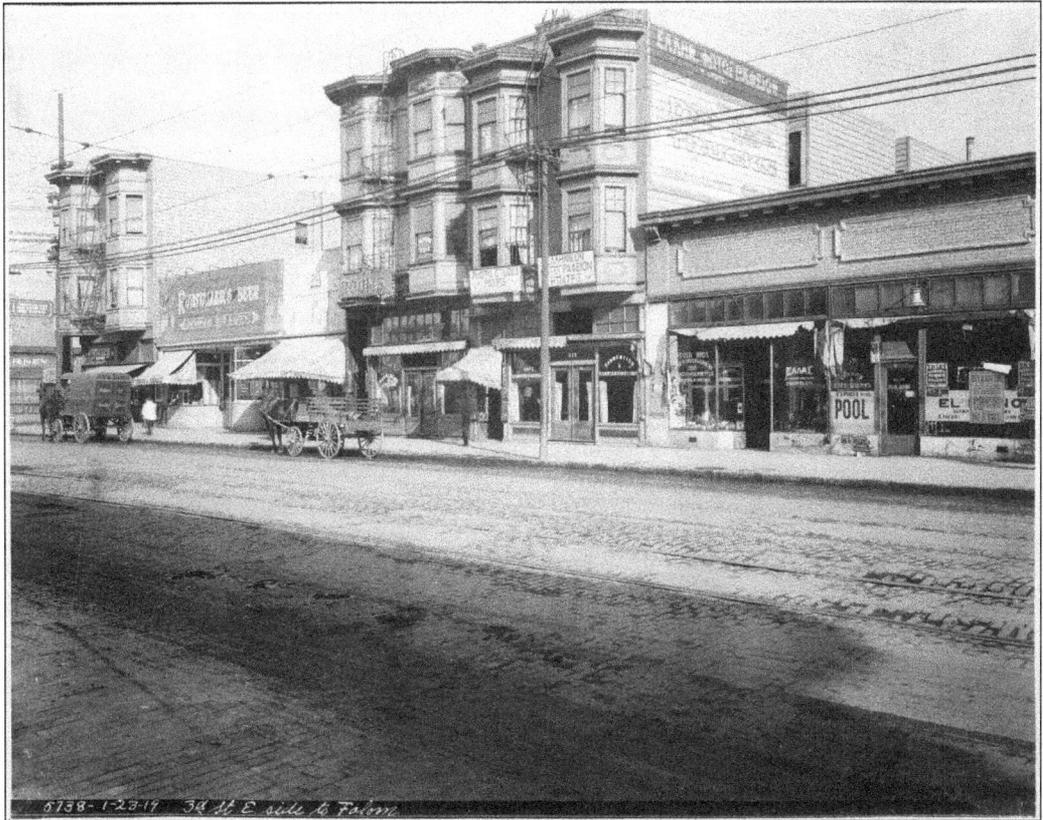

In this 1919 photograph of the east side of Third Street to Folsom Street, one sees the delivery wagon of the Athens Baking Company, the Acropolis Café and Grill, the Café Arcadia, the Café Constantinople, the Photo Studio Patris (Greek and English signage), and Hellas Printing. In 1925, Greeks owned 58 percent of the businesses on the 300 block of Third Street. (Courtesy of the San Francisco History Room, San Francisco Public Library.)

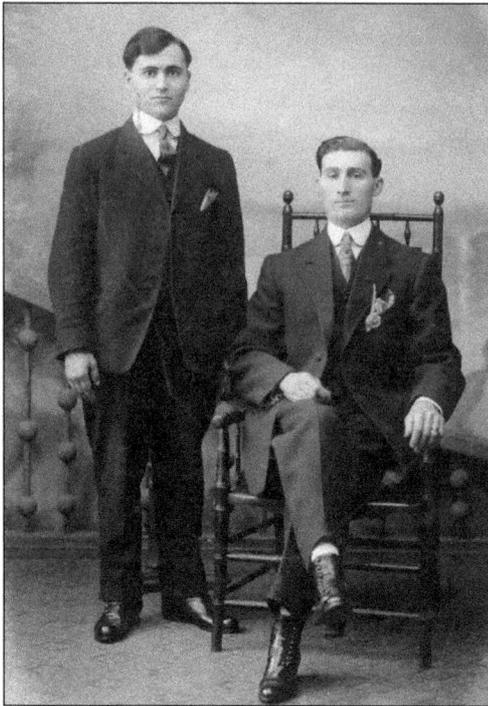

Dionysios (standing) and George Hlebakos are in this Leon Pantoti (Leonidas Pantotio) photograph taken at Photo Studio Patris at 319 Third Street. Pantoti and his wife, Urania, immigrated from Patras, Greece in 1912. Many early Greek immigrant photographs were taken by him between 1914 and 1922. (Courtesy of Jim Lucas.)

In this 1919 photograph of the south side of Folsom Street looking east from Third Street, one sees the Athens Saloon and the Regal Hotel (315 Third Street). Other Greek-owned businesses were the Acropolis Fruit Store, Hellas Importing House, the Smyrna Coffee House, the Third Street Grocery, John's Barber Shop, and the Venus Coffee House. (Courtesy of the San Francisco History Room, San Francisco Public Library.)

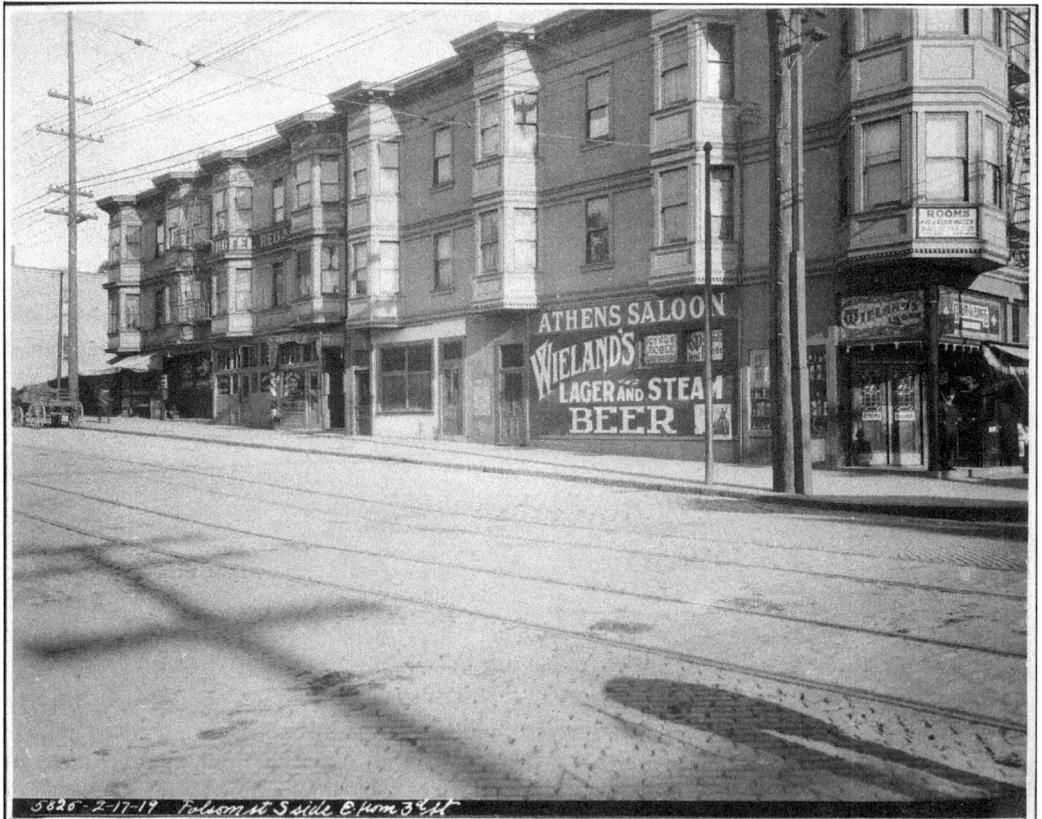

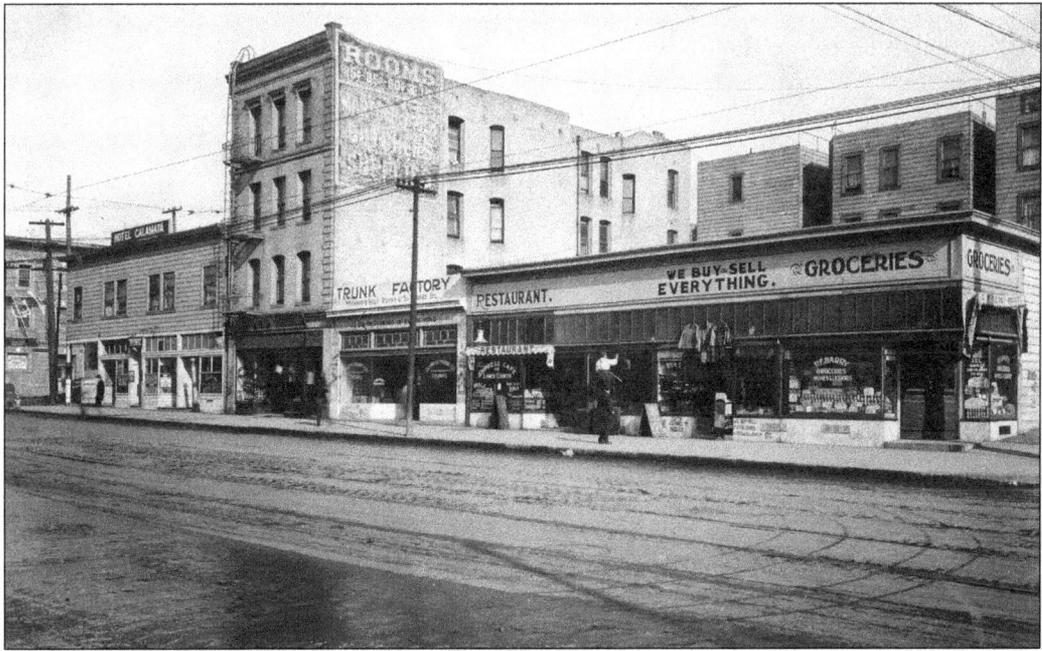

In this 1919 photograph of Third Street, looking east between Perry and Harrison Streets, one sees the signage atop the building at the far left, Hotel Calamata. By the 1960s, the old buildings on Third Street had deteriorated. They were demolished for the creation of the Moscone Center, the San Francisco Museum of Modern Art, and apartment buildings. (Courtesy of the San Francisco History Room, San Francisco Public Library.)

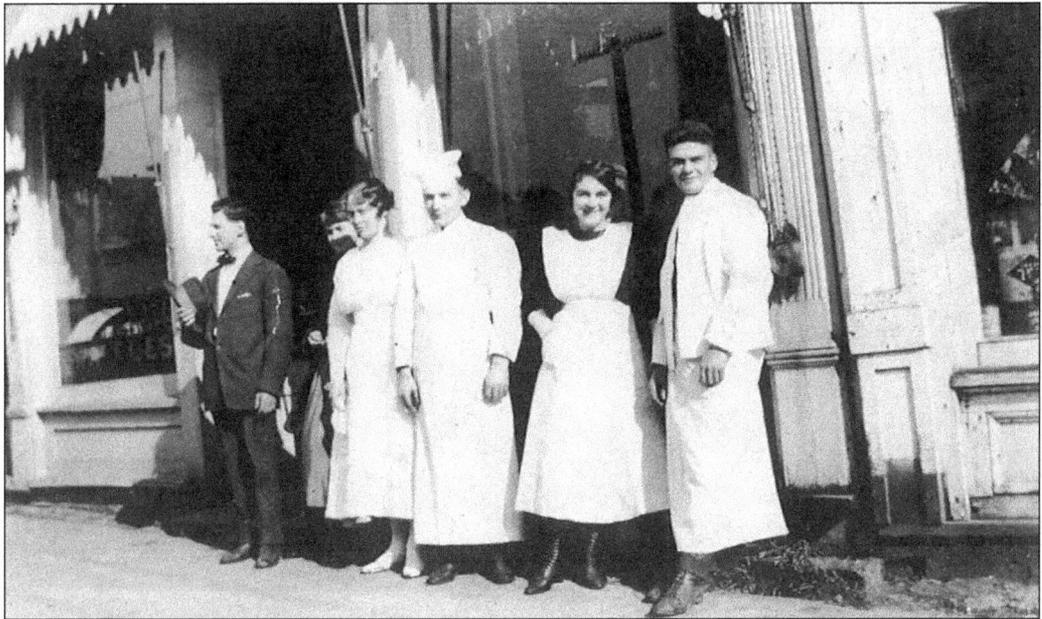

The Pacific Pie Company, owned by Costas Triggas, was located at 123 Stillman Street, near Third Street. Costas's son, PFC James Triggas, served in the 4th Marine Division in the Battles of Saipan and Tinian and with the 2nd Marine Division in Okinawa. He also served in Nagasaki, Japan. (Courtesy of Audrey Triggas Bogdis.)

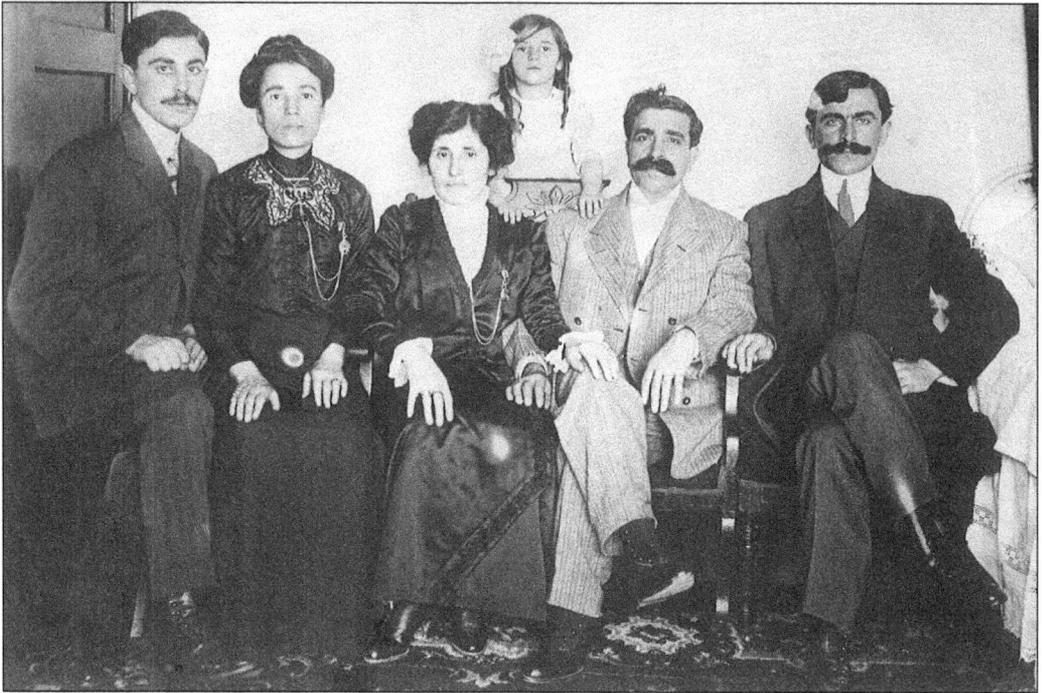

The Samoulides family is pictured here; sitting from left to right are Demetri Samoulides, Mary Polizopoulos Boyiarides, Sophia Samoulides, Paul (Apostolos) Boyiarides and John G. Samoulides, with little Lambathia standing behind them. They all lived in and around Harrison Street. Demetri was a barber, John was a tailor, and Paul had a fruit and vegetable cart. They were from Luleburgaz, Babaeski, and Urgup, Turkey. (Courtesy of George and Artemis Samoulides.)

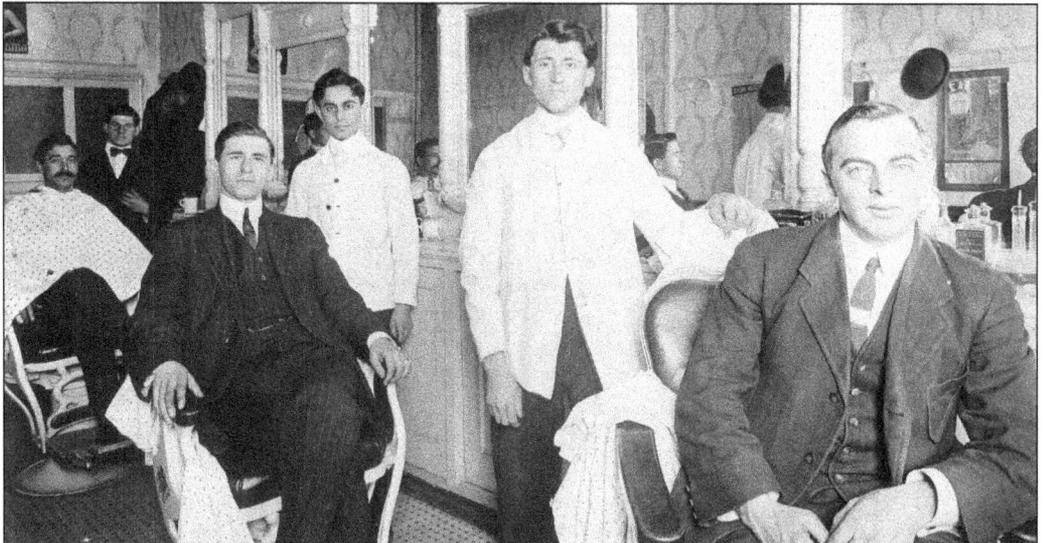

John Samoulides (standing, second from the left) arrived in the United States on July 5, 1907, at age 17. He was born in Urgup, Cappadocia, Turkey. He settled in San Francisco and opened John's Barber Shop at 347 Third Street in the 1920s. As the Greek immigrants relocated to other parts of the city, he eventually moved his barbershop to Taylor Street. (Courtesy of George and Artemis Samoulides.)

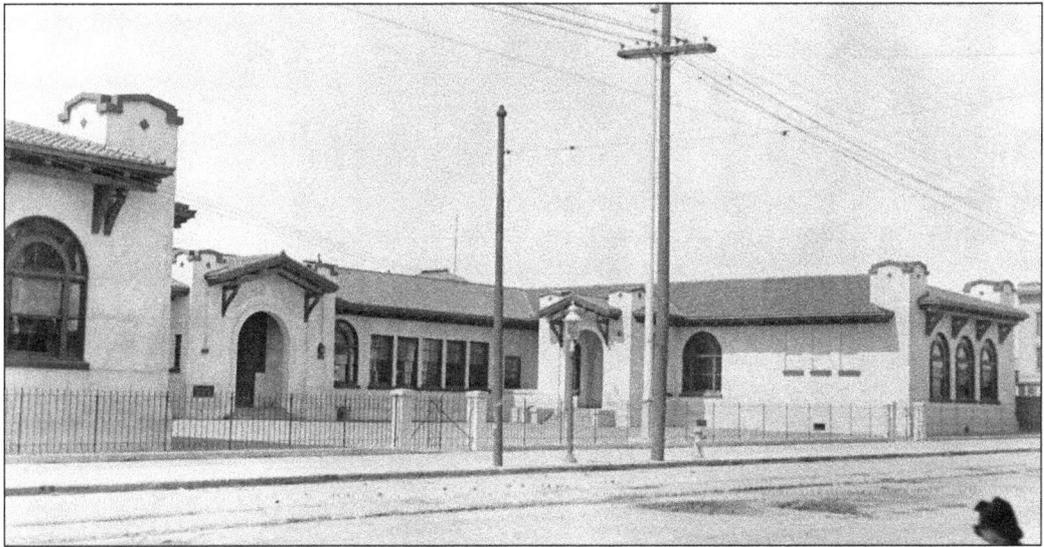

Greek American students living around Third Street began their English-language education at the Lincoln Grammar School, on the north side of Harrison Street between Fourth and Fifth Streets. The school, established in 1856, was the largest all-boys school on the Pacific coast. It was destroyed in the 1906 earthquake and fire and rebuilt. (Photograph by Leonard L. Hohl, courtesy of the San Francisco History Room, San Francisco Public Library.)

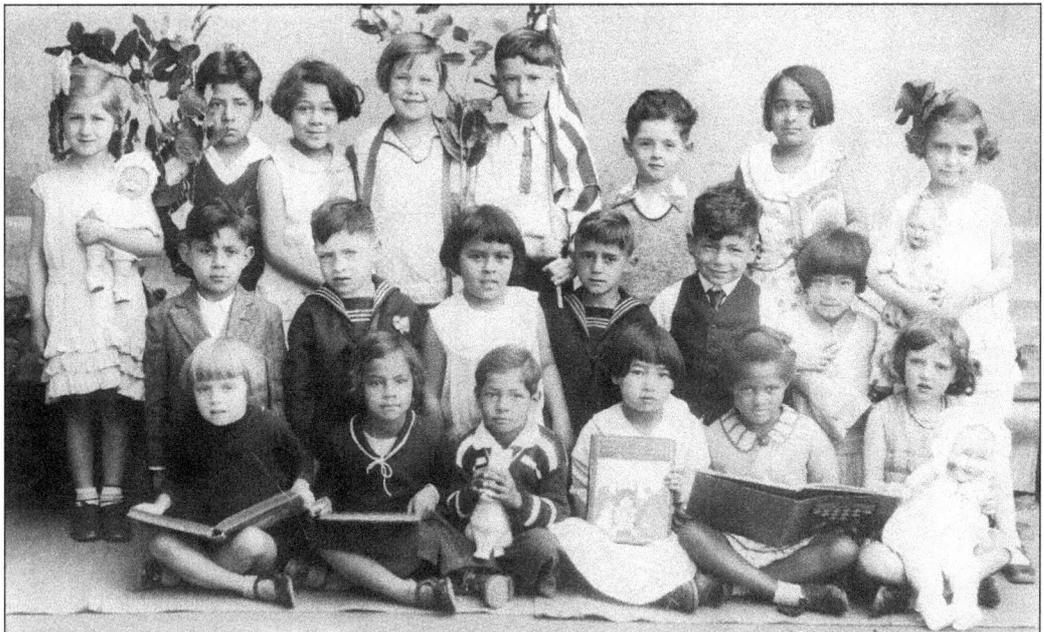

George Samoulides (second row, far left) is pictured in 1932 at the Lincoln Grammar School, located in the heart of San Francisco's Greek community. Many Greek American children growing up around Third Street attended the school, including future mayor George Christopher. As evidenced in this photograph, the school reflects the diversity of San Francisco. (Photograph by Frances Thompson Studio, courtesy of George and Artemis Samoulides.)

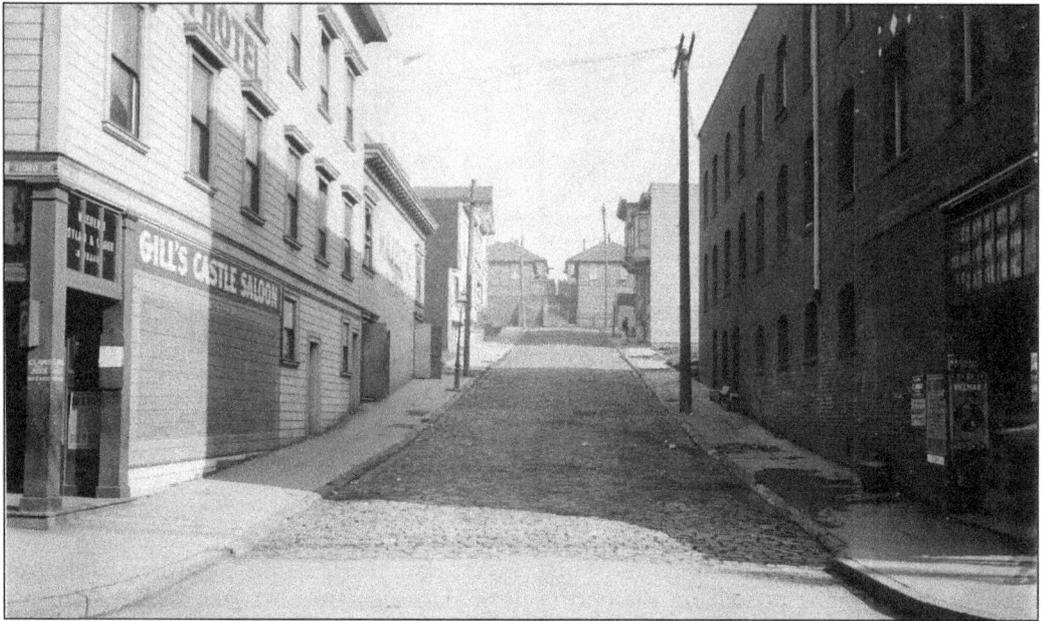

Verona Place, a one-block street between Folsom and Harrison Streets off of Third Street, was home to many Greek immigrants. According to the 1925 Crocker Langley San Francisco City Directory, 42.9 percent of Verona Place's residents were Greek. Several generations of the Triantos (Triantaphilou), Varellas, and Zamboukos families lived at 54 Verona Place from the 1910s to the 1930s. (Courtesy of the San Francisco History Room, San Francisco Public Library.)

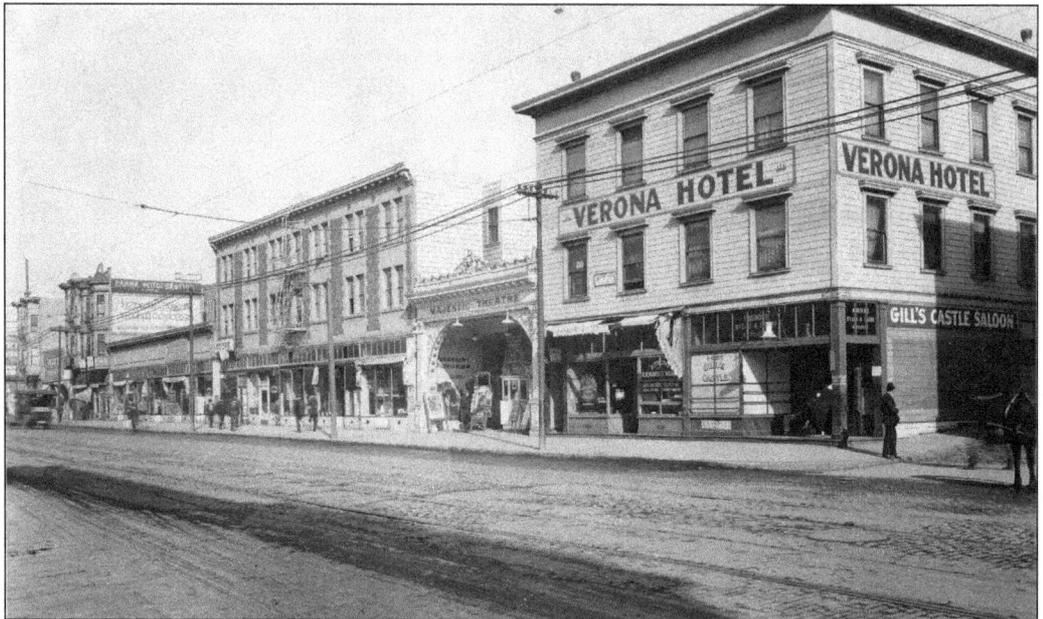

In this 1919 photograph of Third Street, looking east between Verona Place and Folsom Street, one sees Greek lettering in windows and on the building at the far left. The 300 block of Third Street was regarded as the center of the Greek business community, along with the adjoining side streets. The Do-Nut King Coffee Shop would replace Gill's Castle Saloon. (Courtesy of the San Francisco History Room, San Francisco Public Library.)

The Triantos (Triantaphilou) family lived at 54 Verona Place, in the heart of the early Greek community. Triantaphilos Triantos immigrated to America from Tiros, Arcadia, Greece, and his wife, Constandina, from Kounoupia, Arcadia. Triantaphilos's store, Third Street Grocery, at 337 Third Street, was the first in San Francisco to offer products from Greece. (Courtesy of Mary James Zamboukos.)

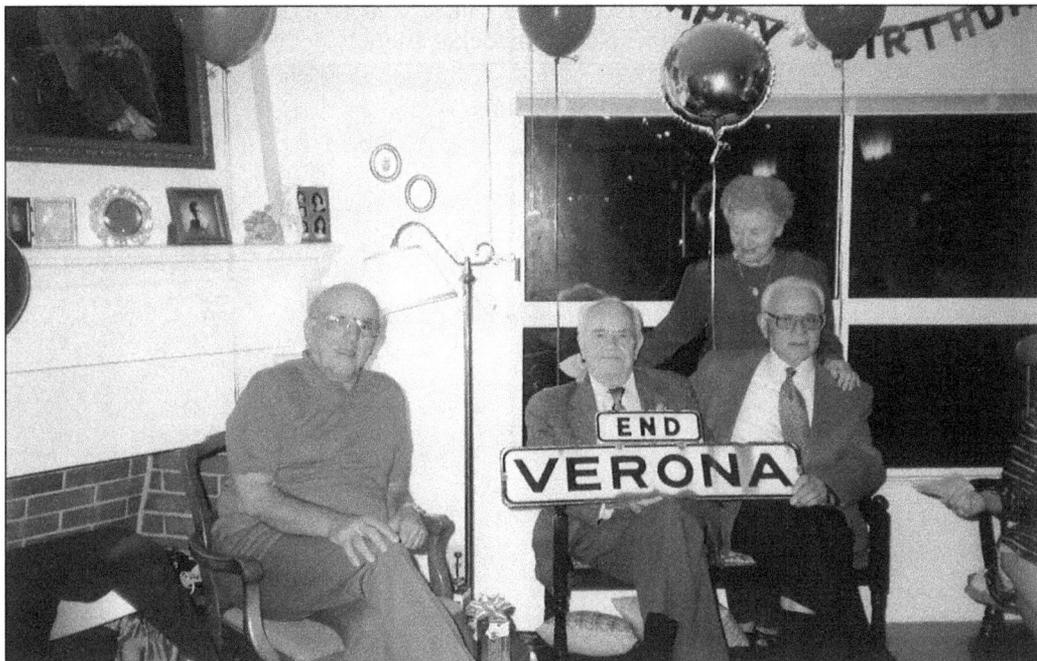

Pictured here are, from left to right, (sitting) Nick Triantos (Triantaphilou), George T. Varellas, and James N. Zamboukos; (standing) Dora Triantos Rubiales. The Verona gang reunited at James's 85th birthday party. They all lived at 54 Verona Place, off of Third Street, between the 1910s and the 1930s. When the street ceased to exist, James petitioned the city to give him the street sign. (Courtesy of Mary James Zamboukos.)

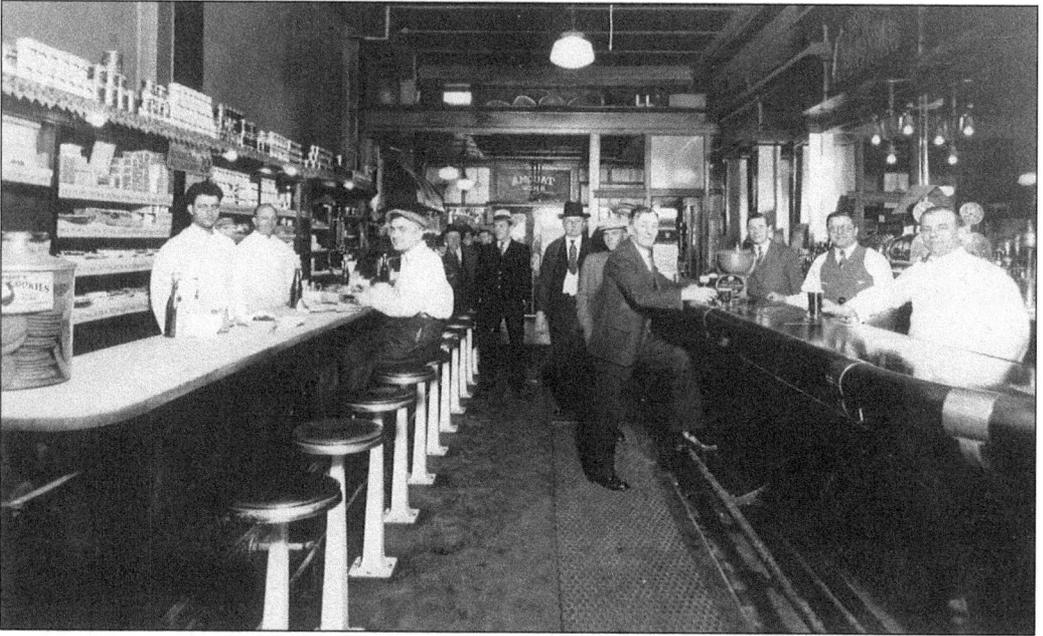

Pictured are James (Demetrios) P. Zamboukos (right front), his brother John P. Zaboukos (second from left), and their first cousin James N. Zamboukos (left front) at the brothers' restaurant, the Waldorf Grill, at 84 Third Street. They immigrated from Kounoupia, Arcadia. James P. arrived in the United States on October 12, 1902, age 12. James N. arrived on December 23, 1923, via Havana, Cuba. (Courtesy of the James Neal Zamboukos estate.)

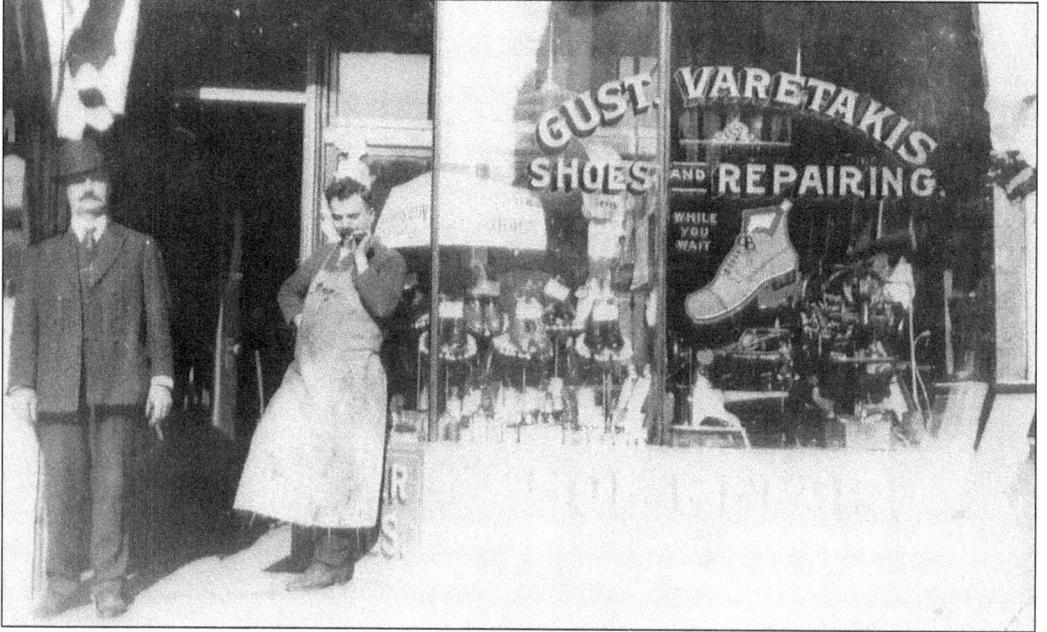

Constandinos Varetopoulos was born in Marmara, Turkey, on June 3, 1885. He left Patras, Greece, aboard the *Eugenia* and arrived in New York City on March 17, 1907. He made his way west to San Francisco and opened Varetakis Shoe Repair at 306 Third Street. In 1938, he became a naturalized citizen and took the name of Gust Varetakis. (Courtesy of Georgia Varetakis.)

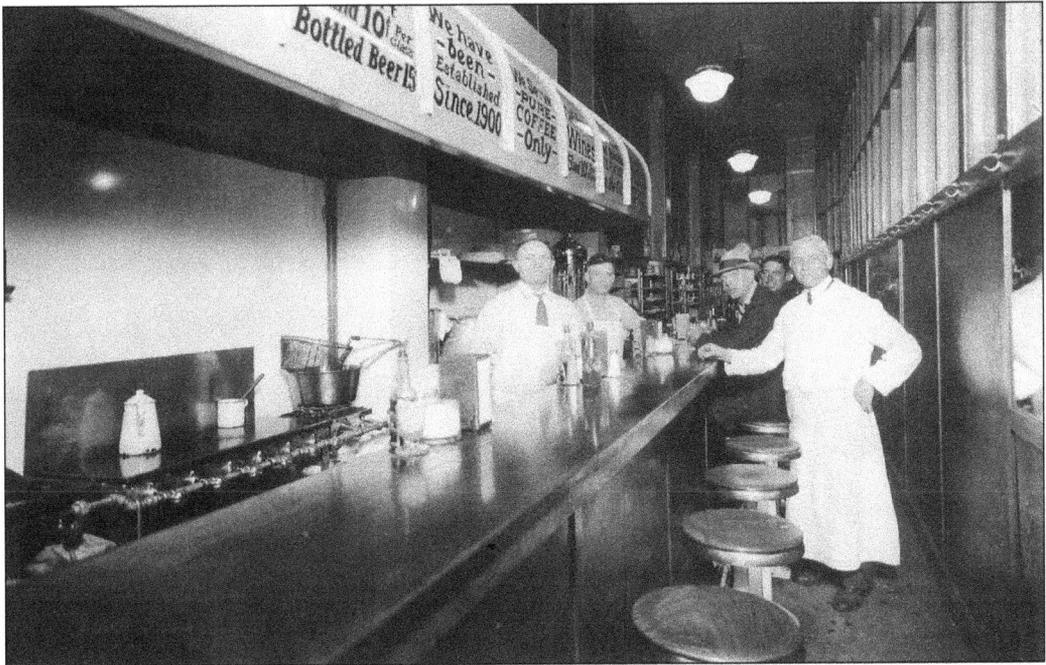

The Chicago Café, at 182 Third Street, was owned by Theodore P. Kerhulas and Constantine Getas. Theodore gave James Christopher, Mayor George Christopher's father, a job where he learned about restaurant operations. James would open his own business shortly thereafter, the Reception Café, at 137½ Third Street. Theodore's son, Dr. Gus Kerhulas, was the building fund chairman for the new Holy Trinity. (Courtesy of the Kerhulas family.)

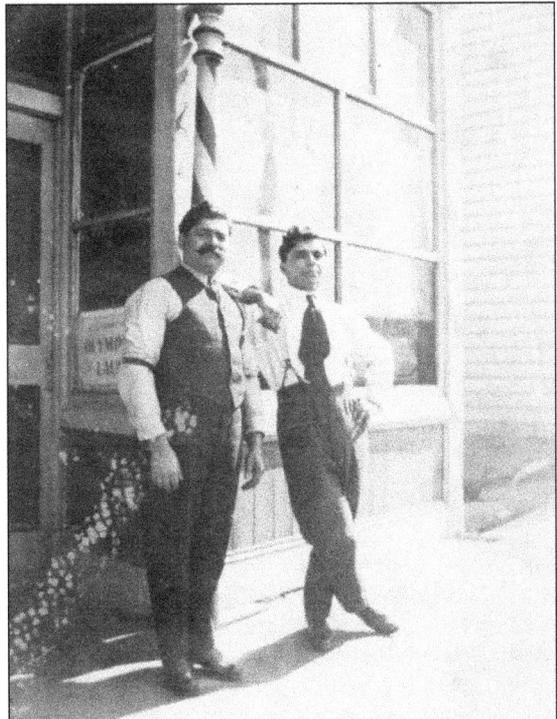

Early Greek immigrants founded or sought employment in a variety of businesses: groceries, restaurants, candy stores, barbershops, fruit and vegetable stands, shoe shine parlors, coffee shops, and tailor stores. Pictured on the left is Athan Elliades (proprietor) and on the right is George Hountalas of the Olympia Laundry, incorporated in 1915 and located at 61 Clara Street. (Courtesy of the Vassiliki Hountalas estate.)

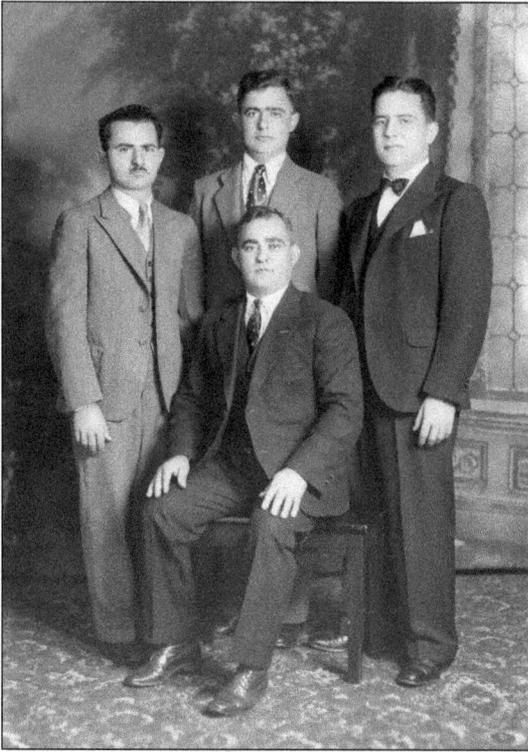

George D. Varellas (seated) came to San Francisco in 1905 at 16. He owned the Reception Café at 137½ Third Street. His nephews (standing from left to right) Jim (Demetrios), Gus (Konstandinos), and George owned their own businesses. Jim and George had the Palace Lunch (737 Third Street), and Gus had the Parcel Post Coffee Shop (115 Mission Street). All immigrated from Mari, Arcadia, Greece. (Courtesy of Carol Varellas-Pool.)

George D. Varellas came to San Francisco in 1905, survived the 1906 earthquake and fire, and lived in a tent city in Golden Gate Park. He returned to Greece to fight in the Balkan Wars of 1912–1913. He opened the Palace Lunch at 737 Third Street. His nephews Jim (Demetrios) and George joined the business and operated it until 1967. (Courtesy of the San Francisco History Room, San Francisco Public Library.)

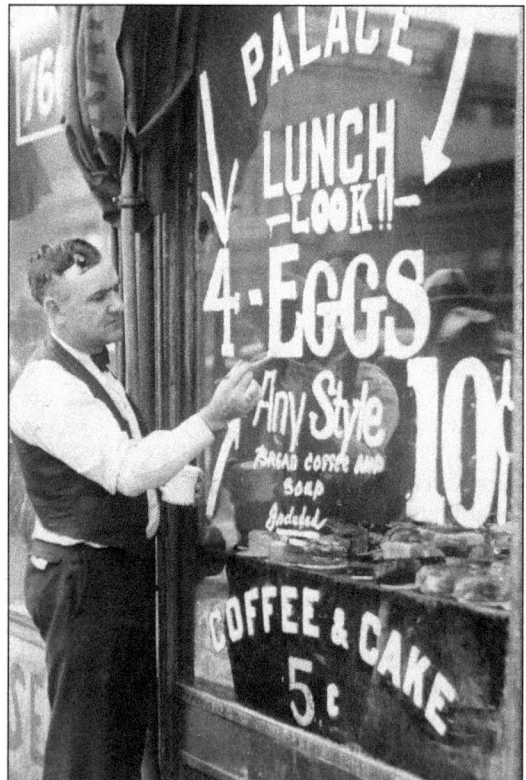

28

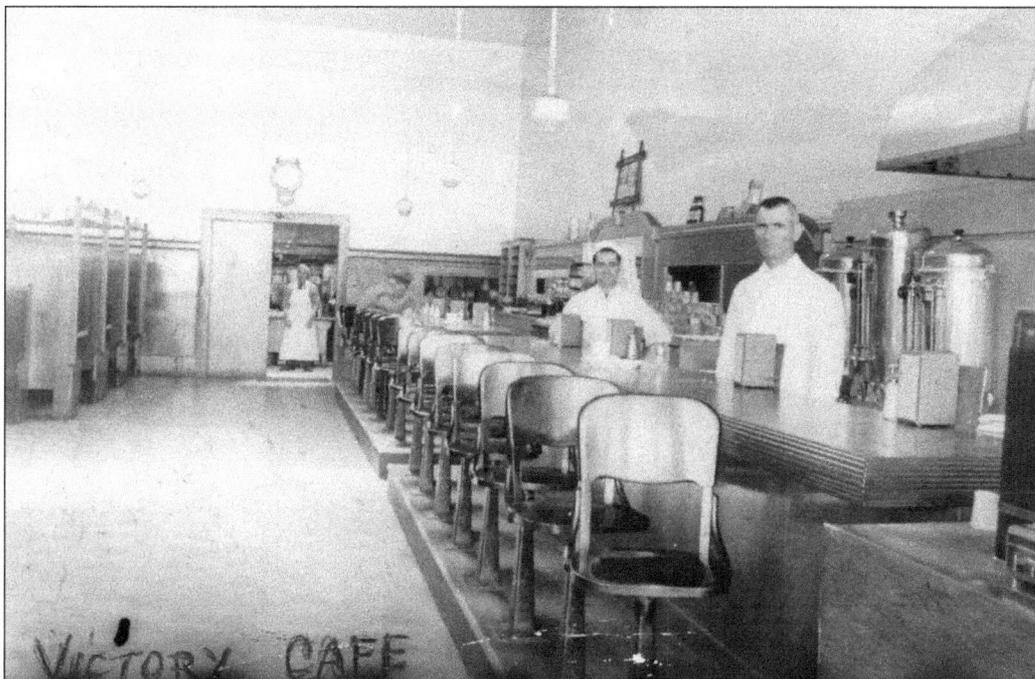

The Victory Café, located at 278 Third Street in San Francisco, is shown as it appeared in 1943. It was owned by Sam Makis (Efthimios Artemakis), William Ballas, and Andrew Stefopoulos. Makis moved to Manteca in 1948. The Victory Café was one of many Greek-owned businesses between Market and Harrison Streets on Third Street. (Courtesy of the Makis family.)

George Morf (1895–1986), born in Marmara, Turkey, immigrated to the United States in 1910. He opened a number of bakeries, and in the early 1930s, George arrived in San Francisco, where he opened the Do-Nut King Coffee Shop at 371 Third Street. He owned the business until it closed in 1967, when the South of Market area was declared a redevelopment area. (Courtesy of Nick Morf.)

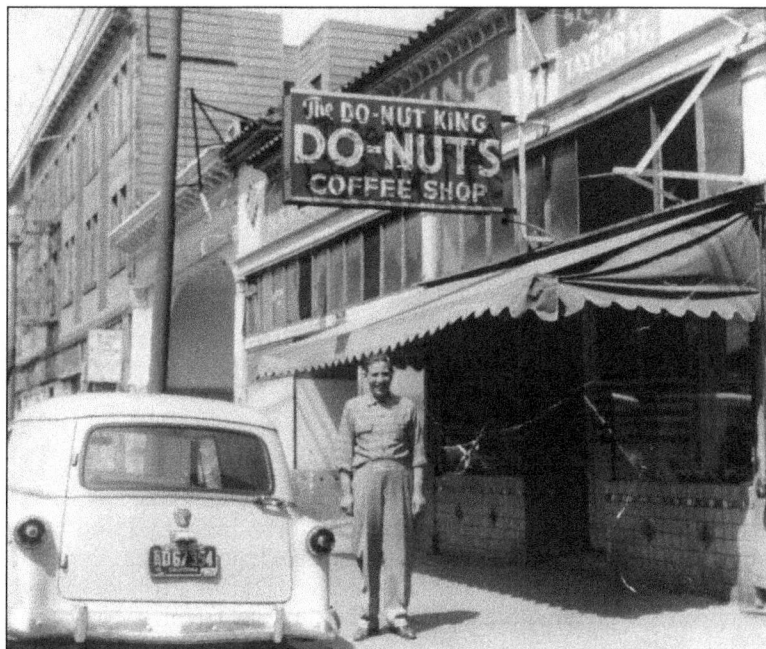

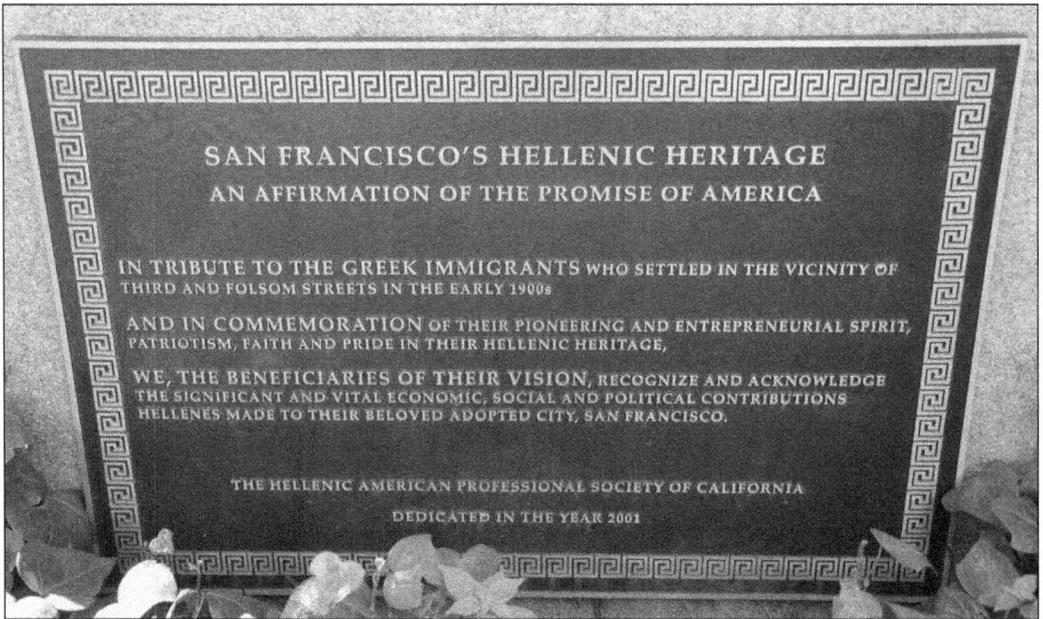

SAN FRANCISCO'S HELLENIC HERITAGE
AN AFFIRMATION OF THE PROMISE OF AMERICA

IN TRIBUTE TO THE GREEK IMMIGRANTS WHO SETTLED IN THE VICINITY OF
THIRD AND FOLSOM STREETS IN THE EARLY 1900s

AND IN COMMEMORATION OF THEIR PIONEERING AND ENTREPRENEURIAL SPIRIT,
PATRIOTISM, FAITH AND PRIDE IN THEIR HELLENIC HERITAGE,

WE, THE BENEFICIARIES OF THEIR VISION, RECOGNIZE AND ACKNOWLEDGE
THE SIGNIFICANT AND VITAL ECONOMIC, SOCIAL AND POLITICAL CONTRIBUTIONS
HELLENES MADE TO THEIR BELOVED ADOPTED CITY, SAN FRANCISCO.

THE HELLENIC AMERICAN PROFESSIONAL SOCIETY OF CALIFORNIA

DEDICATED IN THE YEAR 2001

On April 22, 2001, Mayor Willie Brown, former mayor Art Agnos, and Assemblyman Lou Papan unveiled the Hellenic Heritage Plaque at the corner of Third and Folsom Streets. The plaque, dedicated by the Hellenic American Professional Society, commemorates the Greek immigrants who settled in the area in the early 1900s. Fr. Anthony Kosturos gave a nostalgic history of "Tres Dromos." (Courtesy of Jim Lucas.)

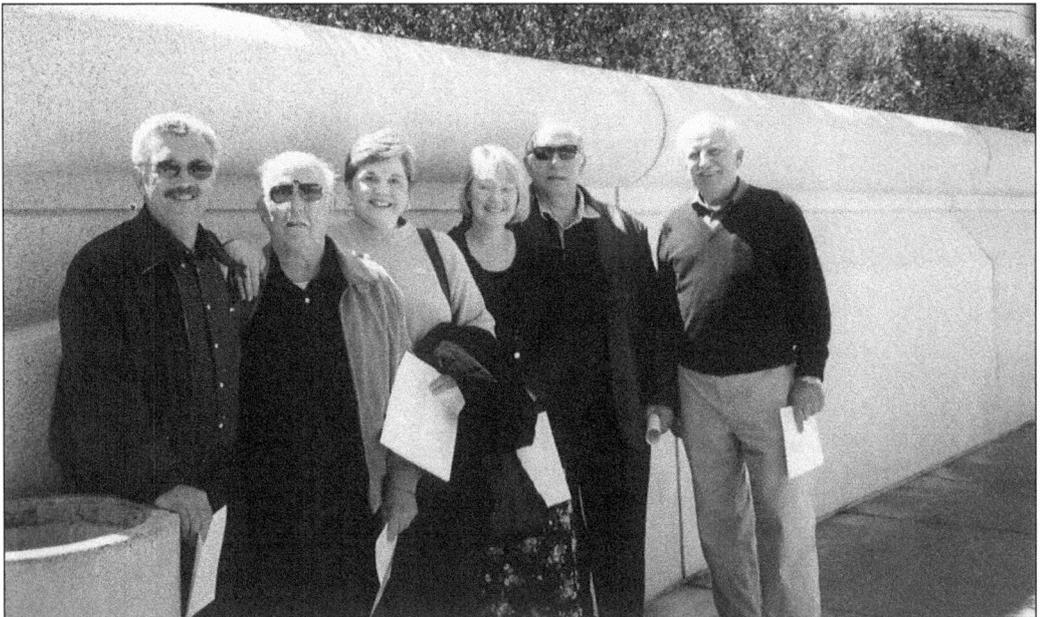

On April 22, 2001, descendants of families who lived on Third Street when it was the center of San Francisco's Greek community, gathered on the corner of Third and Folsom Streets for the unveiling of the Hellenic Heritage Plaque, paying tribute to their immigrant parents and grandparents. Pictured from left to right are Tom Triantos, Nick Triantos, Carol Varellas-Pool, Sharon Zamboukos, Ellis Varellas, and Pete Zamboukos. (Courtesy of Mary James Zamboukos.)

Three

HOLY TRINITY CHURCH

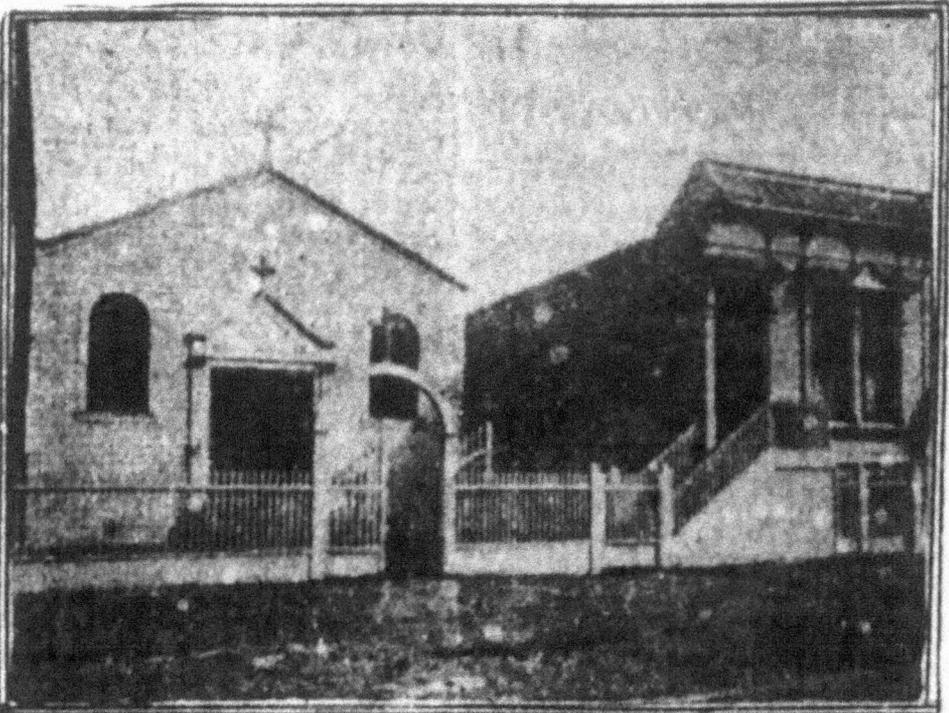

The only existing photograph of Holy Trinity, the first Greek Orthodox church west of the Mississippi River, appeared in the *San Francisco Chronicle* on March 12, 1904. The priest's home is on the right. The church was completely destroyed by earthquake and fire on April 18, 1906, and was rebuilt in 1907. (Courtesy of the *San Francisco Chronicle*.)

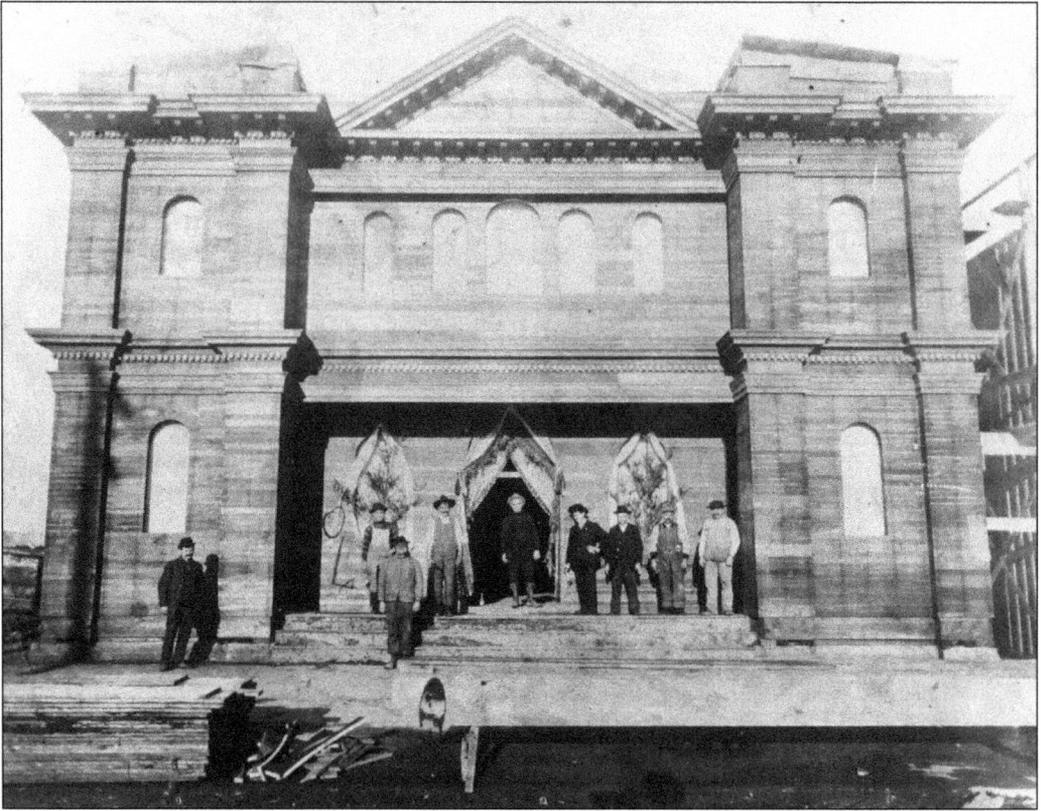

This is the earliest known photograph of Holy Trinity Church at 345 Seventh Street in San Francisco as it neared completion in 1908. The first church, built in 1903, was destroyed by the 1906 San Francisco Earthquake and Fire. The community rallied quickly to raise funds to rebuild its beloved sanctuary. (Courtesy of the Greek Historical Society of the San Francisco Bay Area.)

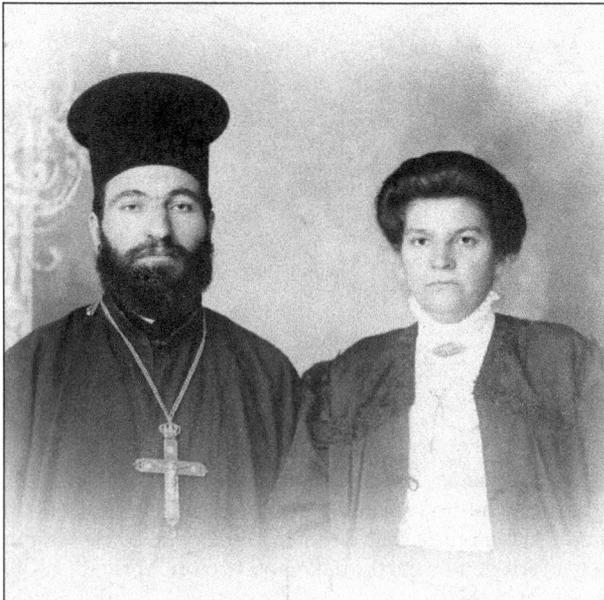

Fr. Constantine Tsapralis, a native of Sanga, Greece, arrived in San Francisco in May 1903. He was Holy Trinity's first priest, traveling to towns and cities throughout California and Nevada to serve the needs of the Orthodox faithful. Father Tsapralis and his wife, Eleni, also owned a candy store and a saloon. In 1936, he was hired by Annunciation Cathedral. (Courtesy of the Greek Historical Society of the San Francisco Bay Area.)

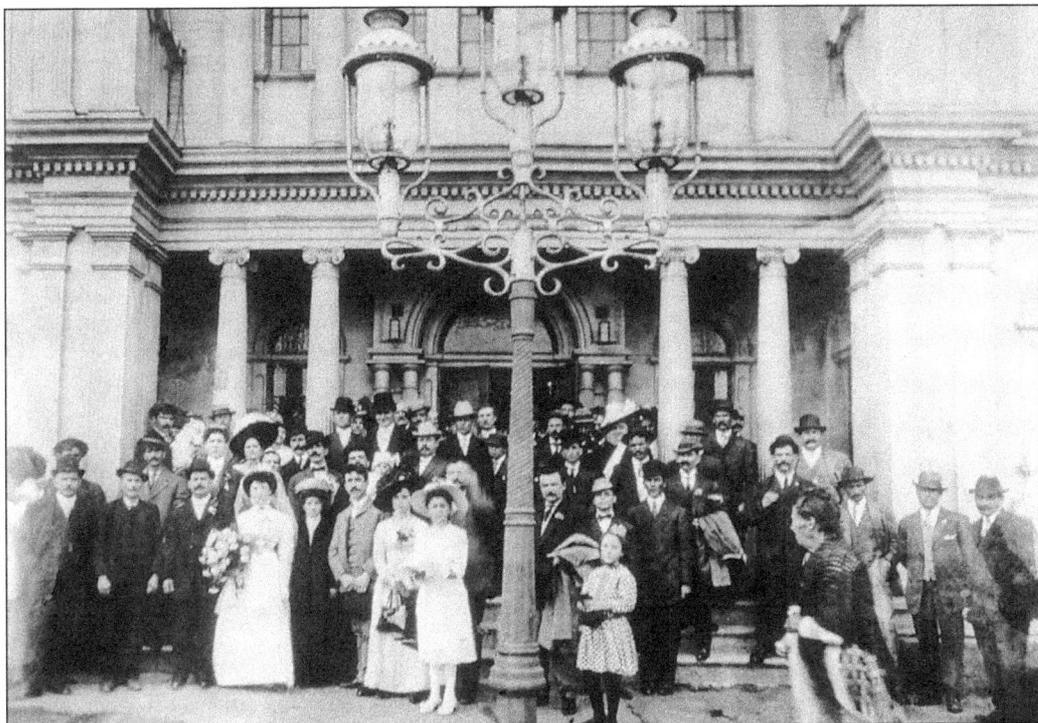

In this historic photograph, taken in 1913, an unidentified bride and groom stand in front of the one-level Holy Trinity Church, which features ornate gas lamps. Teenager Chrissie Kosta (center front), wearing a white dress, is the only identifiable person. She is the daughter of one of Holy Trinity's founders, Alexander Kosta. She would marry Basil George, the son of another Holy Trinity founder. (Courtesy of Peter B. George.)

Holy Trinity's choir, pictured in front of the altar on Good Friday, 1937, is shown alongside the beautiful *iconostasio* (altar screen) and *epitaphio* (tomb of Christ). When Holy Trinity relocated to Brotherhood Way in 1964, this church was sold to the Ukrainian Orthodox community and renamed St. Michael's. St. Michael's Ukrainian Orthodox Church has preserved the splendor of the post-1906 earthquake Holy Trinity. (Courtesy of the Greek Historical Society of the San Francisco Bay Area.)

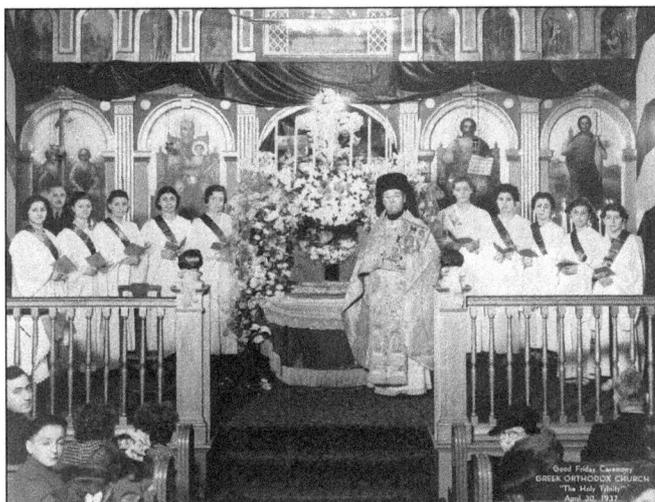

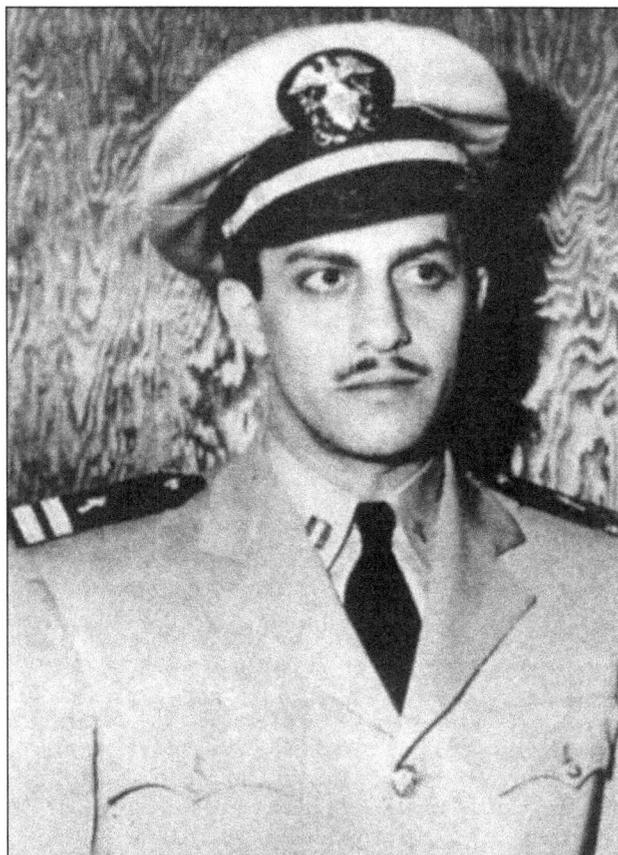

Fr. George Paulson (Pavloglou) was the first American-born priest to serve at Holy Trinity (1949–1953). He revitalized church ministries and added an English sermon to the service. In 1952, he became the first Greek Orthodox chaplain in the history of the US military. During his 28 years of active service in the Navy, he attained the rank of captain. (Courtesy of the Greek Historical Society of the San Francisco Bay Area.)

Holy Trinity's Greek School students are pictured in the 1950s with their teachers, Pauline Tasiopulos (center back) and Demetrios Gianikos (second row, center), who was also the principal. Fr. Constantine Bithos (Bithitsikis) (far right, front) served at Holy Trinity from 1953 to 1955. Tasiopulos also operated the Peters Travel Service on Taraval Street. Tasiopulos and Gianikos were also active in the Pan Arcadian Federation of America. (Courtesy of Jim Lucas.)

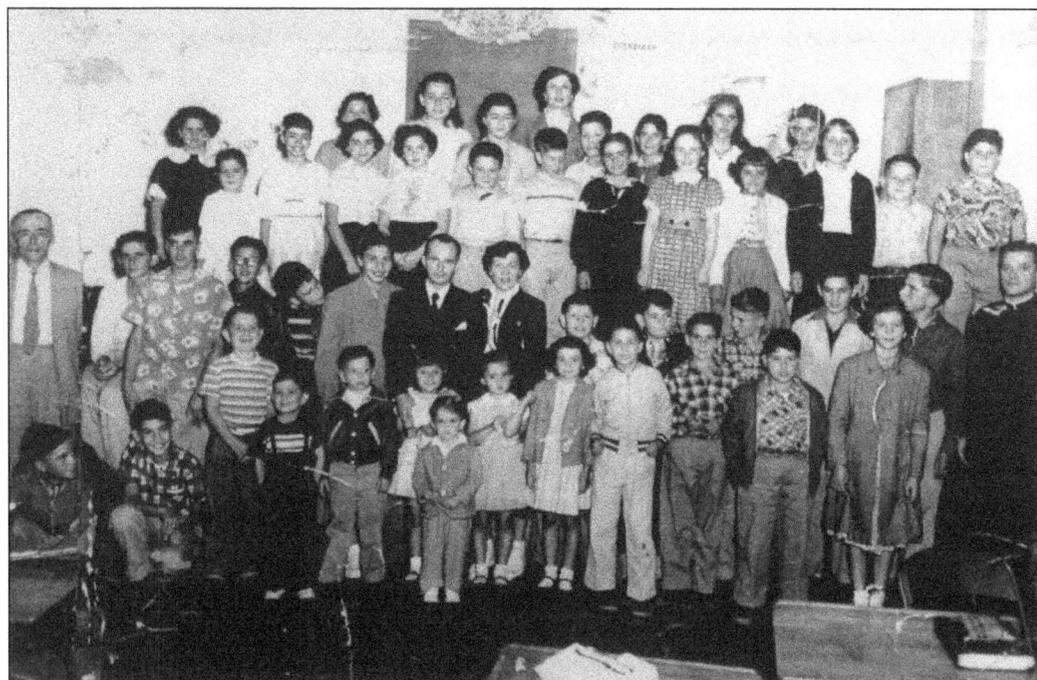

Fr. Anthony Kosturos (1926–2004) a native San Franciscan, served at St. Sophia Cathedral in Los Angeles after graduating from Holy Cross Theological School. In 1955, he was assigned to Holy Trinity, where he spearheaded the relocation of the church to Brotherhood Way. During his 49 years serving Holy Trinity, the parish constructed a church, school, and community center. (Photograph by Romaine of Moulin Studio, courtesy of the Greek Historical Society of the San Francisco Bay Area.)

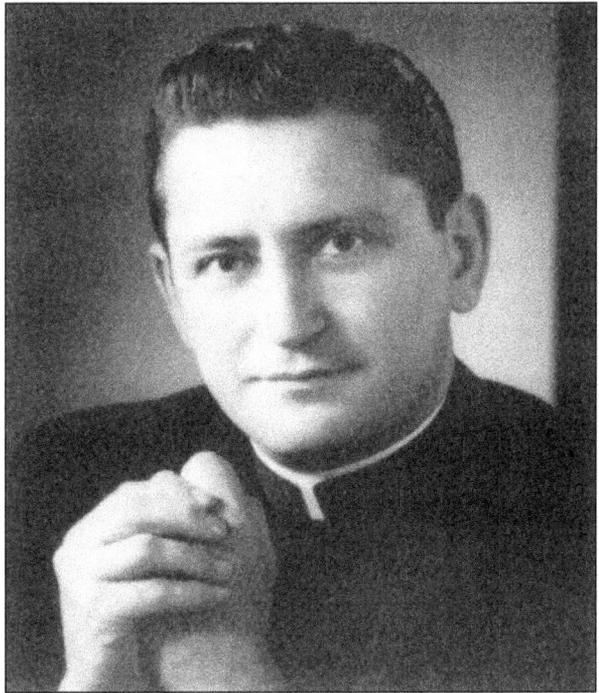

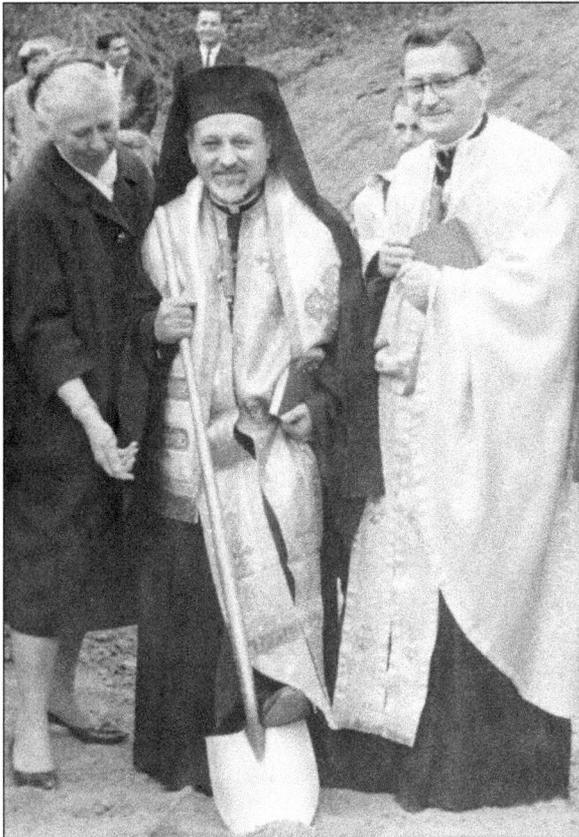

At the ground-breaking ceremony for the new Holy Trinity Church at 999 Brotherhood Way in San Francisco are, from left to right, Esther Peterson, assistant secretary of the Department of Labor and director of the Women's Bureau, representing Pres. John F. Kennedy; Right Reverend Demetrius, Bishop of Olympus; and Fr. Anthony Kosturos, pastor of Holy Trinity Church. (Courtesy of the Greek Historical Society of the San Francisco Bay Area.)

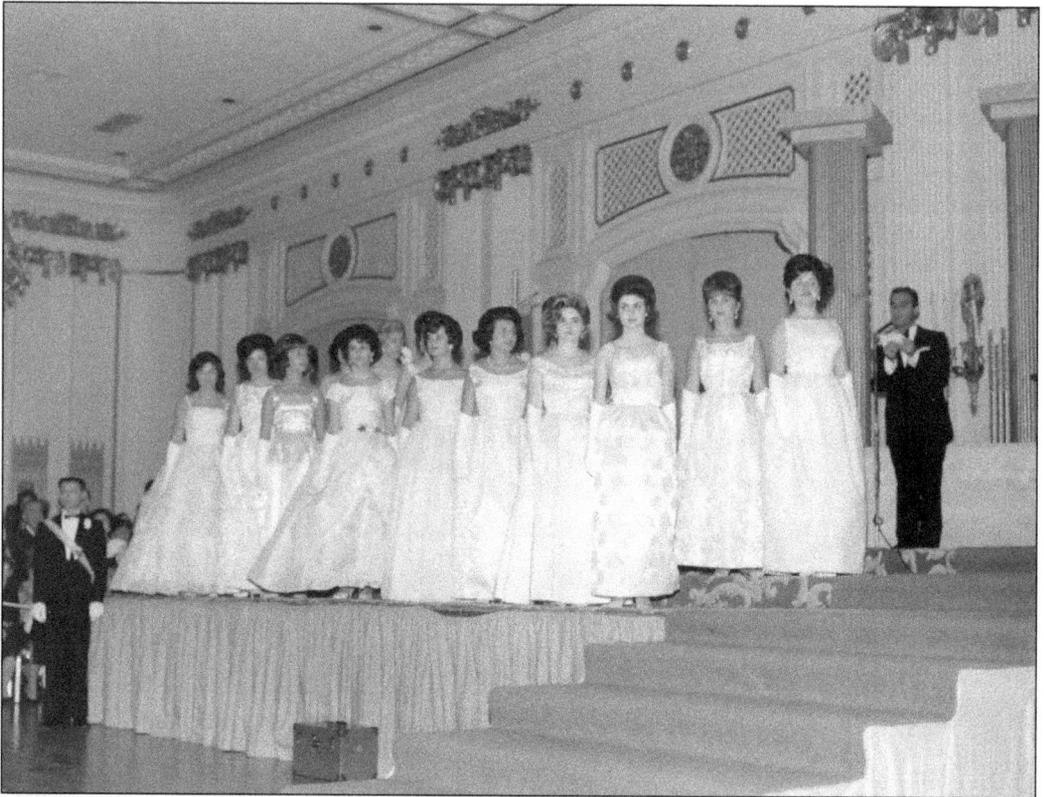

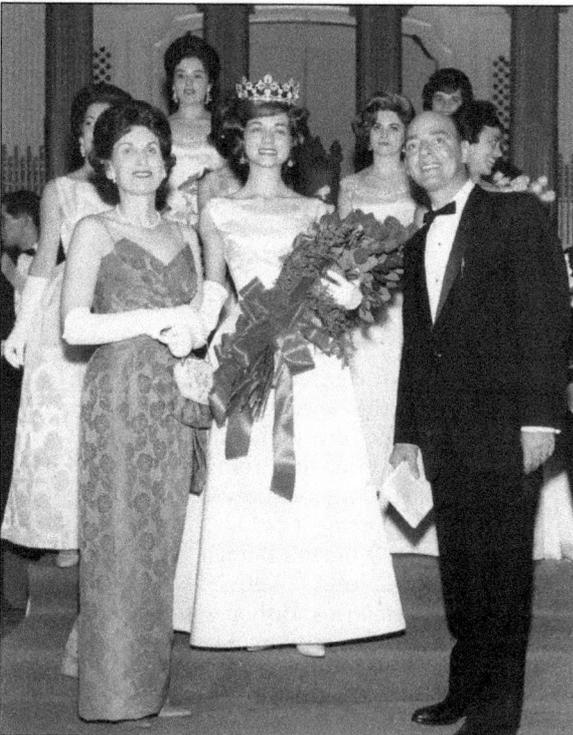

Pictured are the candidates for queen and six princesses to be selected by a panel of judges at Holy Trinity Church's Coronation Ball, held in the Grand Ballroom of the historic Sheraton Palace Hotel. Music was provided by Ray Hackett and his Orchestra and the Mediterranean Orchestra. (Photograph by Romaine of Moulin Studio, courtesy of the Amanda Antipa estate.)

The Coronation Ball was sponsored by the Holy Trinity Church Building Fund Committee and took place at the historic Sheraton Palace Hotel on Saturday, September 29, 1962. Admission to the ball was $5. Pictured in the foreground are executive chair Amanda Antipa (left), Queen of the Coronation Ball Angie Touloume (center), and Coronation Ball chair Peter J. Gray (right). (Photograph by Romaine of Moulin Studio, courtesy of the Amanda Antipa estate.)

Parishioners descend the steps of the old Holy Trinity at 345 Seventh Street on January 19, 1964, after the last Sunday service before moving to the new Holy Trinity at 999 Brotherhood Way. Many parishioners shed tears of sadness upon leaving the quaint little church on Seventh Street that had served the Holy Trinity community for 60 years. (Courtesy of the Greek Historical Society of the San Francisco Bay Area.)

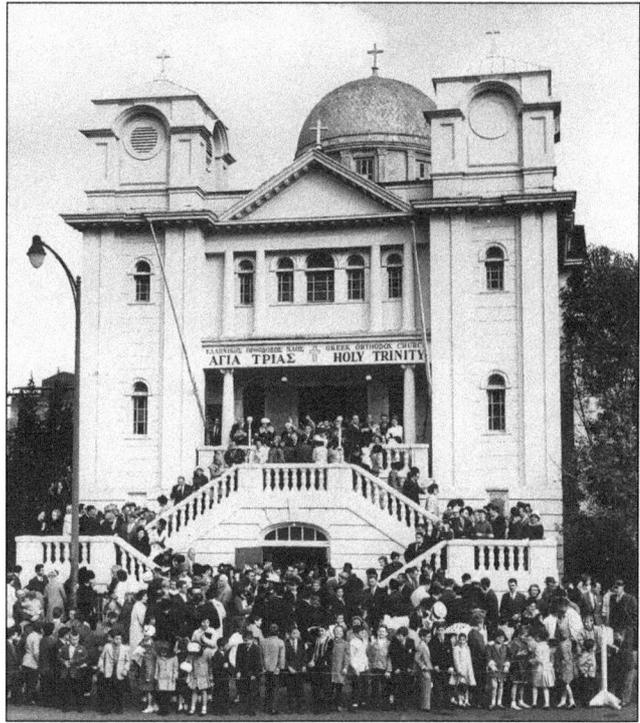

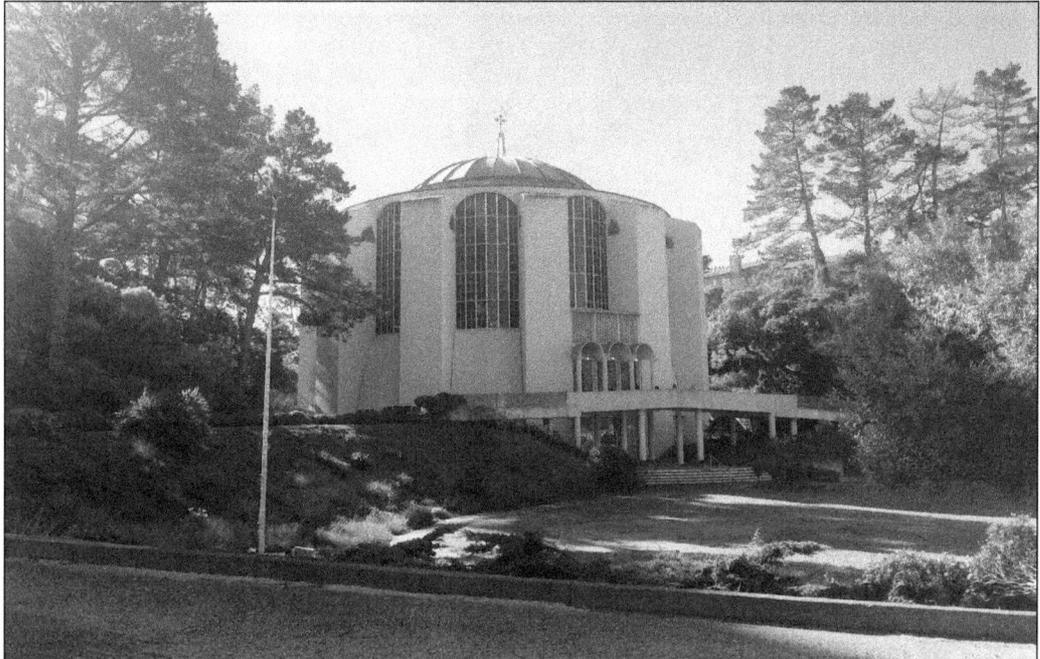

In a lively public auction of vacant city land, Fr. Anthony Kosturos's bid of $44,300 for eight-and-one-half acres on which to construct the new Holy Trinity Church was accepted. Construction began on November 13, 1961, and the church on Brotherhood Way, designed by the architectural and engineering firm of Reid, Rockwell, Banwell, and Tarics, was completed in October 1963. (Courtesy of Cynthia Soteria Zamboukos.)

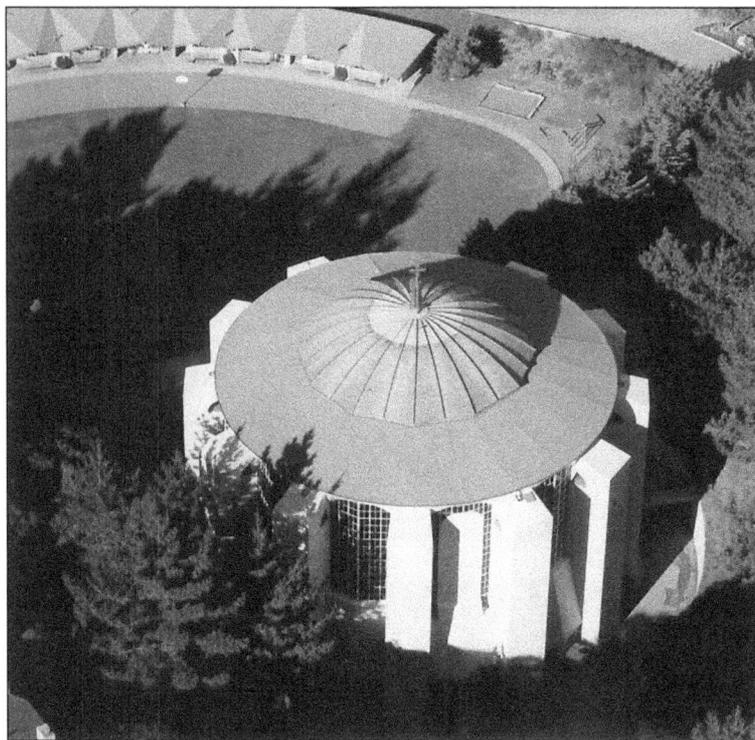

This aerial view of Holy Trinity Church reveals the modern yet traditional Byzantine architecture. Twelve massive pier buttresses, 70 feet high, support a dome that spans the 60-foot center. A helicopter was used to place the 20-foot gold cross atop the dome. World-famous architect Frank Lloyd Wright had drafted a preliminary sketch for the proposed church when he passed away. (Courtesy of the Greek Historical Society of the San Francisco Bay Area.)

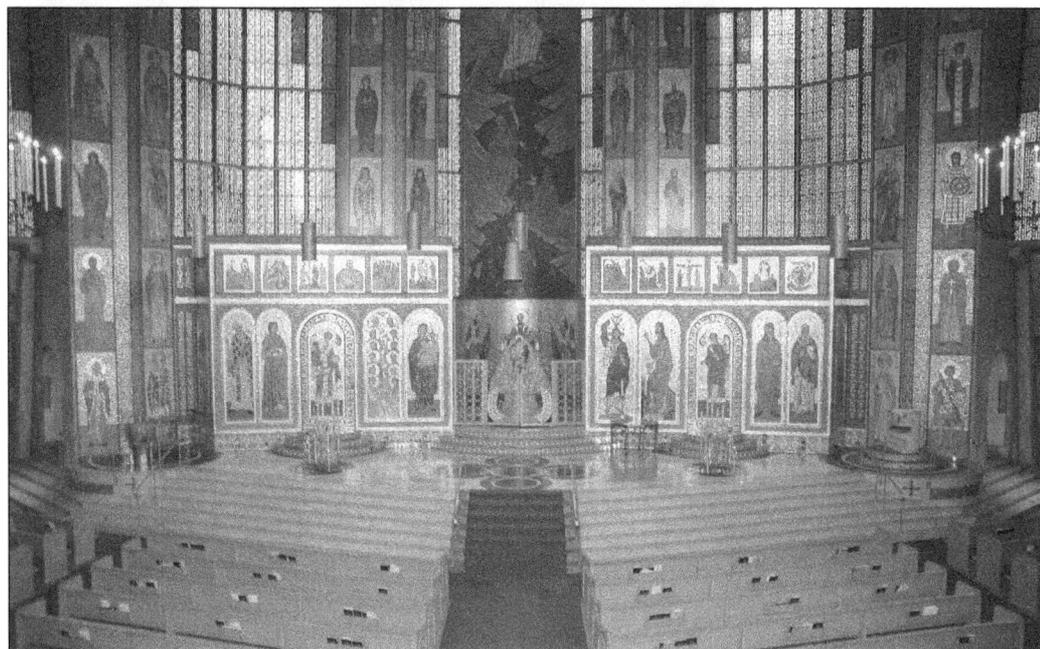

The interior of Holy Trinity Church is adorned by over 100 mosaic icons created by iconographer and artist Robert Andrews. Robert studied portrait painting and ceramics at Massachusetts College of Art and taught art for 36 years. In the early 1960s, he began designing tile mosaic icons. He is one of a handful of artists in the country who specialize in mosaic religious icons. (Courtesy of Jim Lucas.)

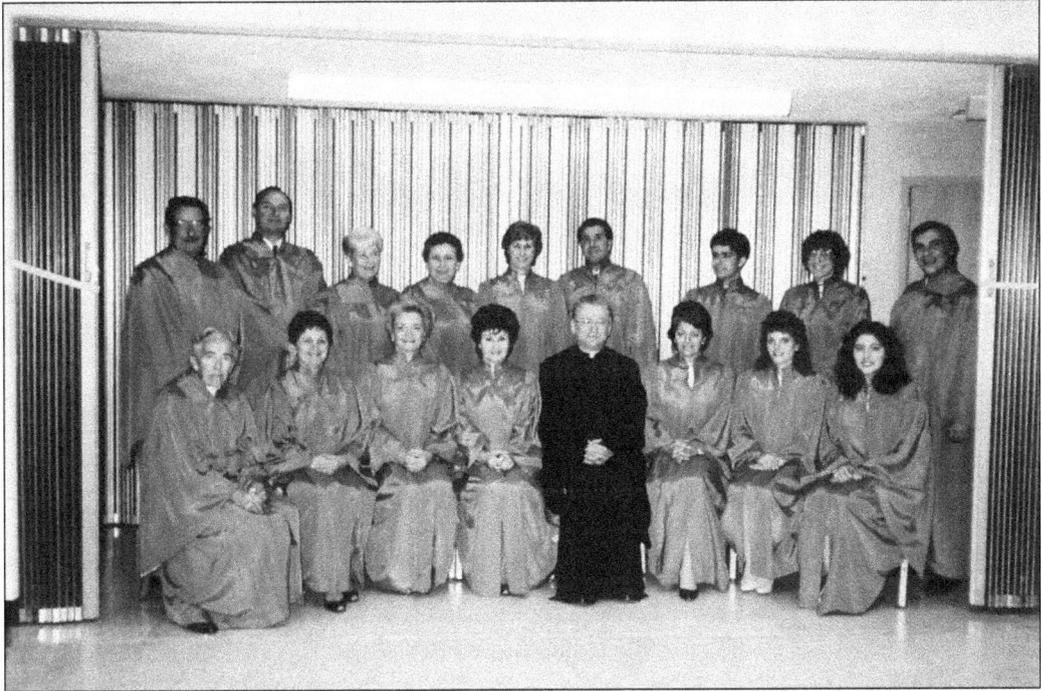

Holy Trinity Church's choir is pictured in 1985 with Fr. Anthony Kosturos and choir director Nick Vitalis (second row, far right). The choir was honored to sing the beautiful, Byzantine-based choral arrangements for the divine liturgy written by Dr. Theodore Bogdanos, choir director at Holy Trinity from 1958 to 1978. (Courtesy of Cynthia Soteria Zamboukos.)

Holy Trinity's dance group, H Neolaia Mas, participated in the Metropolis of San Francisco's 1992 Folk Dance Festival in Anaheim, California. First organized in 1977, the Folk Dance Festival (FDF) later added a choral competition. The acronym FDF now stands for "Faith, Dance, and Fellowship." It has developed into the largest exhibition of authentic Greek folk dance, costume, and music in the world. (Courtesy of Patricia [Yiota] K. Antonis Makris.)

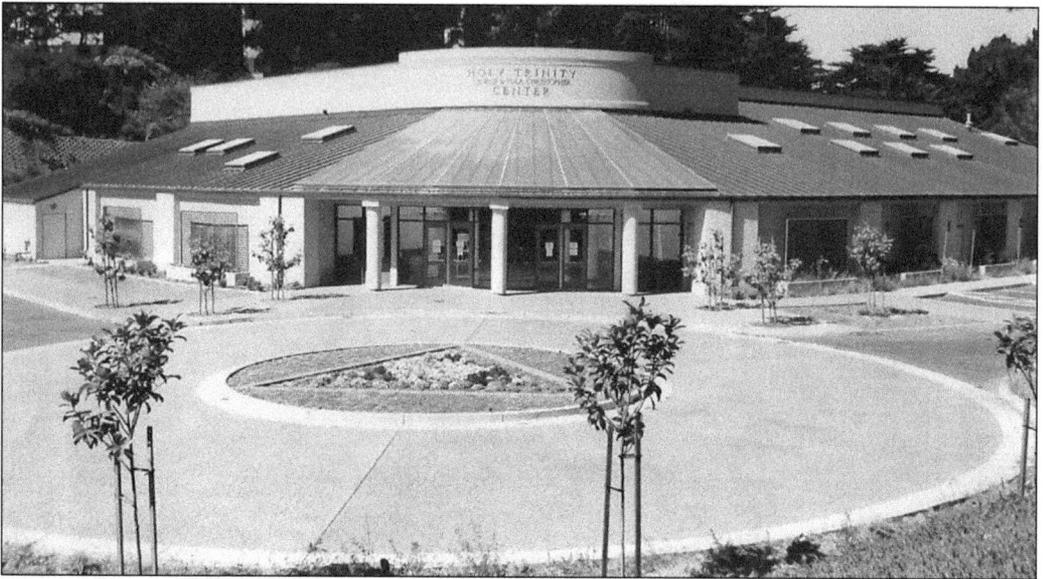

Fr. Anthony Kosturos shared his vision with former mayor George Christopher for a center where people of all ages could gather and engage with each other. With Mayor Christopher as the project's greatest benefactor, the Holy Trinity George and Tula Christopher Center was dedicated on August 10, 1994. The center has a professional-size basketball court, fitness, skills, and crafts rooms, a library, and other facilities. (Courtesy of the Greek Historical Society of the San Francisco Bay Area.)

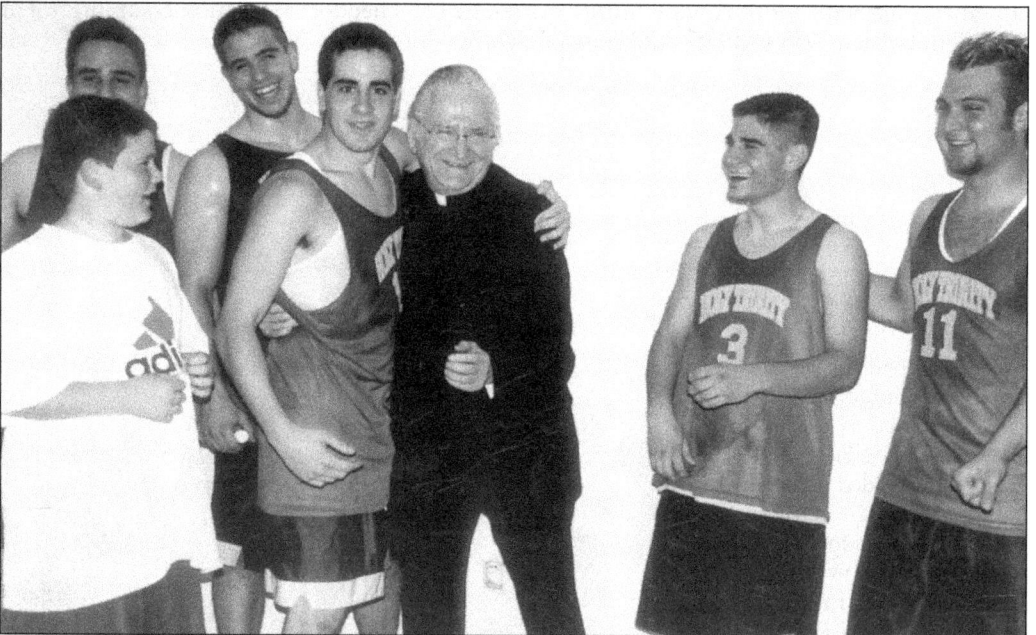

The Orthodox Youth Athletic Association (OYAA) is comprised of basketball teams from Greek, Antiochian, Armenian, Assyrian, and Russian Orthodox churches in the Bay Area. Fr. Anthony Kosturos loved basketball and rarely missed a game. Holy Trinity's young men aged eight to 18 practice and play at the Christopher Center's professional basketball court. (Courtesy of John Skinas.)

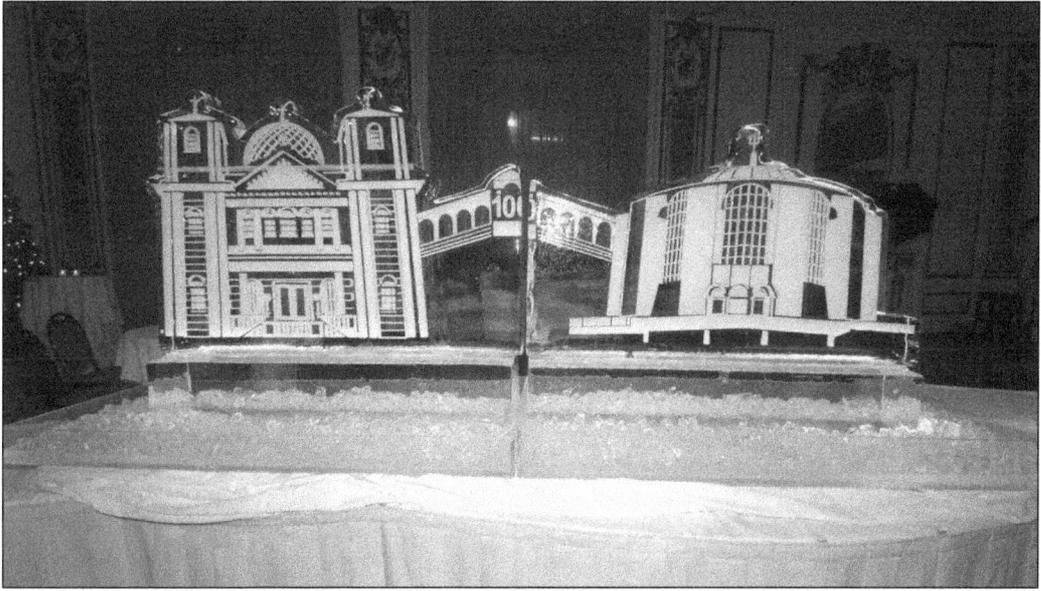

A beautiful ice sculpture represented the connecting bridge from the old Holy Trinity Church to the new Holy Trinity Church at the 100th-anniversary celebration at the historic Palace Hotel in San Francisco on December 30, 2004. It was a memorable evening of tributes, reminiscing, dancing, and music. (Courtesy of the Greek Historical Society of the San Francisco Bay Area.)

The 100th anniversary of the founding of Holy Trinity Church is celebrated in San Francisco on December 30, 2004, at the historic Palace Hotel. The Holy Trinity community gathered to pay tribute to beloved Fr. Anthony Kosturos of blessed memory and loved ones who labored and sacrificed for Holy Trinity Church, the oldest Greek Orthodox church west of the Mississippi River. (Courtesy of the Greek Historical Society of the San Francisco Bay Area.)

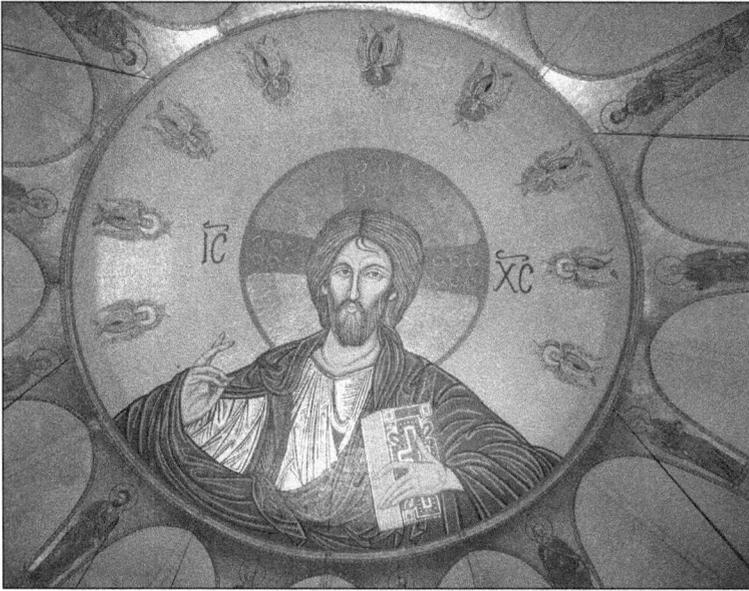

At a cost of $1.7 million, the Pantokrator features the largest mosaic face of Christ in the Western Hemisphere. The face of Christ measures 23 feet from the top of the forehead to the chin and is installed 75 feet above the church floor. It contains 1.4 million individual hand-cut glass mosaic tiles (tesserae). The Pantokrator mosaic is the creation of Robert Andrews. (Courtesy of Jim Lucas.)

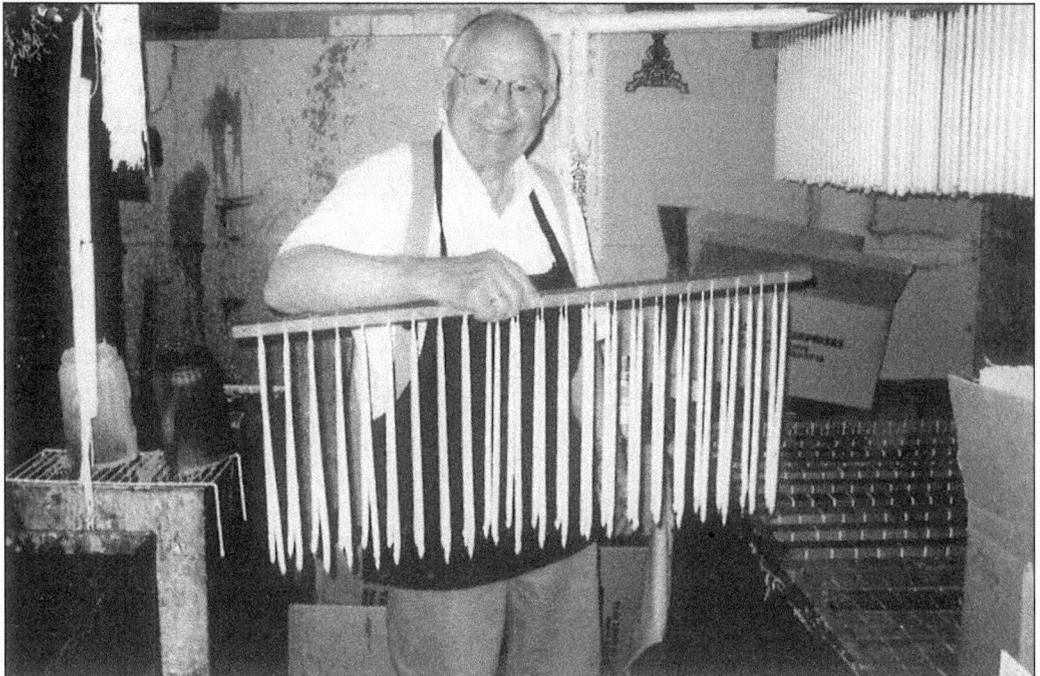

Anthony G. Cherolis (1922–2011) came to San Francisco after serving in World War II. After making a personal vow, he made all the candles at Holy Trinity Church for over 50 years. In retirement, he spent every day in the little "candle hut" behind the church. He was bestowed with the Medal of St. Paul in 2004, the highest laity award of the Greek Orthodox Archdiocese. (Courtesy of Lido Chu.)

Four

St. Sophia/
Annunciation
Cathedral

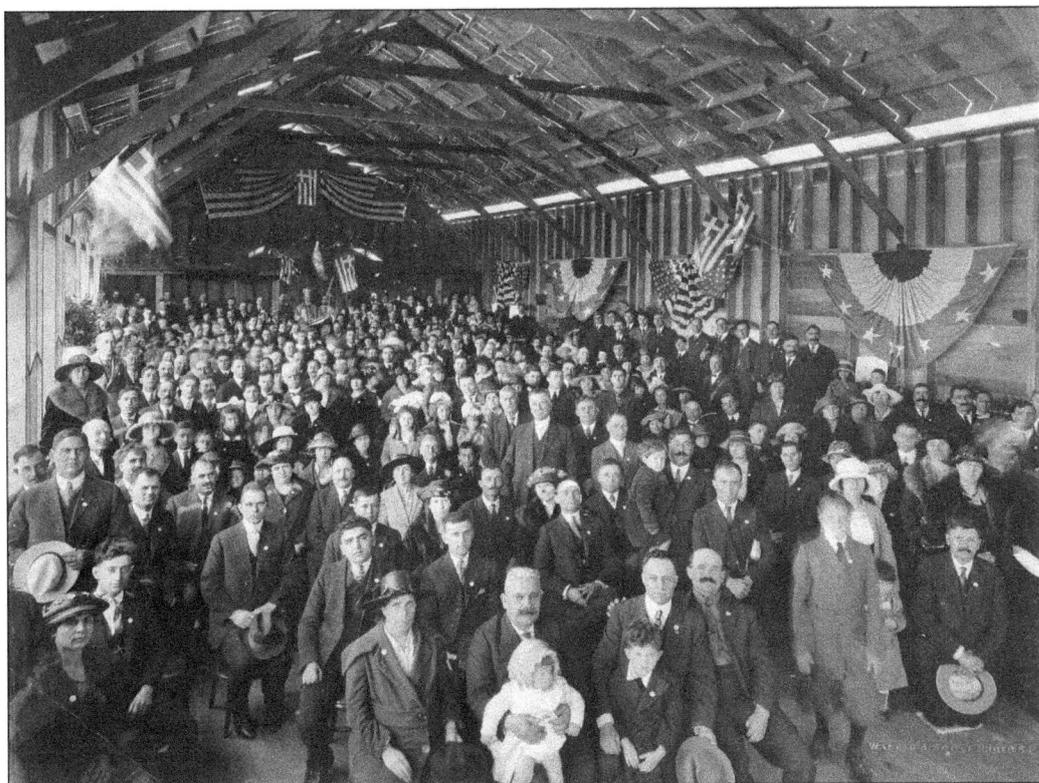

St. Sophia, the precursor to Annunciation Cathedral, was established at the corner of Hayes and Pierce Streets in San Francisco by a group of parishioners from Holy Trinity who were sympathetic to Greek prime minister Eleftherios Venizelos. His Eminence Metropolitan Meletios Metaxakis laid the cornerstone at the ground-breaking ceremony on June 26, 1921. He was subsequently elected ecumenical patriarch of Constantinople. (Courtesy of the Faye Caravellas family.)

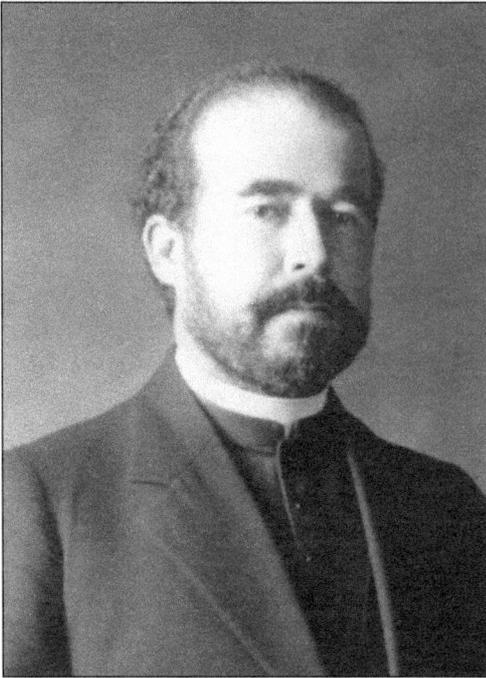

Metropolitan Philaretos Ioannides served as the first priest of St. Sophia. He served St. Sophia from 1921 to 1923. On June 23, 1923, he was consecrated as the first bishop of the Chicago Diocese by Archbishop Alexandros of North and South America and Archbishop Theatyron, metropolitan and legate of North and Central Europe. (Courtesy of Annunciation Cathedral.)

The baptism of Nestor Harpending Palladius was unique in that it includes all of the early priests who served St. Sophia Cathedral. From left to right are (first row) Alexander K. Pavellas (godfather), Nestor Harpending Palladius, Mary Genevieve Harpending Palladius (mother), and George D. Papageorge-Palladius (father), and unidentified; (second row) two unidentified men, Archbishop Alexandros, Fr. Philaretos Ioannides, Bishop Kallistos Papageorgopoulos, and Fr. Pythagoras Caravellas. (Courtesy of Ron Pavellas.)

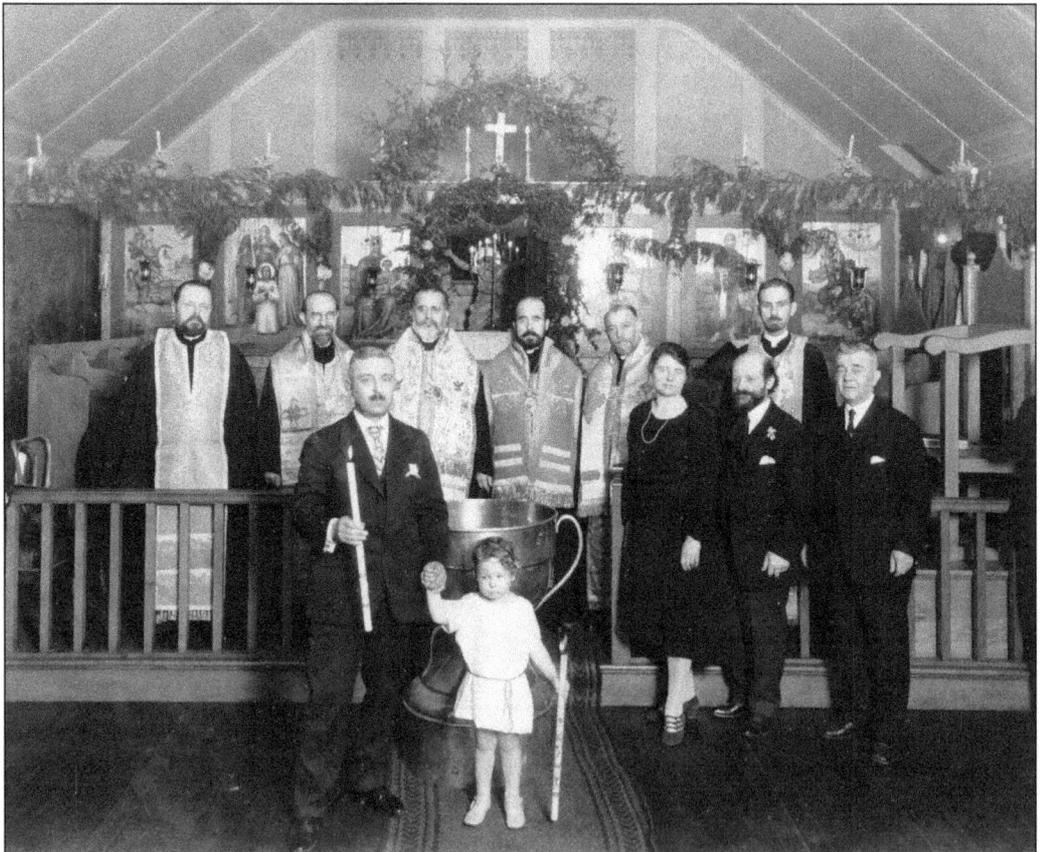

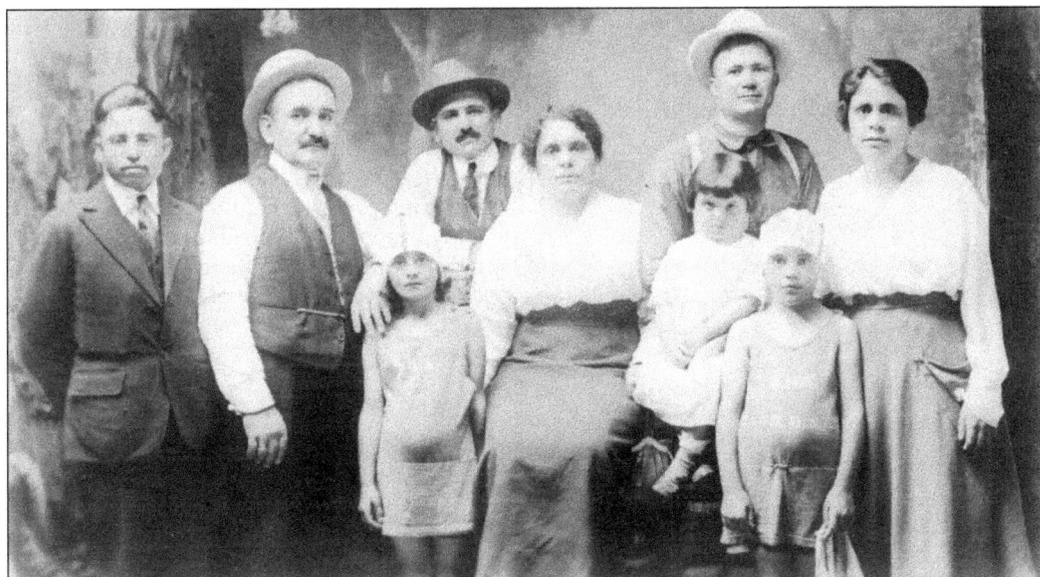

Chris Catharios (standing second from right) and Chris Sarris, brothers-in-law, were founders of St. Sophia Cathedral. Catharios immigrated from Agios Nikolaos, Monemvasia, Lakonia, Greece, and Sarris immigrated from Tsitalia, Arcadia, Greece. Chris Catharios operated Chris' Grill at 993 Market Street near Sixth Street, and Chris Sarris owned the Star Grocery on Post Street. (Courtesy of the Helen and Homer Coreris estate.)

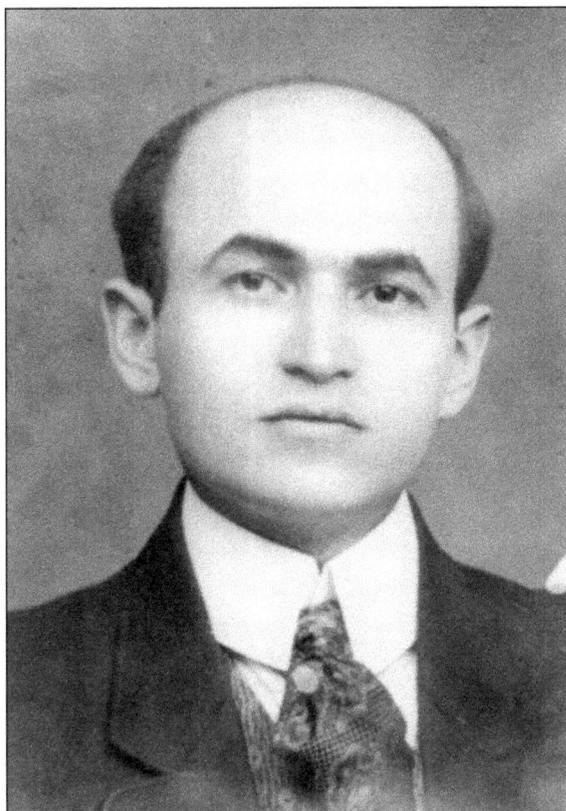

Harry Franco (Harilaos Frangogiannis) came to America from the island of Lesbos at age 17. He operated the Splendid Café at 516 Kearney Street and had a restaurant in the Crystal Palace on Market Street. In 1912 he returned to Greece to fight in the Balkan Wars. He married Ourania in 1915. He was one of the founding members of Saint Sophia. (Courtesy of the Vicky Vozikes estate.)

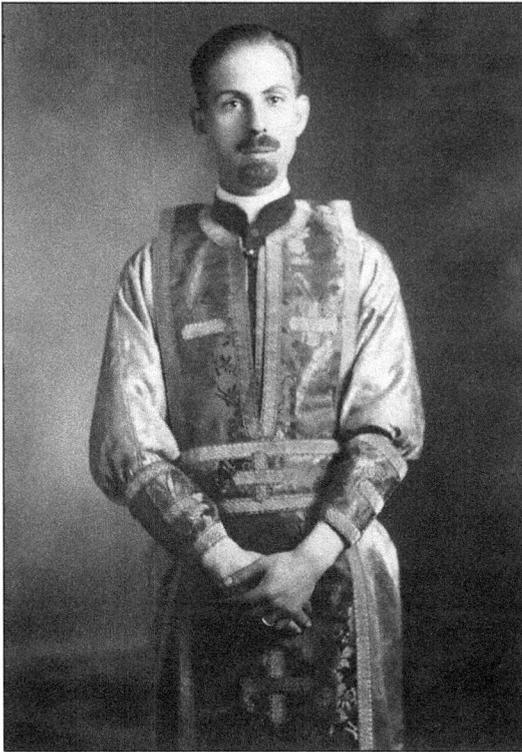

This photograph of Fr. Pythagoras Caravellas, a native of Samos and a Harvard-educated doctor, was taken in the early 1920s. Answering a call to the priesthood, he left medicine. Father Caravellas became St. Sophia's presiding priest in 1923. He and his wife, Evangeline, helped many Greek immigrants adjust to life in America. He died in 1934 at the age of 44. (Courtesy of the Faye Caravellas family.)

The Valencia Street Theatre was built in 1908 and served San Francisco audiences until 1928, when it was purchased by St. Sophia Greek Orthodox Cathedral. In 1936, the church was renamed the United Greek Orthodox Community of San Francisco, the Annunciation. This photograph dates from the 1920s. (Courtesy of the San Francisco History Room, San Francisco Public Library.)

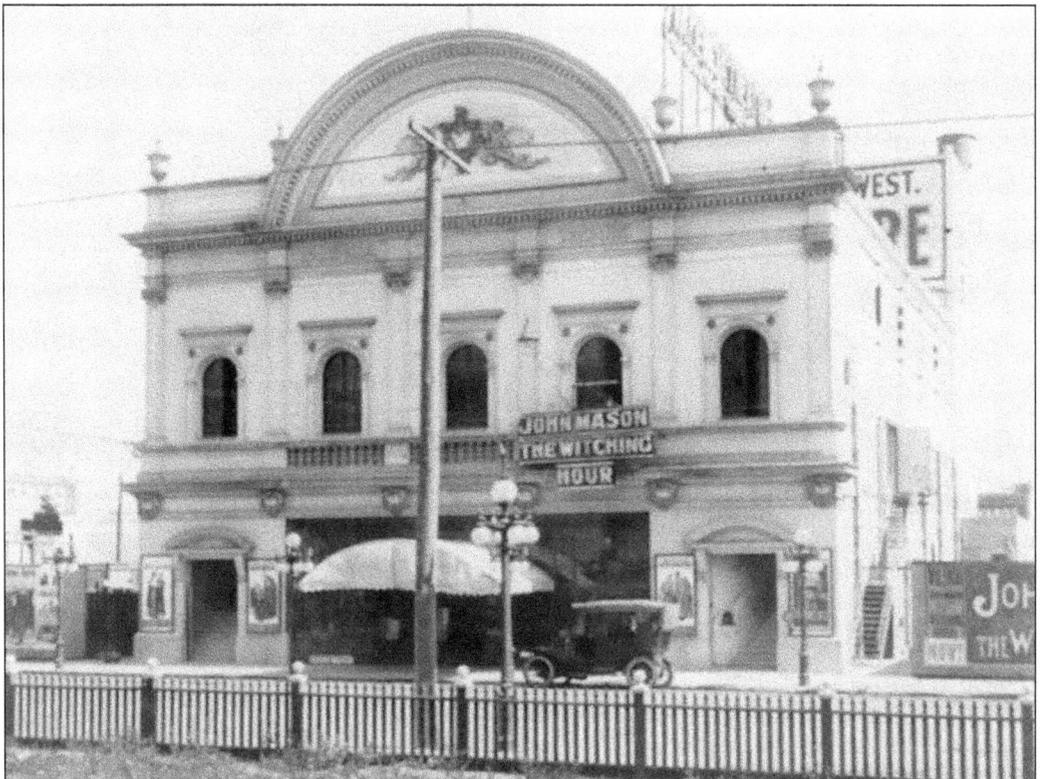

Fr. Vasilios Lokis, born in 1899 in Stratinista, Greece, graduated from the Theological School of Halki and the National University of Athens. He served at Holy Trinity and then at Annunciation Cathedral (1936–1943). He spoke Greek, English, French, Arabic, Turkish, and German. He joined the OSS (Office of Strategic Services), precursor to the CIA, and served in Washington, DC, and Egypt during World War II. (Courtesy of Annunciation Cathedral.)

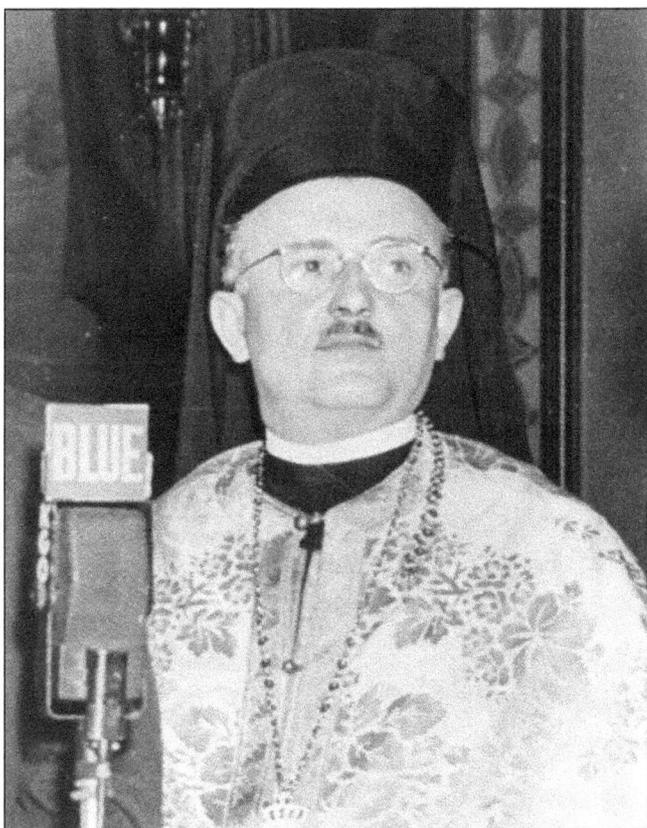

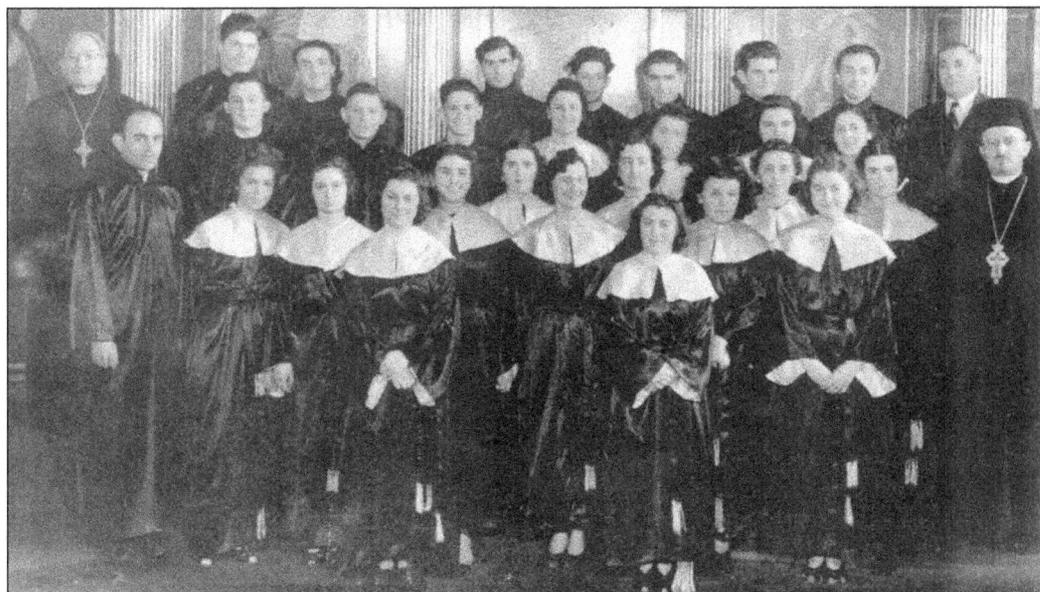

Pictured is the 1940 Annunciation Cathedral Choir, with Fr. Constantine Tsapralis (back, far left); choir director, concert violinist and future city attorney Frank Agnost (second row, far left); Fr. Anthony Kosturos as a young man (second row, second from left); and Fr. Vasilios Lokis (first row, far right). (Courtesy of Annunciation Cathedral.)

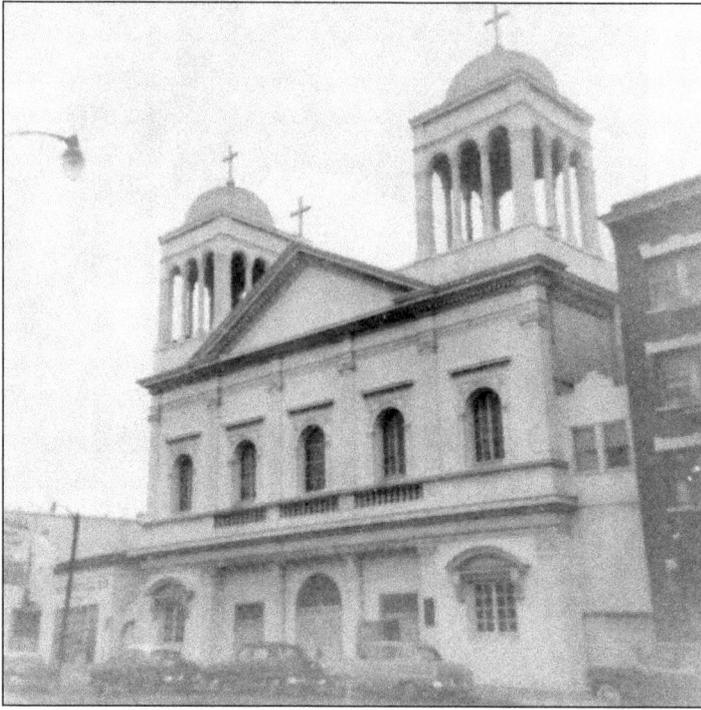

After St. Sophia's community purchased the Valencia Street Theater in 1928, the building, shown in this 1938 photograph, underwent renovation to convert it to a church. Renovations consisted of removing the balcony, leveling the lower floor, constructing a second floor, and adding towers for the church bells. (Courtesy of Annunciation Cathedral.)

Pictured are students and teachers of Annunciation Cathedral's Greek school in 1950. At center, from left to right, are Christos Makreyiannis, Androniki Johns (Ioannidou), Mrs. Chrisithou, and Fr. Polykeftos Finfinis. Children learned grammar, conversation, reading, and writing, with Greek culture and heritage incorporated in the readings. Ioannidou, born in Cassandra, Halkidiki, Greece, and an accredited teacher in Greece, taught Greek school at the Annunciation until 1954. (Courtesy of Joan M. Peponis Rinde.)

48

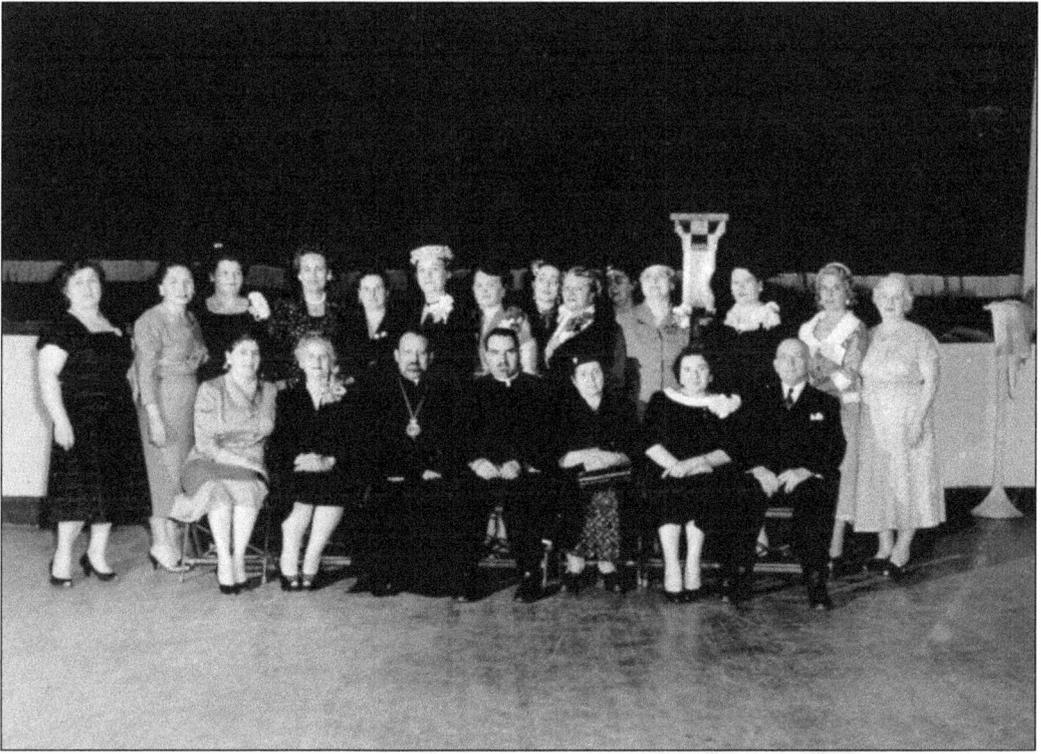

Annunciation Cathedral's Ladies Philoptochos Society, pictured in the mid-1950s, provides women with the opportunity to share their unique gifts in service to their church and community. The Philoptochos provides scholarships to needy students, performs community outreach, and organizes the annual Vasilopita, Crab Feed, Mother's Day, and Father's Day luncheons. Pictured front and center are Bishop Demetrios of Olympus (left) and Fr. Meletios Tripodakis (right). (Courtesy of Annunciation Cathedral.)

Irene Gianaras, a native San Franciscan, married Panos Gianaras in 1946. After the birth of her children, John and Eugenia, Irene became a realtor and started her own company. She was the first woman elected president of Annunciation Cathedral. Irene also served as president of the Diocesan Philoptochos Board and was a member of the Archdiocesan National Philoptochos Board. (Courtesy of John Gianaras.)

49

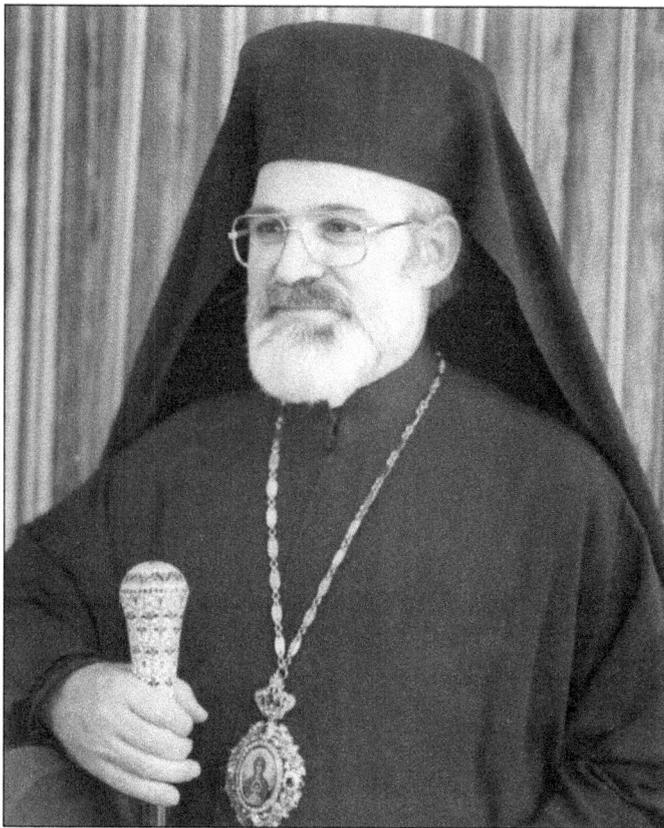

His Eminence Metropolitan Anthony (1935–2004) was born in Avgeniki, Crete, and graduated from Halki Theological School in 1960. Furthering his education in America, he earned several advanced degrees. He was enthroned as the first bishop of the newly created Diocese of San Francisco in 1979. His tenure saw the founding of over 20 new parishes and missions and the St. Nicholas Ranch and Retreat Center. (Courtesy of Annunciation Cathedral.)

Annunciation Cathedral's dance group, Vlastaria, pictured in this 1987–1988 photograph, participated in the annual Greek Orthodox Metropolis of San Francisco's Folk Dance Festival in Sacramento and won first place in the Intermediate Division. Their dance instructor was Phaedon Eliadis, who served at the Greek Consulate in San Francisco. (Courtesy of Carol Varellas-Pool.)

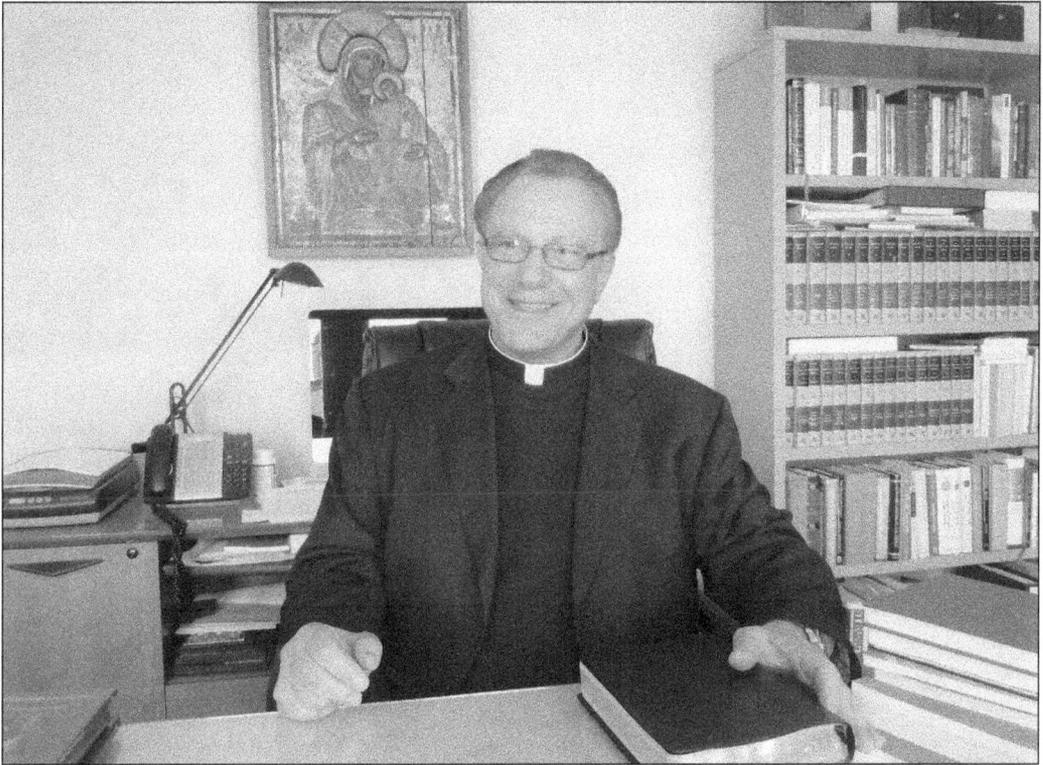

Fr. Stephen Kyriacou is the dean of Annunciation Cathedral and its longest serving priest. Father Stephen was born in Hartford, Connecticut, the son of Cypriot immigrants. He attended Hellenic College, Princeton Theological Seminary, and Trinity College. He served parishes in New York City and Cranston and Newport, Rhode Island, before coming to San Francisco in 1987. He and Presvytera Aliki have three children and seven grandchildren. (Courtesy of Annunciation Cathedral.)

Alexandra Ossipoff's marriage to Richard Kleinehorte was the last wedding at Annunciation Cathedral prior to its destruction during the 1989 Loma Prieta Earthquake. Alexandra was the 10th bride to wear this dress, worn first by her aunt Teia Tamaras Nuris (1952) and subsequently by her mother, Lula Tamaras Ossipoff (1960). It was then sent to Greece, where it was worn by seven more brides before returning to America. (Courtesy of Lula Tamaras Ossipoff.)

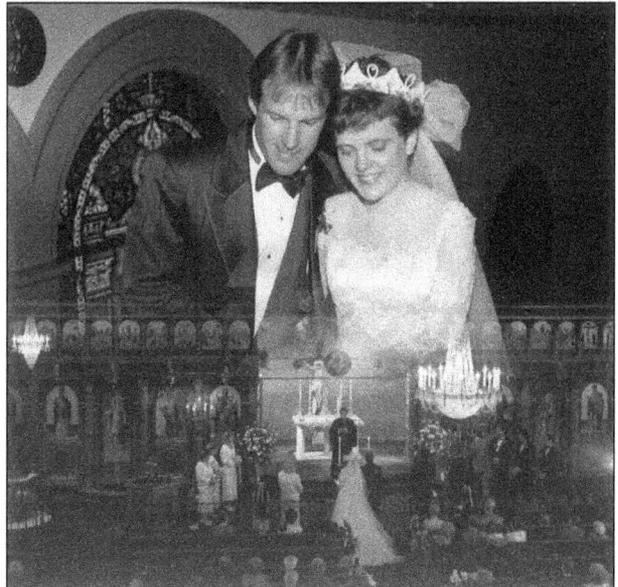

51

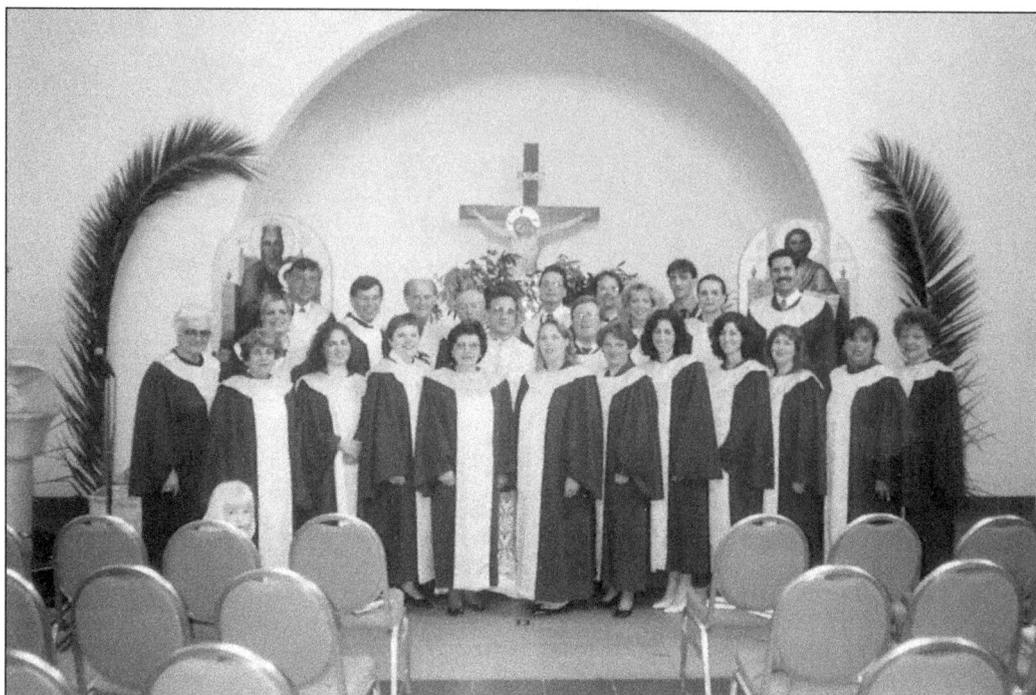

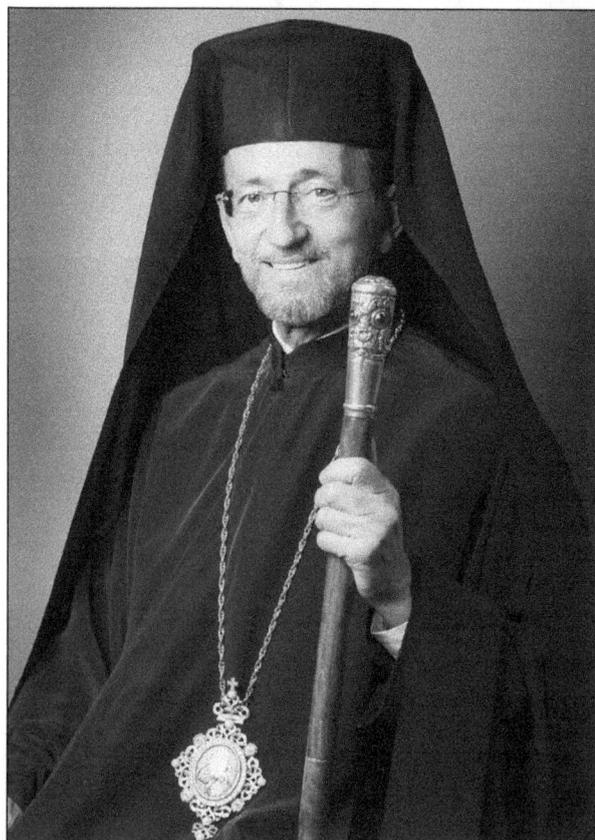

The Annunciation Cathedral Choir is pictured with Fr. Stephen Kyriacou in the center, choir director Nick Tarlson to Father Kyriacou's right, and choir director Athena Tsougarakis (first row, far left). The choir is pictured in the Bishop Anthony Hall and Chapel, completed in the mid-1990s as part of phase I of the reconstruction of the cathedral after the 1989 Loma Prieta Earthquake. (Courtesy of Lula Tamaras Ossipoff.)

His Eminence Metropolitan Gerasimos was born in Kalamata, Greece. Upon immigrating to America, he enrolled at Hellenic College, receiving his bachelor of arts and master of divinity degrees. He continued his education at Boston College, earning a master's and doctorate in counseling and school psychology. He was enthroned as metropolitan of San Francisco on April 2, 2005, by His Eminence Archbishop Demetrios of America at Ascension Cathedral. (Courtesy of the Metropolis of San Francisco.)

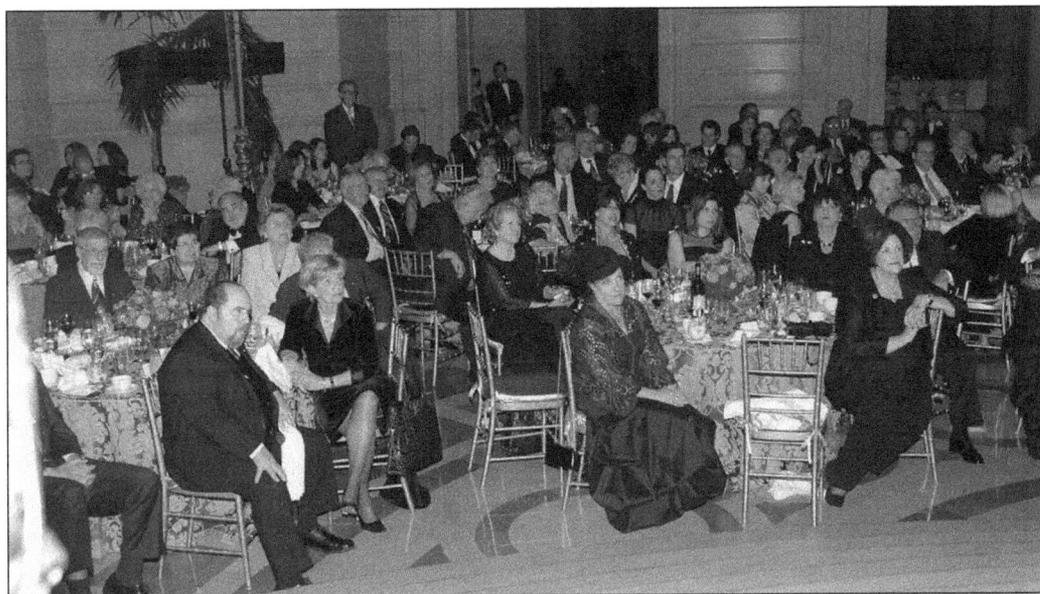

The 85th anniversary of the founding of Annunciation Cathedral was held on November 12, 2006, in the historic rotunda of San Francisco's city hall. Founded in 1921 as St. Sophia, the community changed its name in 1936. In attendance were special guest of honor Archbishop Demetrios of America, Metropolitan Gerasimos, and the evening's mistress of ceremonies was Amb. Eleni Tsakopoulos Kounalakis. (Courtesy of Kostas Petrakos.)

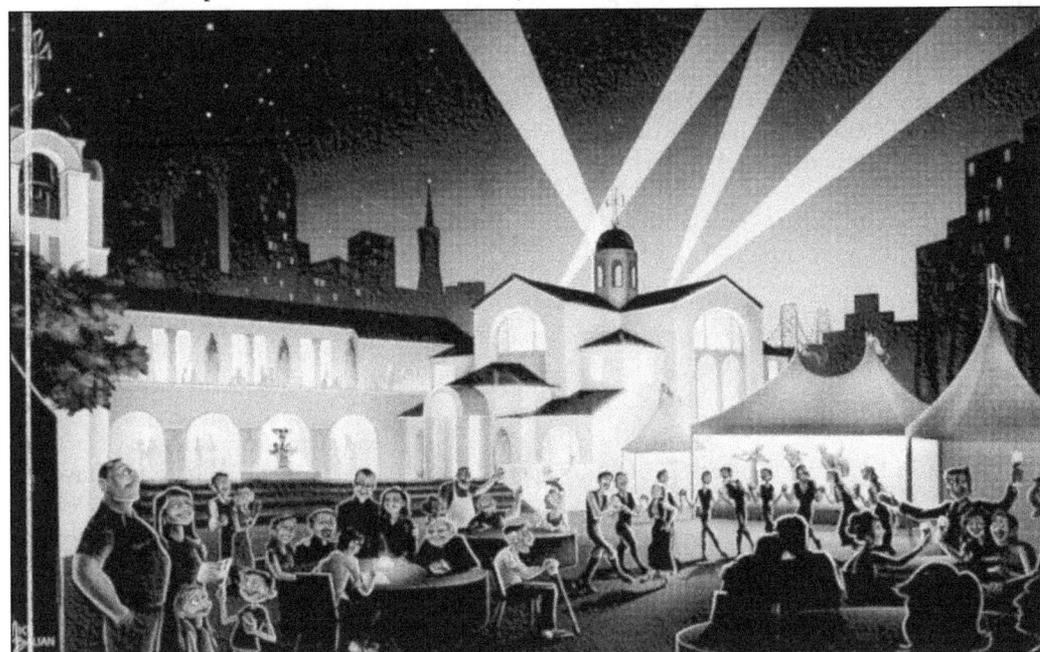

Annunciation Cathedral hosts San Francisco's only Greek festival. This festival program cover was designed by Nick Balian, a Bay Area native and lifelong member of the cathedral. Nick received a bachelor of fine arts in traditional animation from the Academy of Art University in San Francisco. Currently the staff illustrator and art manager for USTYME, Inc., Nick enjoys sharing his artistic talents with the Greek community. (Courtesy of Lula Tamaras Ossipoff.)

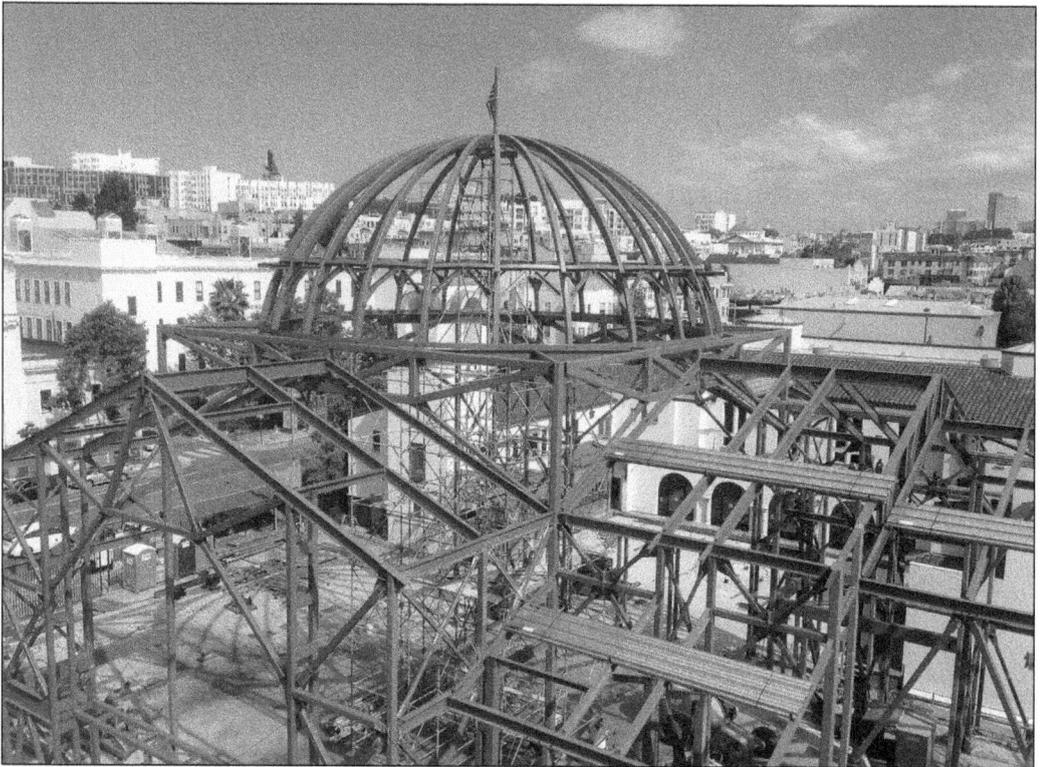

The dome of the magnificent new Annunciation Cathedral is seen rising against the San Francisco skyline in this photograph. Building of the new sanctuary commenced on October 28, 2013, with anticipated completion in 2017. The building permit was issued on the 24th anniversary of the Loma Prieta Earthquake, which destroyed the original church building. (Courtesy of Annunciation Cathedral.)

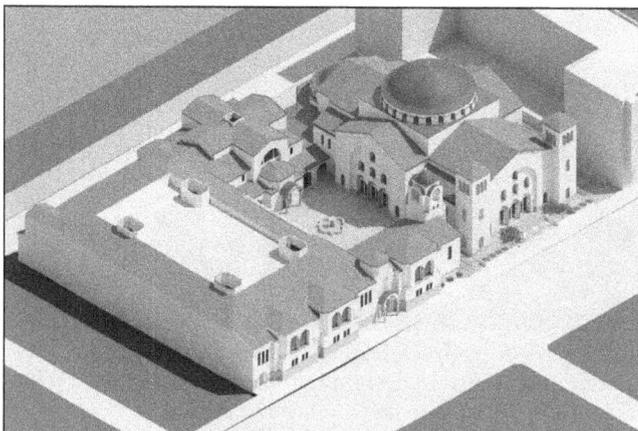

Overhead View From Valencia Street

The new Annunciation Cathedral, designed by Goldman Architects in authentic Byzantine style, will seat 525 people and have underground parking. McNely Construction of San Leandro is constructing it at an estimated cost of $13 million. At the 85th-anniversary celebration of the cathedral, Archbishop Demetrios of America exhorted, "Build a landmark or build nothing at all." As seen here, it will be a landmark. (Courtesy of Annunciation Cathedral.)

Five

BUSINESSES

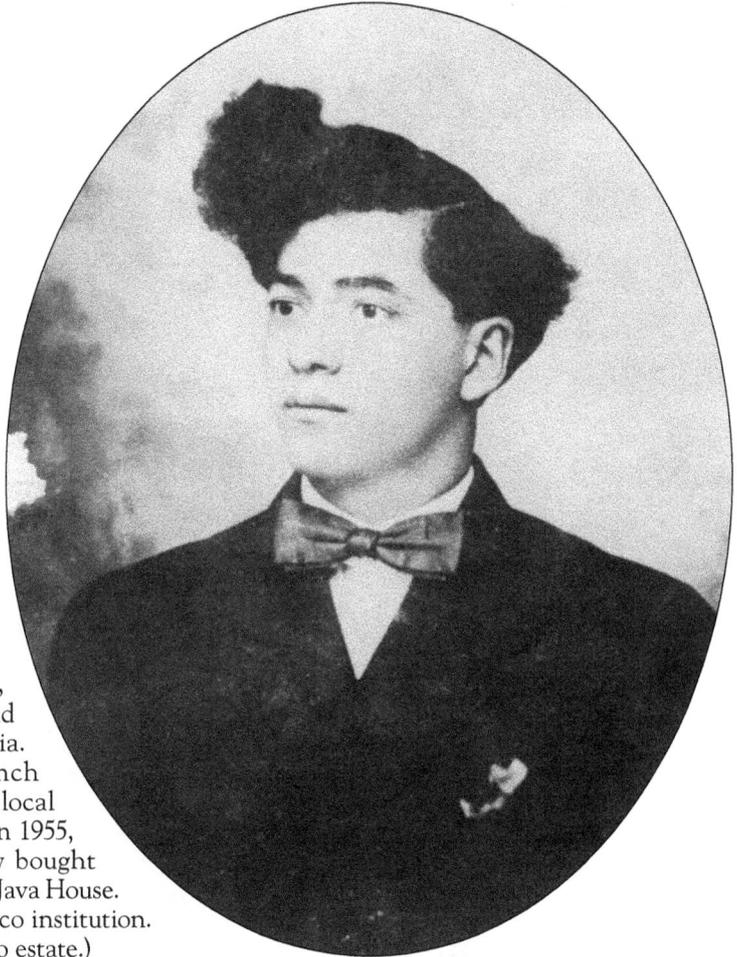

Thallasinos Franco (1889–1989) immigrated from Filia, Lesvos, Greece, along with his brothers John, Harry (Harilaos), Euripedes, Achilles, and Stavros and sisters Anthipi and Virginia. He opened Franco's Lunch on Pier 30, selling food to local longshoremen and sailors. In 1955, Tom and Mike McGarvey bought Franco's and named it Red's Java House. Red's remains a San Francisco institution. (Courtesy of the Gus Franco estate.)

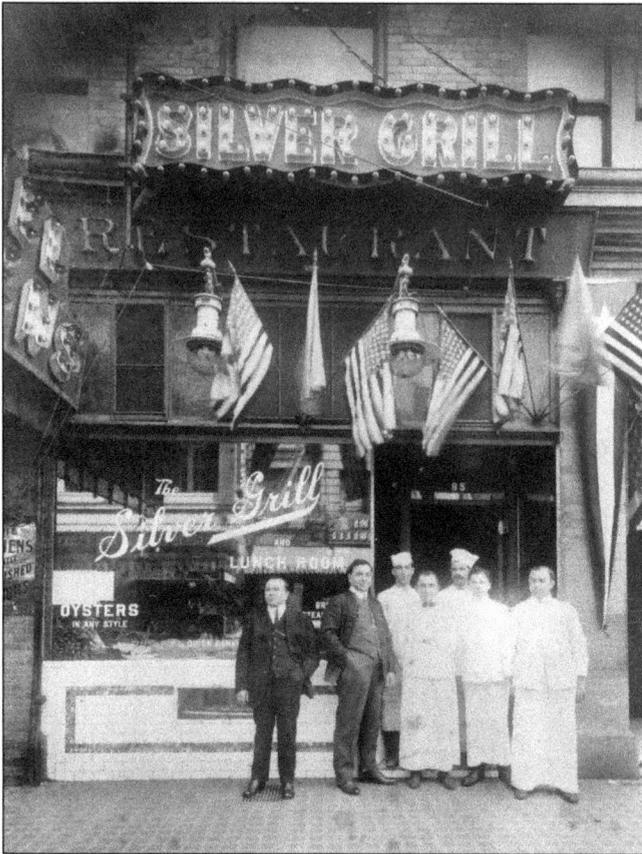

The well-known Silver Grill (pictured around 1925), was located at 85 Eddy Street in San Francisco's Tenderloin district and was owned and operated by the Ellis brothers: Peter (center), Ernest (far right), and George (not shown). The Parc 55 San Francisco Hotel currently occupies this location. (Courtesy of the Matina Pappas estate.)

Andrew K. Thanos (center, with cap and long coat) is pictured about 1909 in front of his wholesale grocery business, located at 609 Franklin Street in San Francisco. He started the business shortly after the 1906 earthquake and fire. Thanos went on to open a car dealership in Vallejo and a wholesale liquor distribution business in San Francisco. (Courtesy of Andrew Thanos.)

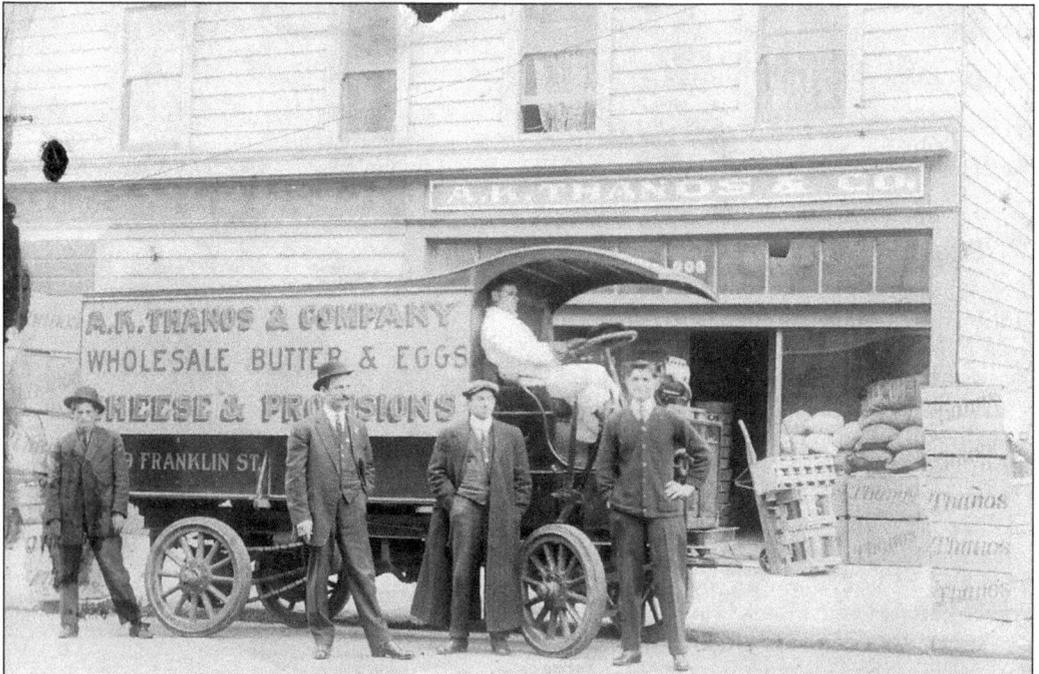

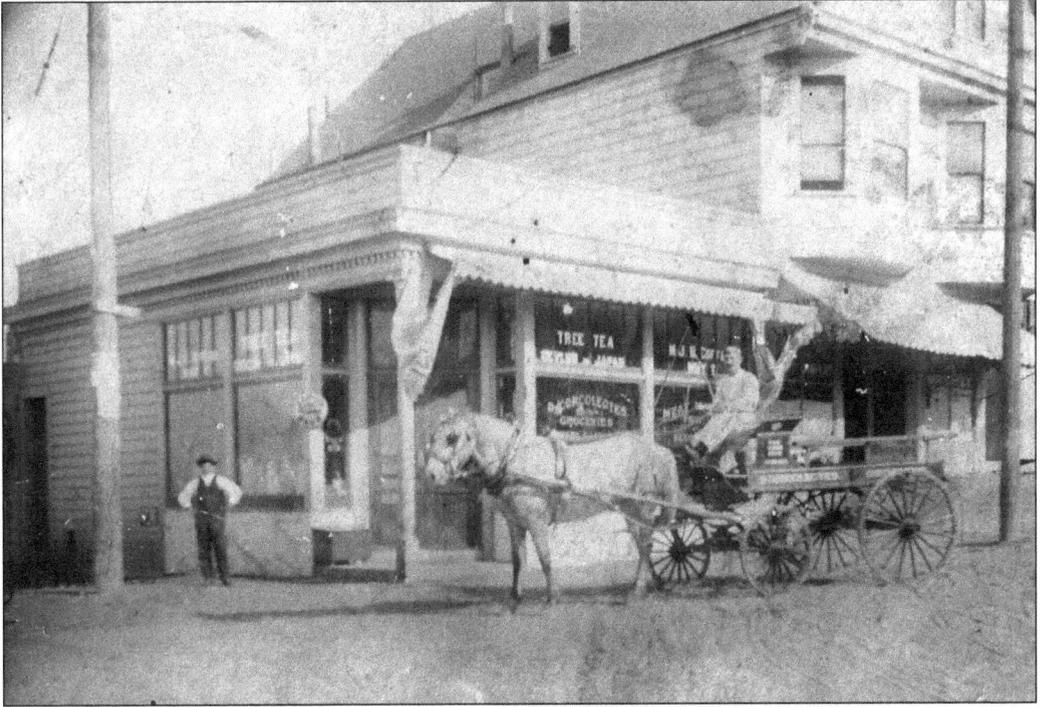

Pictured is the Corcoleotes (Kourkouliotes) Grocery store at 601 Kansas Street in San Francisco's Potrero Hill district. The Corcoleotes family immigrated from the island of Evvia. The grocery was in business for over 30 years. Dimitrios Kourkouliotes gave a teenage John Afendras (also from Evvia) a place to stay and a job while he studied music. Afendras became a classically trained violinist and band leader. (Courtesy of the Corcoleotes family.)

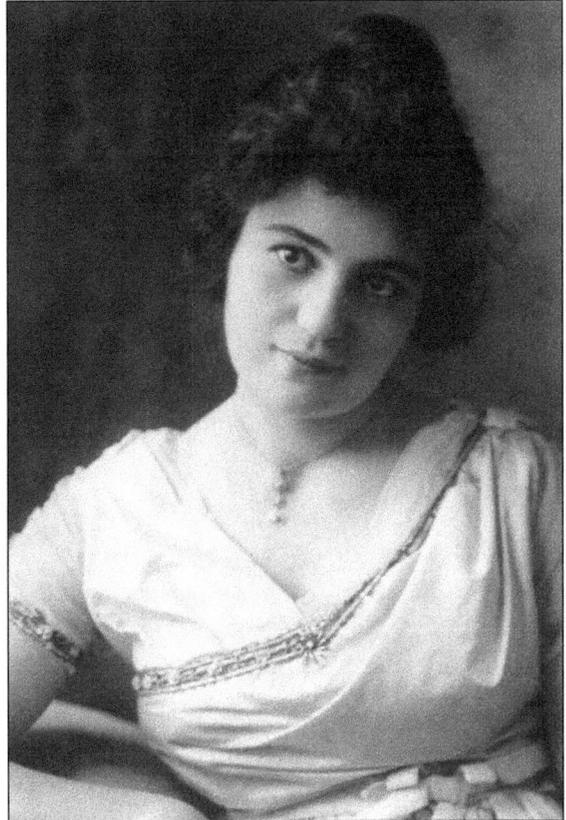

Alyce George Bell, born Elisavet Georgopoulos in Kiparissia, Greece, immigrated to America prior to the 1906 earthquake and fire. Due to unfortunate circumstances, she found herself a single mother of three children. She operated the Nile Café at 55 Grant Avenue. She encouraged her children to get a college education and supported her daughter Helen's desire to serve her country during World War II. (Courtesy of Peter B. George.)

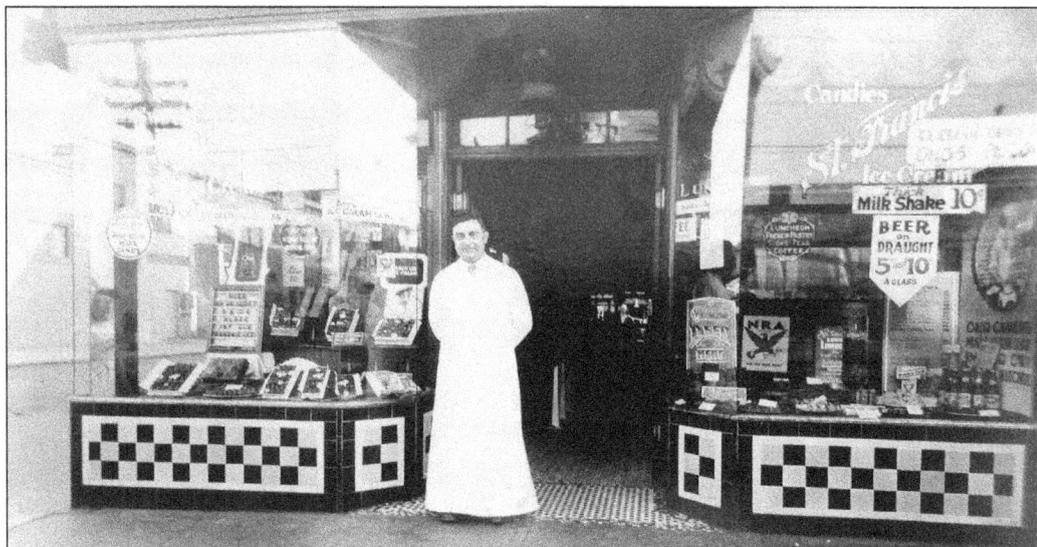

St. Francis Fountain, at 2801 Twenty-Fourth Street, was first founded as a confectionery by James Christakis in 1918. The Fountain is known as San Francisco's oldest ice-cream parlor. Three generations of the Christakis family operated the Fountain as a candy store, ice-cream parlor, and lunch counter until 2000. James Christakis is pictured here about 1933. (Courtesy of Steven Christie.)

James Couch (Dimitrios Koutsogianis) was born in Partheni, Greece, in 1897. At age 16, he immigrated to San Francisco and worked as a grocery clerk. He opened his own business, the Domo Market at 1090 Bush Street (pictured), in the 1930s. In 1940, he was elected president of the San Francisco Retail Association, and he later served as a director of the local and state grocers associations. (Courtesy of Dorothy Vasiloudis.)

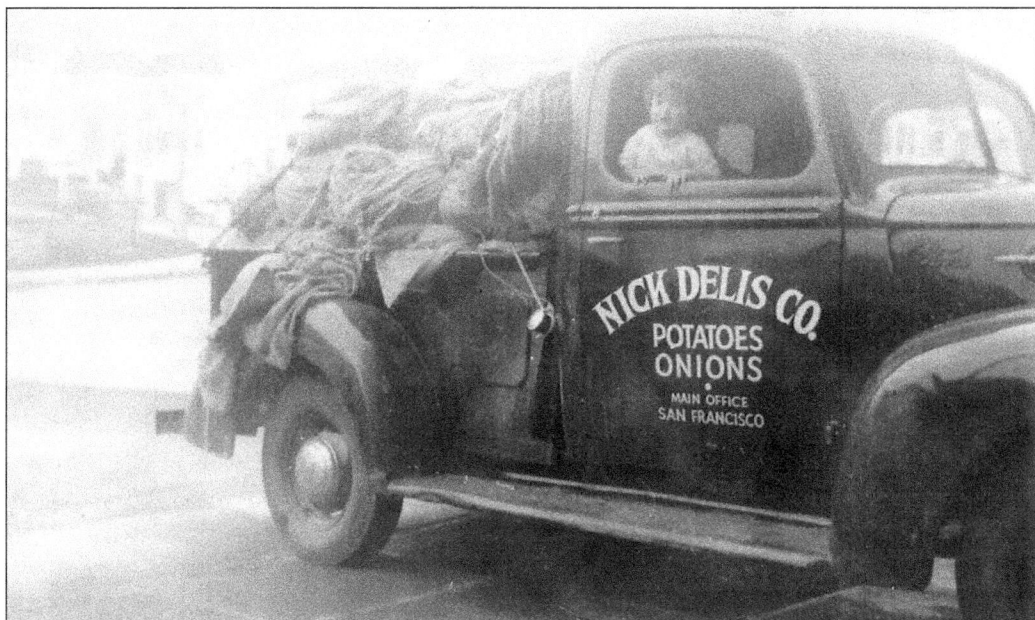

Nick Delis (Delakis) immigrated to the United States from Chania, Crete. In 1928, he came to San Francisco, started as a produce clerk, and became one of the biggest potato growers and shippers in the West. He was known as the "Potato King." Nick Delis Company, Inc. was located at 450 Front Street. Pictured is Katina "Karen" Delis Vandarakis, age 16 months, in one of her father's trucks. (Courtesy of Nick Delis.)

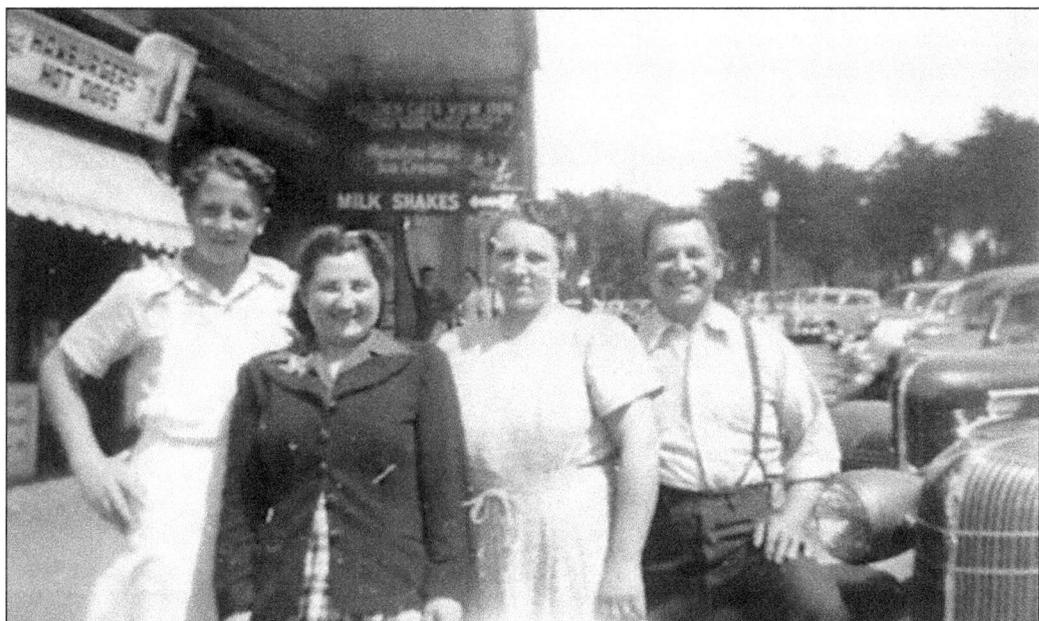

Louis' Restaurant was opened by Louis and Helen Hontalas on Valentine's Day, 1937. Louis immigrated to America from Greece in 1906 at age 11. Their three sons, John, Jim (Demostenes), and Gus (Constantine), worked at Louis', and son Jim took over the business. Louis' is now run by the third generation, grandsons Bill and Tom Hontalas. Pictured from left to right are Jim Hontalas, Rachel Lelchuk, Helen Hontalas, and Louis Hontalas. (Courtesy of the Hontalas family.)

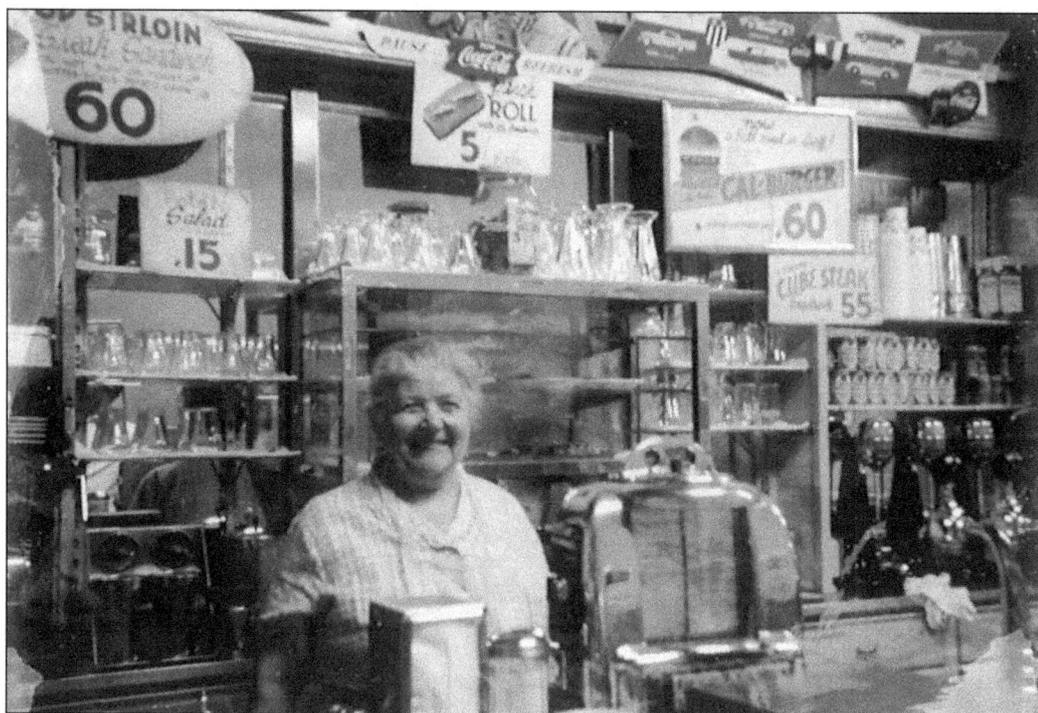

The California Candy Kitchen & Fountain, at 2783 Mission Street, was started in 1906, survived the 1906 earthquake, and remained in business until 1967, when construction of the Bay Area Rapid Transit (BART) system forced its closure. Pictured here is Demetroula Prongos, who—with her husband Manuel and son John—was the longtime owner. (Courtesy of Carole Varellas Karkazis.)

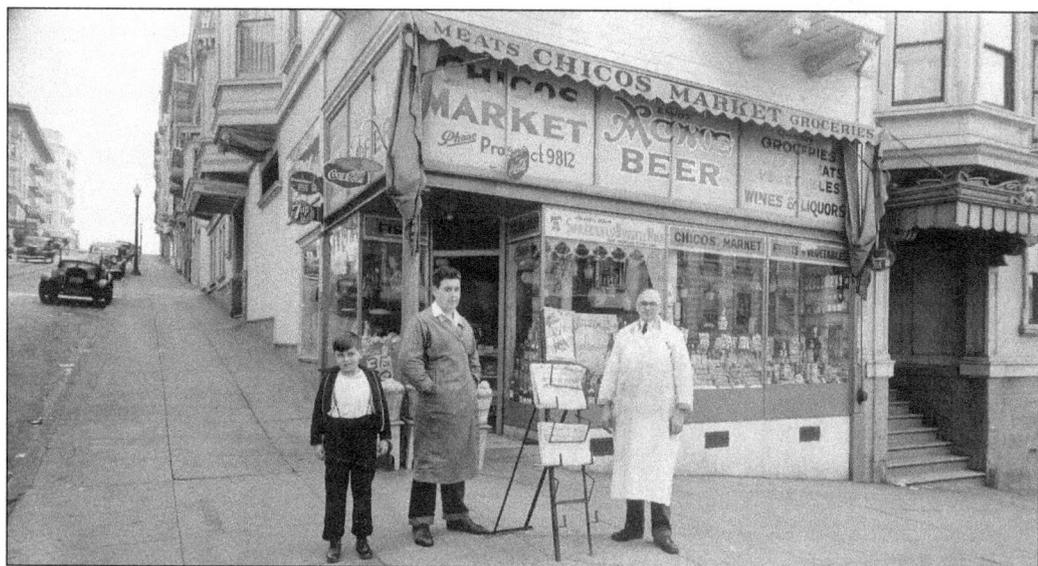

The Chicos Market (1928–1997), at 1168 Leavenworth Street, was started in 1928 by two brothers, William (Vasilios) and Gus (Konstandinos), immigrants from Rizes, Tegea, Greece. Their sons, Sam W. Chicos and Samuel G. Chicos, respectively, followed in their footsteps. From left to right are Samuel G., Sam W., and William Chicos. (Courtesy of Mary and Sam Chicos.)

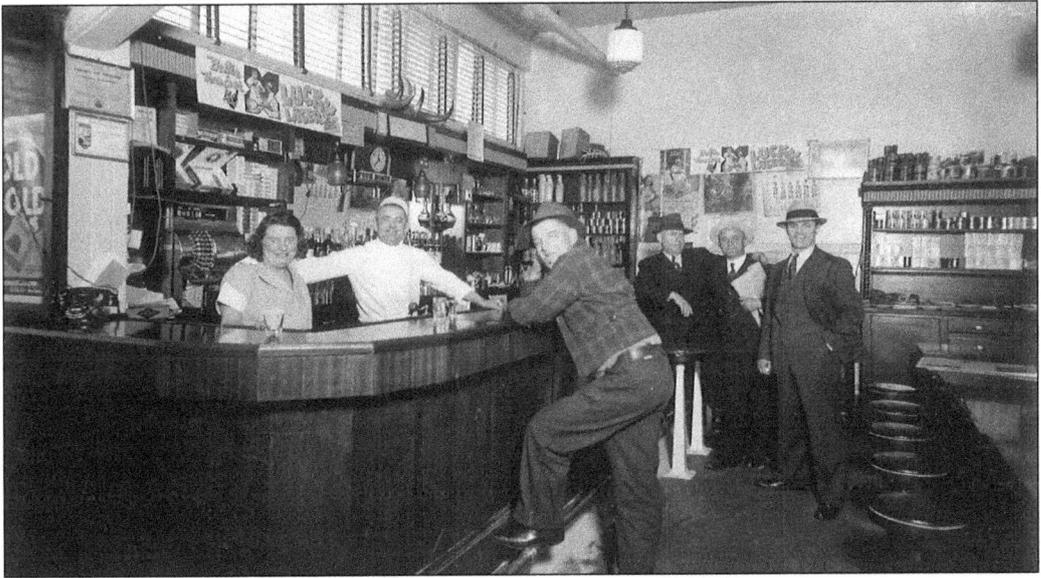

The Maragos Café was located at 299 Fourth Street, where the Moscone Center is now located. James Maragos (1902–1977) was born in Kotsikias, Evvia, Greece, and came to the United States at age 22. He came to San Francisco in 1933 and opened the Maragos Café with his brothers-in-law Alec and Frank Polos and Peter Marcopulos. The Maragos Café was in business from 1933 to 1962. (Courtesy of Cynthia Marcopulos.)

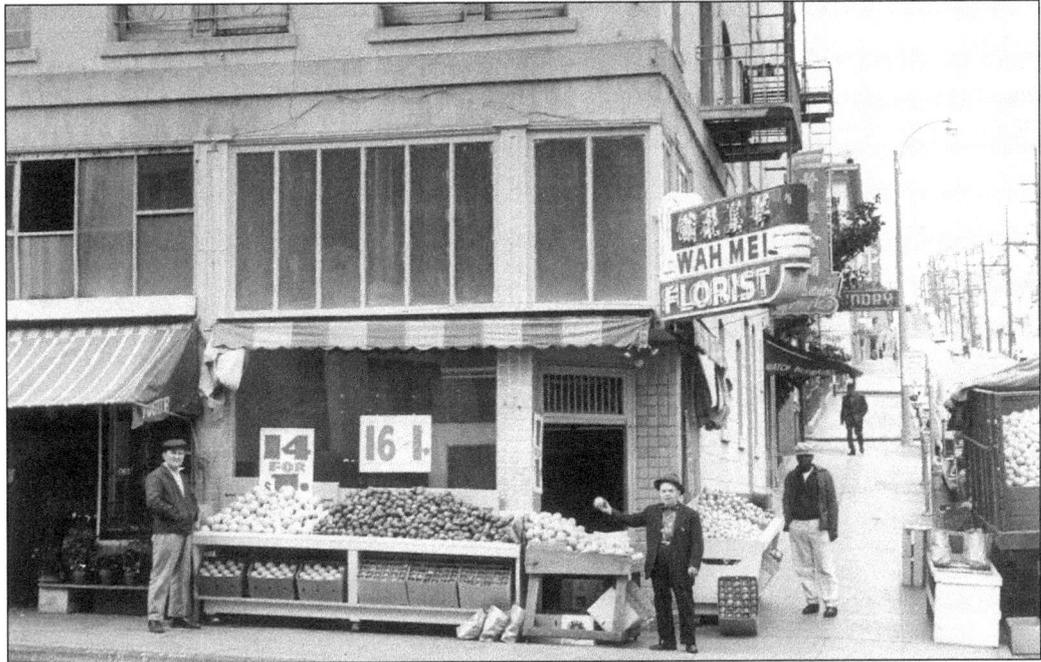

Orangeland, located at 1055 Stockton Street in Chinatown, was owned by Arthur Angelopoulos and Nick Tsiplakos from 1957 to 1974. When Arthur and Nick opened it, they were the first white male merchants to open a business in Chinatown. One year, they set a record for selling 1,000 boxes of oranges for Chinese New Year. Orangeland pioneered a trend for an open market with sidewalk fruit stands. (Courtesy of Sula Anagnostou.)

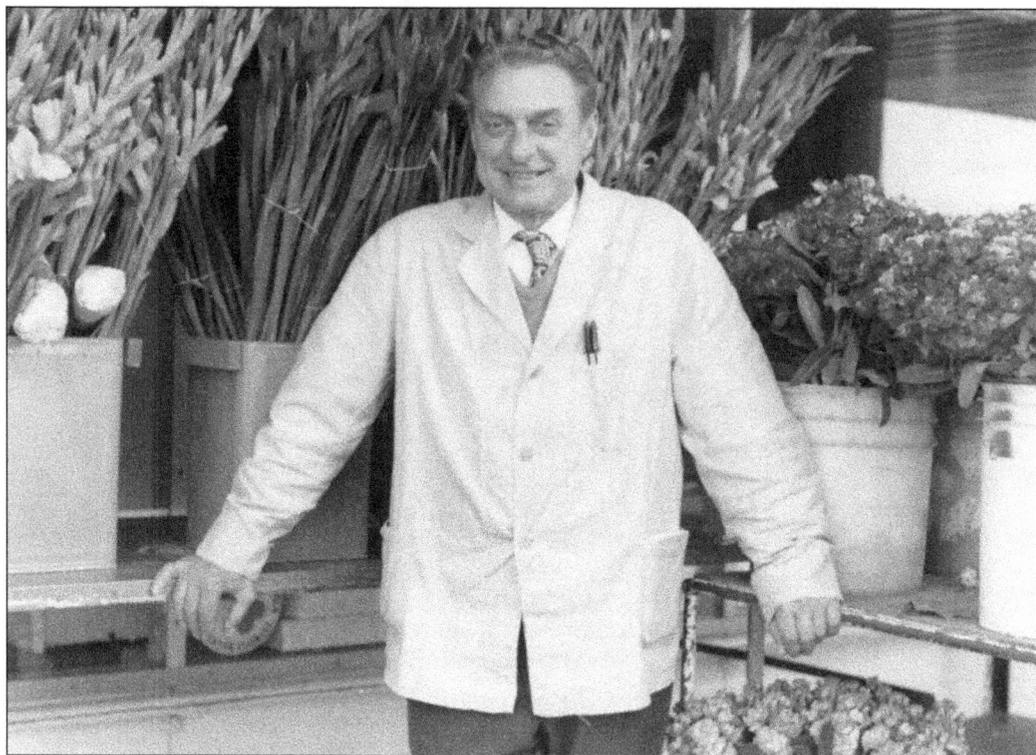

George Themelis, born in Greece in 1917, came to the United States and worked in the wholesale flower business in New York City. After serving in World War II, he and a partner bought John Nuckton Company, a wholesale florist, in 1950. His son Nick took over the business, located at 668 Brannan Street, in 1992 and is the owner to this day. (Courtesy of Georgia Themelis Morrow.)

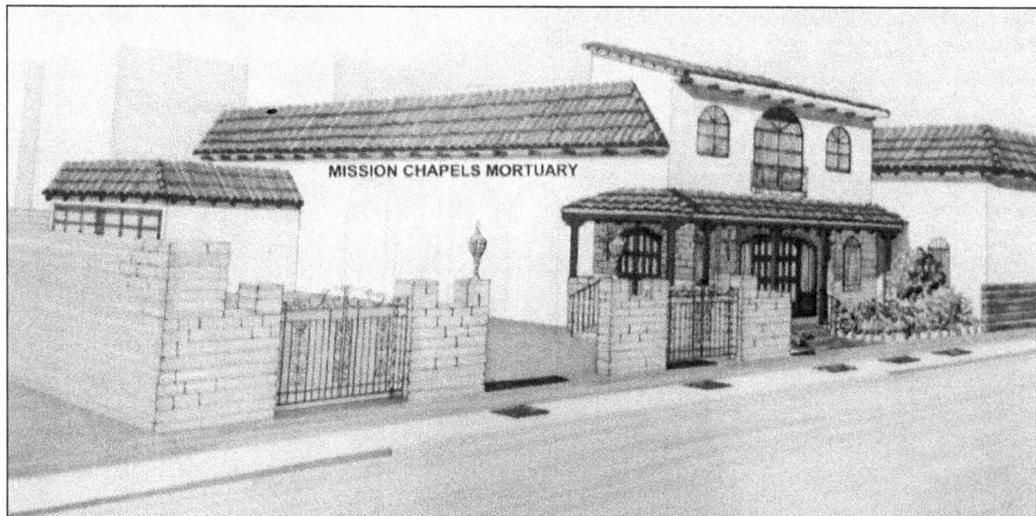

Mission Chapels (1954–2005), located at 435 Valencia Street, was opened by Louis "Lou" Paponis. After an honorable discharge from the US Army following World War II, Lou worked in the Plexiglas and Lucite manufacturing industry. He then graduated from the San Francisco College of Mortuary Science and became a licensed funeral director, funeral counselor, and embalmer, serving the Greek and Greater San Francisco community for decades. (Courtesy of Louis Paponis.)

The Avenue Sweet Shop, located at 2680 San Bruno Avenue in San Francisco's Portola District, was opened in 1937 by Costas Boyadzis. In its 57 years of operation, it relocated once to another location on the same block. Pictured are, from left to right, Sophia and Costas Boyadzis, Millie (waitress), Pete (cook), and an unidentified young man who served as dishwasher. (Courtesy of Anthony Boyadzis.)

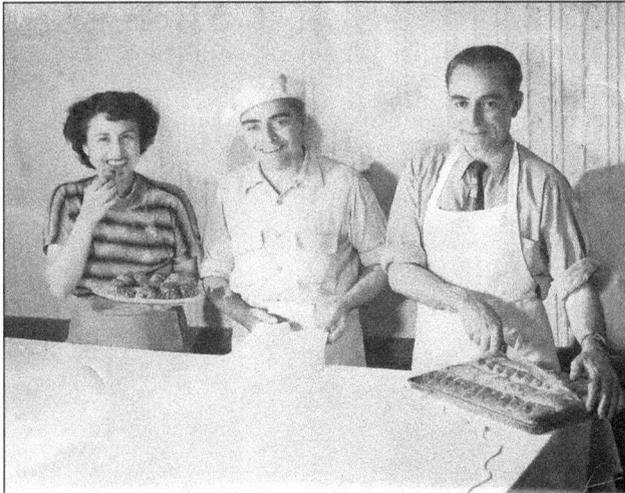

Mary Ballas Husband Bill (Vasili) Brother Kostas

Ballas Pastry 1953
San Francisco

Hand Made Filo & Kantifi
Greek Pastries
Imported Foods

Ballas Pastry (1953–1977), at 3120 Sixteenth Street, was owned by Mary, Bill, and Kostas Ballas. Kostas won gold and silver medals in pastry-making at the Grand Fair of Thessaloniki in 1937. Mary was born in Hannah, Wyoming. Her husband, Bill, and his brother, Kostas, immigrated from Crete. Mary managed the business. Kostas was the lead pastry chef, and Bill produced handmade *kataifi* and filo. (Courtesy of Bill Ballas.)

63

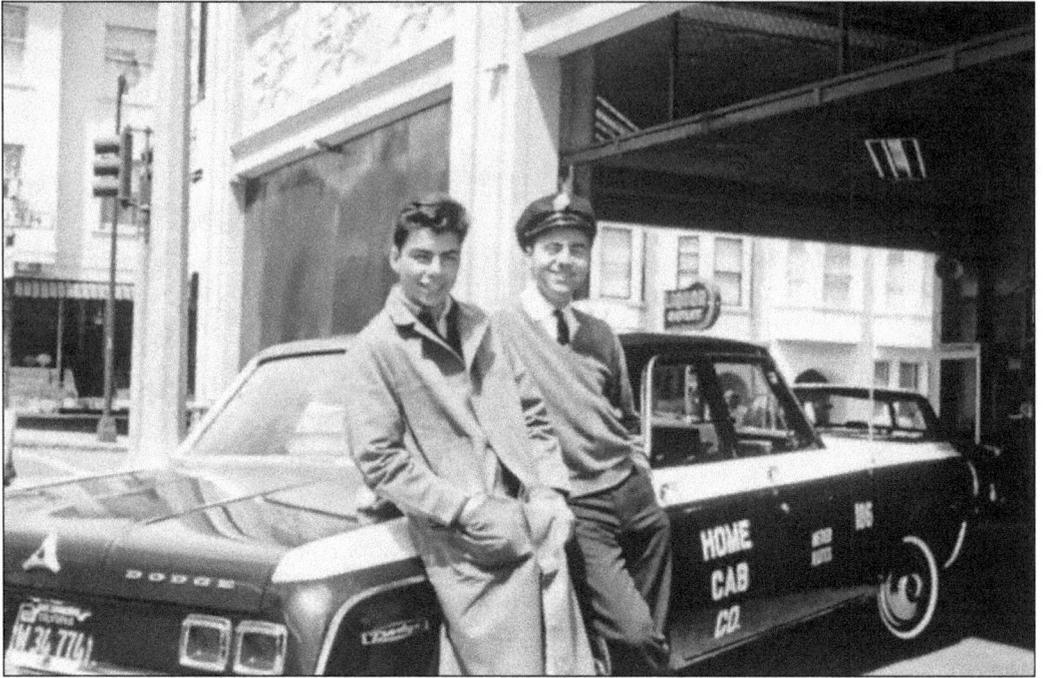

Christos Mardakis and his brother Frank (Anastasios) were owners of the Home Cab Company, located at Bush and Franklin Streets in San Francisco. The brothers were born in Pende Oria, Greece, and came to the United States in the 1920s. They drove jitney buses and taxi cabs before starting their own company. They operated over 20 taxis 24 hours a day from the 1940s through the 1960s. (Courtesy of Chris Gus Kanios.)

Mary Hatzidakis was the longtime proprietress of Mary Hatzis Travel Agency, at 1639 Market Street. She made travel arrangements for generations of families visiting Greece. Hatzidakis (back row, center) is next to the captain on board the SS *Queen Frederica* with members of the Pan Cretan Epimenides/Ariadne San Francisco Chapter en route to a Cretan convention in 1959. (Photograph by Nicholas Gounarakis, courtesy of Bill Ballas.)

Elias Tsiknis is the owner of Greek Imports, Inc., the oldest continuously operating Greek import store in the United States. Founded in 1908 by Anastasios Mountanos as Mountanos Imports at Third and Howard Streets, the store relocated to 132 Eddy Street in 1947, where it was operated by his son Angelo Mountanos. In 1998, the store relocated to its current location at 6524 Mission Street in Daly City. (Courtesy of Elias Tsiknis.)

Nick Verreos was a US Navy interpreter and signalman on the SS *Niki*, commissioned to the Greek navy in World War II. After the war, he graduated from the University of San Francisco. He founded the Orthodox Youth Association, precursor to the Greek Orthodox Youth of America (GOYA). In 1956, he founded Verreos Insurance Agency and served as National Professional Insurance Association president in 1985–1986. (Courtesy of Adrienne Verreos.)

George Marcus immigrated to the United States from Evvia, Greece. After graduating from San Francisco State University, he founded Marcus & Millichap Real Estate Investment Services. Under his leadership, the company grew into an internationally renowned provider of premier investment real estate brokerage services. George has also served as a regent and trustee of the University of California and California State University Systems, respectively. (Courtesy of George Marcus.)

Gumas. was founded in 1984 by John Gumas, one of the country's foremost authorities on challenger brand marketing. The award-winning firm is consistently named as one of the top branding and marketing firms by the *San Francisco Business Times*. John Gumas is the author of the popular book *Marketing Smart* and is an adjunct professor of branding, advertising, and interactive marketing. (Courtesy of John Gumas.)

The critically acclaimed and award-winning Kokkari Estiatorio (200 Jackson Street), named after a small fishing village on the island of Samos in the Aegean Sea, was opened in 1998 by proprietors George and Judy Marcus and Dr. Kenneth and Angie Frangadakis. In 2010, Erik Cosselmon and Janet Fletcher published *Kokkari Contemporary Greek Flavors*, offering an opportunity for the wider community to experience delicious Hellenic cuisine. (Courtesy of George Marcus.)

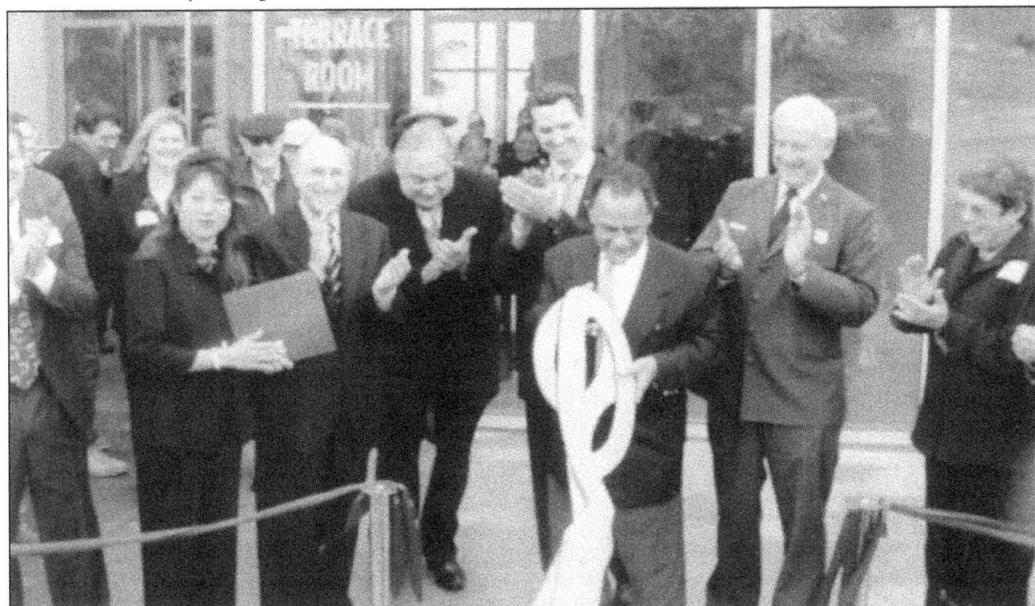

On October 19, 2004 the landmark Cliff House reopened. At the ribbon-cutting ceremony are Mayor Gavin Newsom (center), Dan Hountalas (doing the honors), and author Mary Germaine Hountalas (far right). Dan and Mary have operated the Cliff House since 1973. The view of the Pacific is as breathtaking today as it was in 1863, when the first Cliff House opened. (Photograph by Susie Biehler, courtesy of Nibbi Bros.)

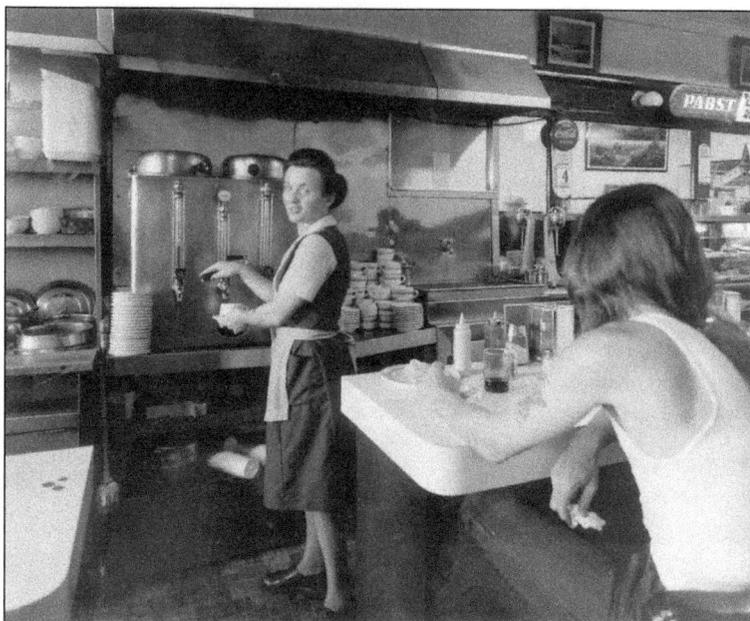

Pat Vlahos, a native of Kastoria, Greece, arrived in San Francisco in 1955. She and her husband, Ted, owned and operated the Gordon Coffee Shop at 104 Seventh Street at Mission Street for over 30 years. Pat was featured in Janet Delaney's book *South of Market*, which is a photographic portrait of a San Francisco neighborhood in the throes of urban renewal. (Photograph by Janet Delaney, courtesy of Pat Vlahos.)

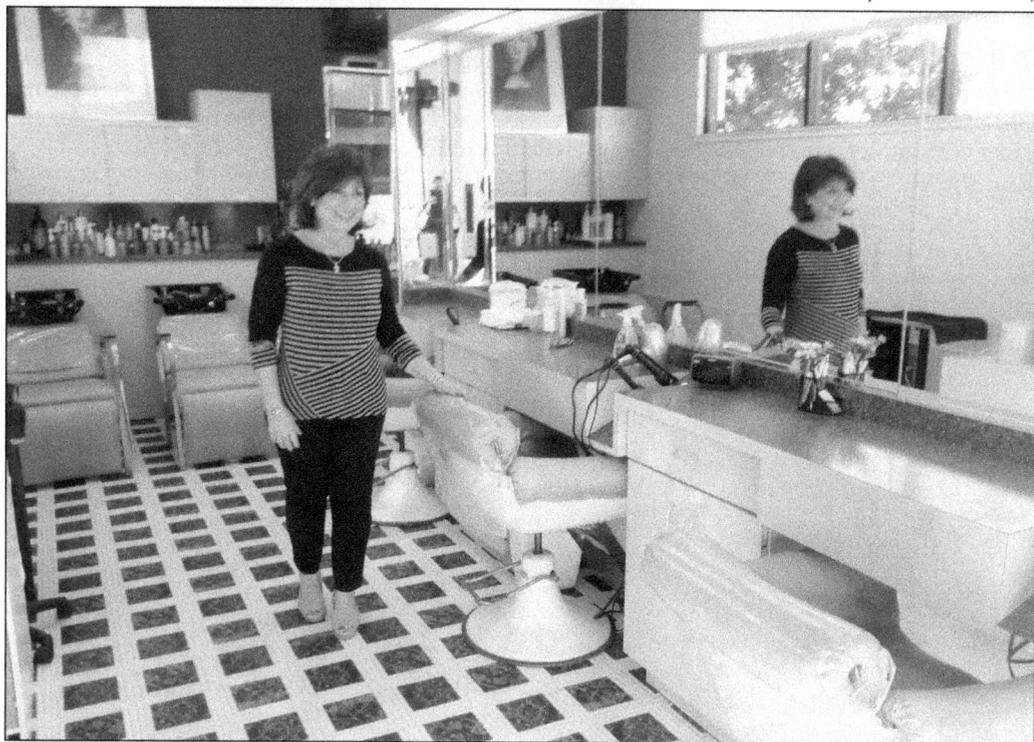

Pauline Johns Deligiorgis, a native San Franciscan and graduate of Lowell High School, received her State Board of Cosmetology license in 1965. She established three hair salons: Pan International, International Hair Design, and International Hair & Skin Care (located at 1590 Taraval Street). Deligiorgis specializes in customized nonsurgical hair replacement systems, including prosthetics for clients undergoing cancer treatments, genetic hair loss, and alopecia. (Courtesy of Pauline Johns Deligiorgis.)

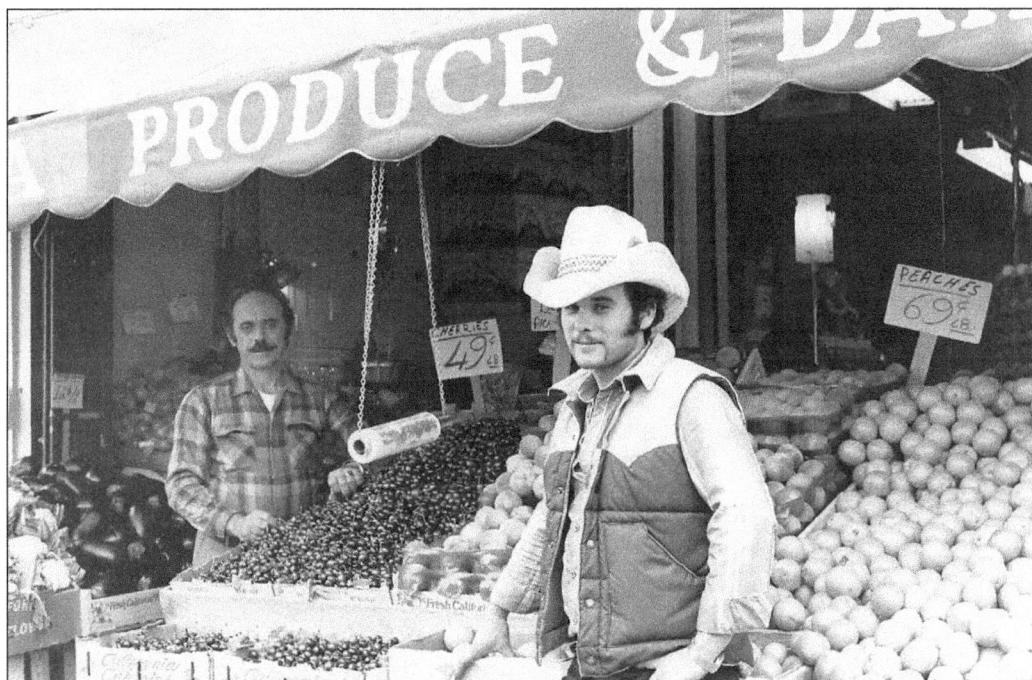

The patriarch of the Vardakastanis family, Dimitri (left), immigrated from the island of Zakynthos in the 1970s. With son Gus (right), he opened Haight Street Market in 1981, followed by Noriega Produce in 1985. Having grown up in the markets, the third generation of the family, grandsons Dimitri and Bobby, continue in the family grocery business, and in 2015, they opened Gus's Community Market in the Mission District. (Courtesy of the Vardakastanis family.)

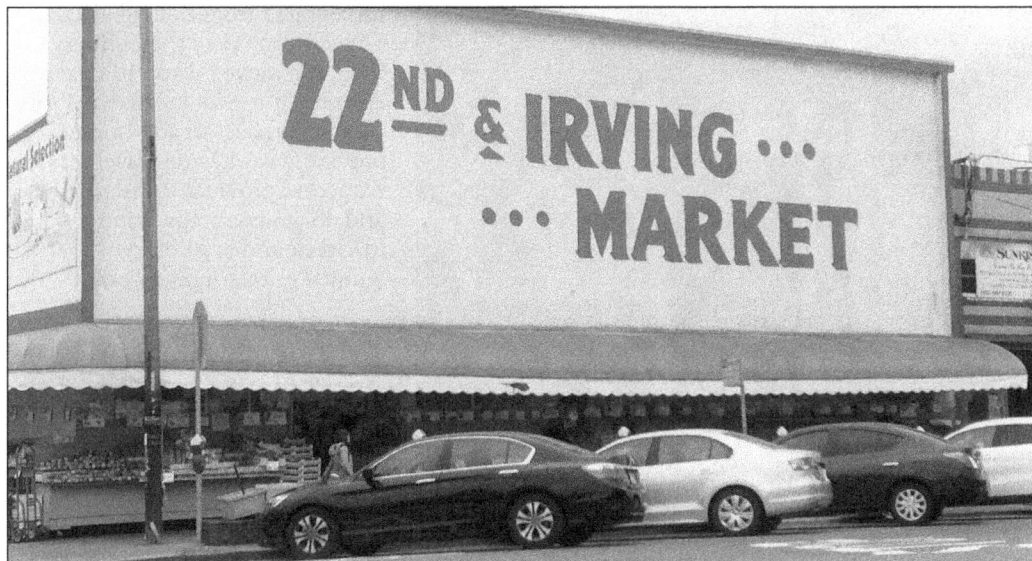

Twenty-Second and Irving Market, at 2101 Irving Street, was opened in 1971 by first cousins Tom Karas (Anastasios Karamoutzos) and Andy Angelopoulos. The store has been in existence since 1931. Tom immigrated from Houni, Argolida, Greece, in 1951 and Andy from Vrousti, Argolida, in 1961. They specialize in fresh fruit and vegetables and carry a wide variety of international food products. Angelopoulos retired in 1999. (Courtesy of Christos Angelopoulos.)

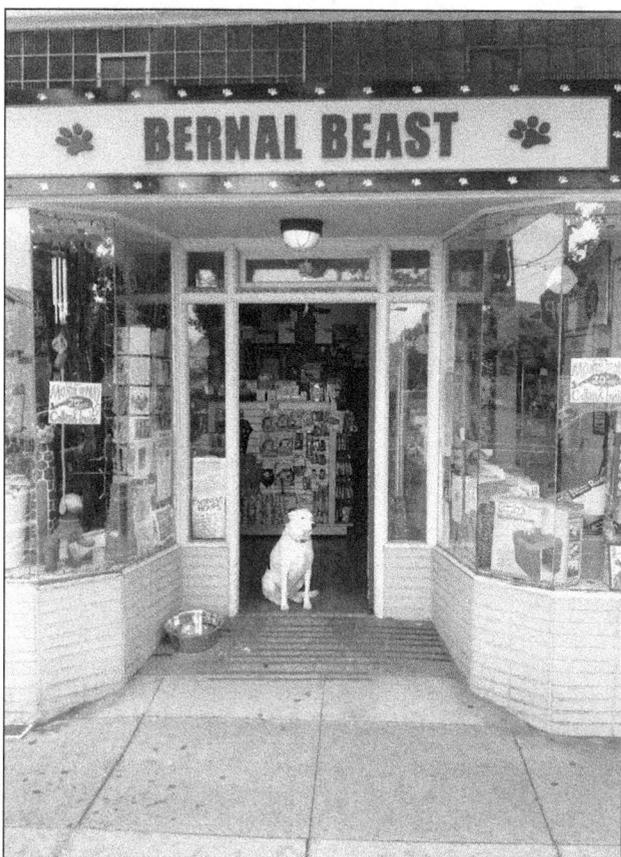

Aster Travel Agency, Inc., originally started by Vasiliki Vagenas in 1950, was located on the corner of Jones and Geary Streets. Tim Zaracotas, who immigrated from Kalambaka, Greece, took over the business in 1979 and moved it to 910 Geneva Avenue. It is now located at 1961 Ocean Avenue. In addition to providing worldwide travel service, Zaracotas provides translation and document preparation in Greek and is a notary. (Courtesy of Tim Zaracotas.)

The Bernal Beast, at 509 Cortland Avenue in San Francisco's Bernal Heights, was opened by Tony Chrisanthis in 1995. Chrisanthis, the son of Greek immigrants from Evvia, grew up on Potrero Hill. It is known for selling only high-end food and treats for dogs and cats. The store donates a percentage of its profits to local animal rescue groups and is very involved with the community. (Courtesy of Tony Chrisanthis.)

Six

COMMUNITY LEADERS AND ORGANIZATIONS

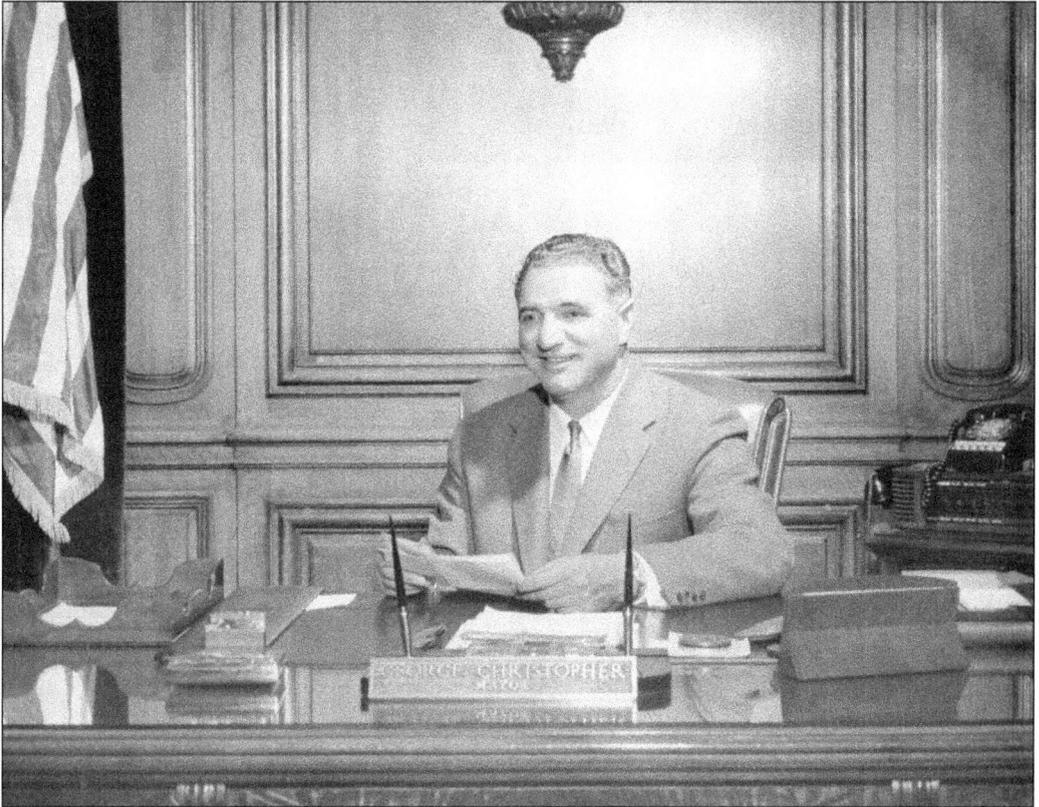

George Christopher (1907–2000), the 34th mayor of San Francisco (1956–1964), was born in Agios Petros, Arcadia, Greece. He was elected to the board of supervisors in 1945. He was instrumental in bringing the New York Giants to San Francisco in 1958, building Candlestick Park, and developing the Embarcadero Center and Golden Gateway. (Photograph by Milton Mann Studios, courtesy of the San Francisco History Room, San Francisco Public Library.)

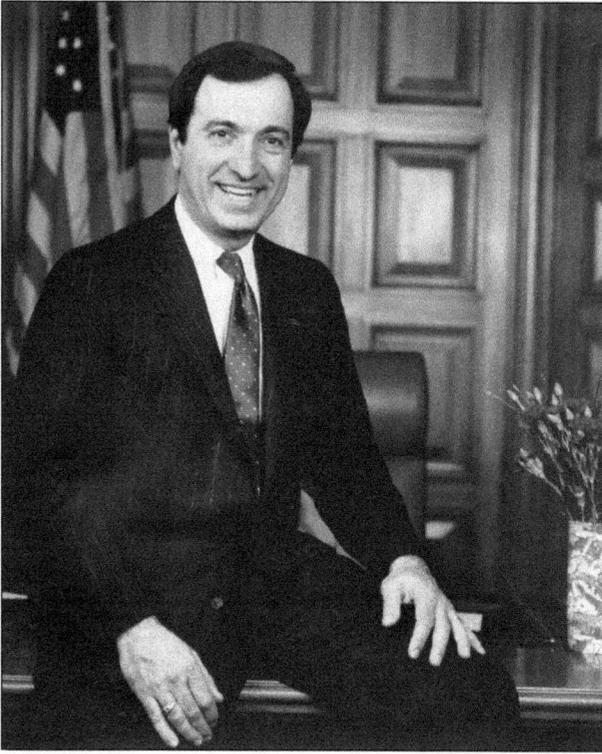

Arthur Christ "Art" Agnos, the 39th mayor of San Francisco (1988–1992), was born in Springfield, Massachusetts, in 1938. He was elected to the California State Assembly in 1976. He was later appointed regional head of the US Department of Housing and Urban Development (1993–2001). He led the city's recovery efforts after the 1989 Loma Prieta Earthquake. (Courtesy of Art Agnos Papers and the San Francisco History Room, San Francisco Public Library.)

RE-ELECT
SUPERVISOR
PETER
TAMARAS
INCUMBENT

WE NEED HIS EXPERIENCE

Peter Tamaras (1911–2006) was born in Birmingham, Alabama. His parents immigrated from Marmara, Turkey. A UC Berkeley graduate, he served as a US Army artillery captain during World War II. Mayor George Christopher appointed him to the board of permit appeals in 1956 and, in 1961, appointed him to the board of supervisors, where he served until 1978—twice as board president. (Courtesy of Lula Tamaras Ossipoff.)

John Bardis graduated from Harvard College and the Harvard Business School, served in the US Air Force, and pursued his financial management career in Silicon Valley, culminating as chief financial officer of two corporations. As a longtime activist, John led community organizations that saved hundreds of affordable family houses in San Francisco. In 1979, Bardis was elected to the San Francisco Board of Supervisors. (Courtesy of John Bardis.)

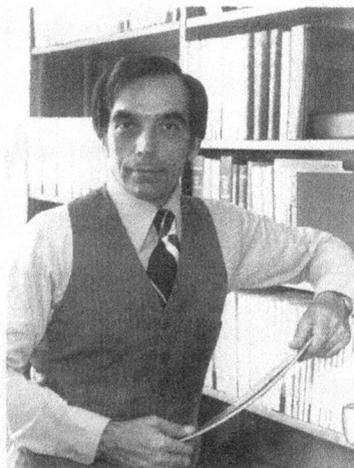

When politicians fail to solve our city's problems, it's time for a new kind of leadership.

It's time for

John Bardis

A *Citizen* Supervisor from District 11

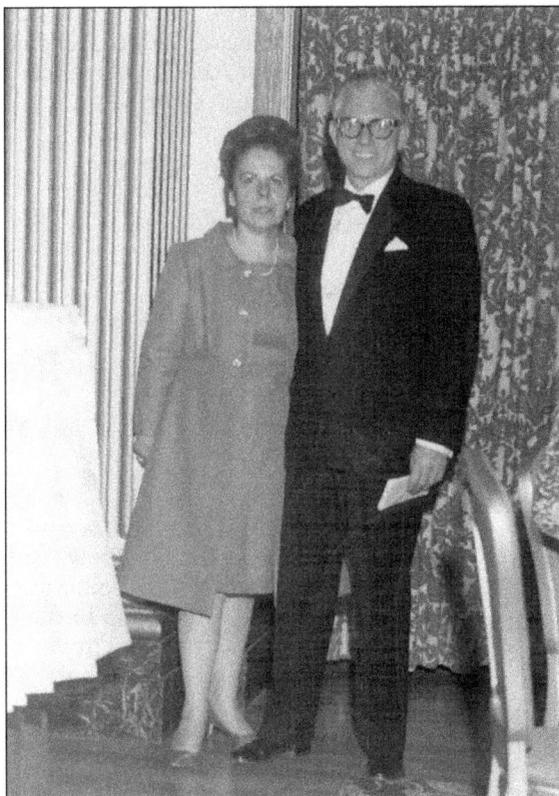

Judge S. Lee Vavuris (pictured with wife Angie), graduated from the University of San Francisco Law School, receiving his juris doctorate in 1944. He was appointed to the municipal court in 1966 by Gov. Pat Brown and to the superior court by Gov. Ronald Reagan in 1971. He believed strongly in the rule of law, the pursuit of justice, and the application of common sense and fairness. (Courtesy of Sophia Fonti.)

73

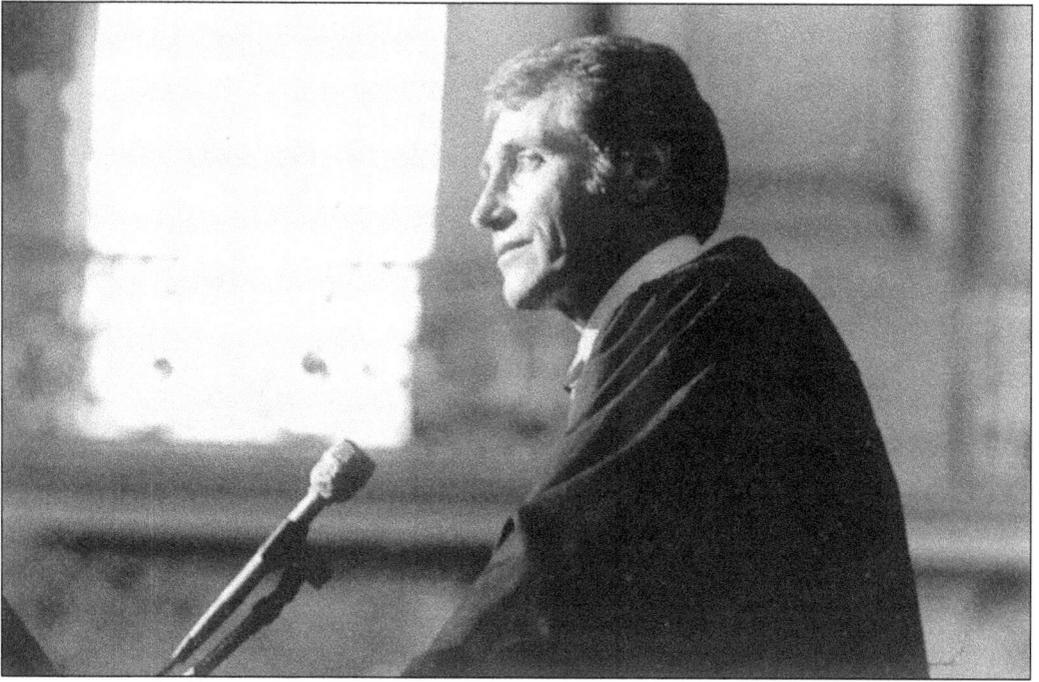

Judge George T. Choppelas retired from the San Francisco Superior Court in 2000 following 18 years of service. Prior to his appointment to the San Francisco Superior Court, he served on the San Francisco Municipal Court, San Francisco Recreation and Park Commission, and San Francisco Economic Opportunity Council. He is also a past president of the San Francisco United Hellenic American Society and Golden Gate–Pacific Chapter No. 150, Order of AHEPA (American-Hellenic Educational Progressive Association). (Courtesy of Judge George T. Choppelas.)

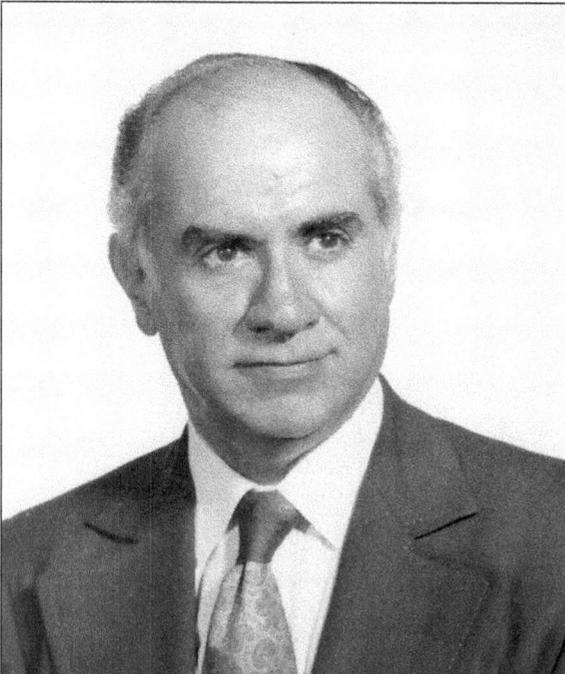

George P. Agnost (1922–1986) served as a nose gunner in the US Army Air Corps during World War II. Following the war, he served as a captain in the US Army Reserves, graduated from the UC Berkeley, and received his law degree from Stanford University. He practiced law and was elected San Francisco city attorney from 1977 to 1986. (Courtesy of Adrienne Verreos.)

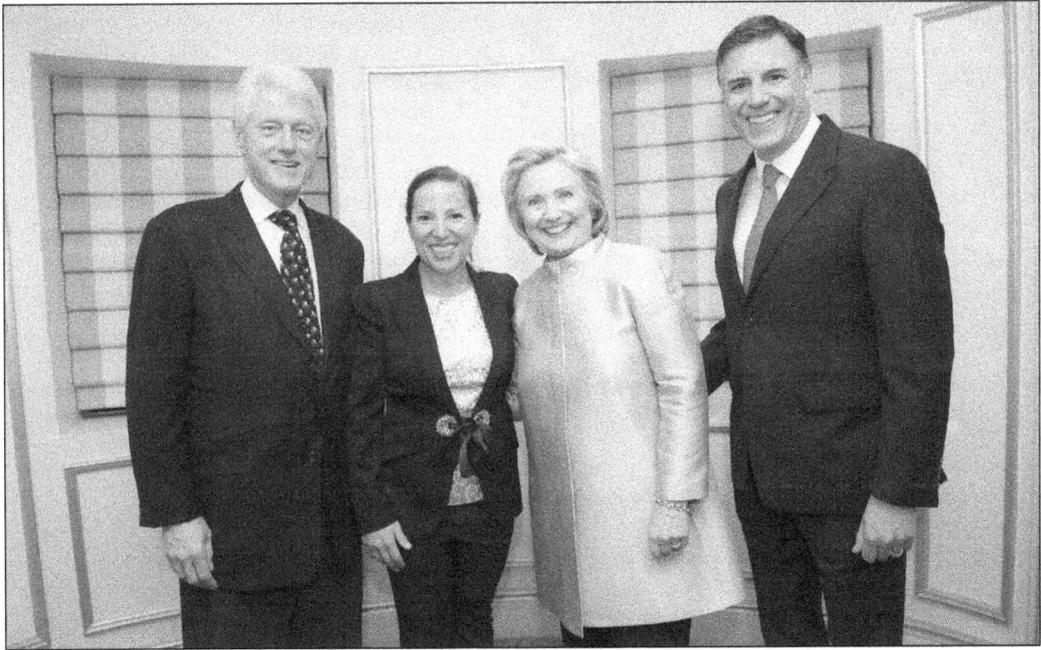

Amb. Eleni Kounalakis and Markos Kounalakis are pictured with Pres. Bill Clinton and former Secretary of State Hillary Clinton in 2015. Markos's parents came to San Francisco from Crete; he grew up in the Mission District and attended Lowell High School. Eleni's father, Angelo Tsakopoulos, moved to Sacramento from Arcadia. The couple is widely recognized for their civic engagement, including endowed chairs at Georgetown and Stanford Universities. (Courtesy of Hillary Clinton.)

Ted Soulis, a first-generation San Franciscan from a Messinian family and graduate of the San Francisco Art Institute, pursued artistic painting two days weekly throughout his life while simultaneously balancing successful business interests. He was a founder of Federal Financial Mortgage, a Board of Realtors member, and San Francisco fire commissioner. An All-City Lincoln High School basketball player, he was inducted into Lincoln's Wall of Fame and Wall of Honor. (Courtesy of Ellen Soulis.)

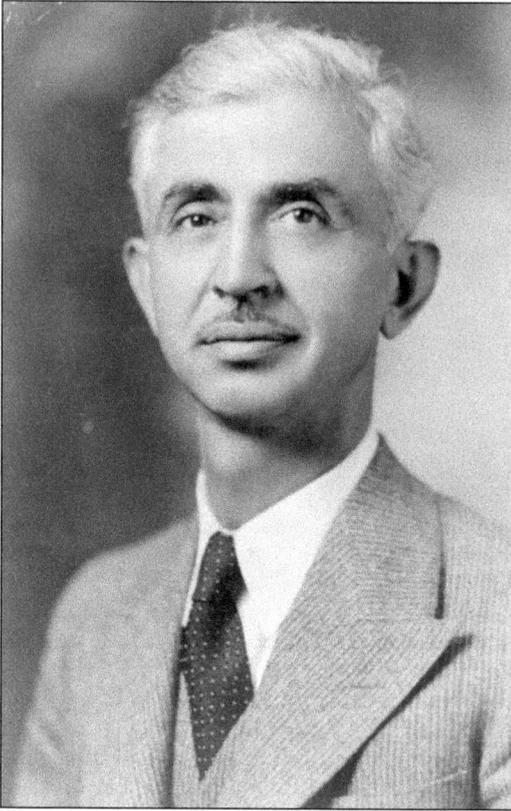

Peter Boudoures (1893–1982) immigrated from Avlona, Messinia, Greece, in 1911. He operated the Maison Paul Restaurant at 1214 Market Street for over 40 years. Active in many Greek American organizations, Boudoures headed Greek war relief efforts in the West and was appointed head of the San Francisco Board of Permit Appeals. He was president of Olympic Federal Savings Bank, specializing in small business loans. (Courtesy of John B. Vlahos.)

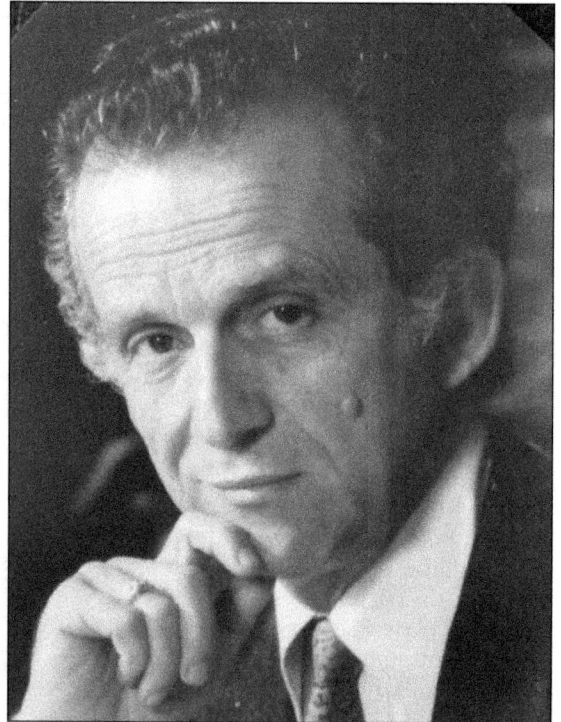

Vasilios Choulos, a San Francisco native, served in the Merchant Marines during World War II. A graduate of UC Berkeley and Hastings Law School, he was part of the legal team that represented assassin Jack Ruby, several infamous bank robbers, and 1960s counter-culture heroes Timothy Leary and Lenny Bruce. He later formed a law firm with his four sons. He founded the Hellenic Law Society. (Courtesy of George Choulos.)

Dr. Anthony Bagatelos (the oldest of five brothers) served with distinction as a navigator on B-24 bombers in the Eighth Army Air Force during World War II. After his honorable discharge, he attended Stanford University, where he received his bachelor's of science and medical doctorate. He was a respected and well-liked general practice physician with an office at 380 West Portal Avenue. He married Emily Pantages in 1946 and had three children. (Courtesy of Peter Bagatelos.)

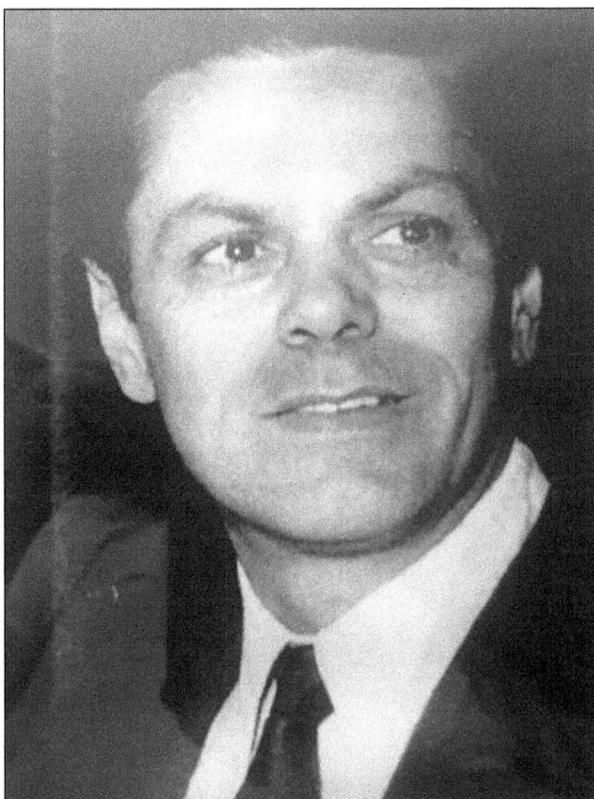

Peter A. Bagatelos is the son of Dr. Anthony and Emily Bagatelos. A graduate of Stanford University and the University of San Francisco School of Law, he is a political law attorney in San Francisco. He was the former administrative assistant to San Francisco supervisor Peter Tamaras and cofounder and president of the California Political Attorneys Association and the Hellenic Law Society of Northern California. (Courtesy of Peter Bagatelos.)

Victor Makras, president of Makras Real Estate, served on the board of permit appeals, San Francisco Public Utilities Commission, San Francisco Police Commission, San Francisco Fire Commission, and San Francisco Employees Retirement Board (on which he serves as of 2016), appointed by Mayors Art Agnos, Willie Brown, Gavin Newsom, and Edwin Lee, respectively. He has also served as president of the San Francisco Association of Realtors. (Courtesy of Victor Makras.)

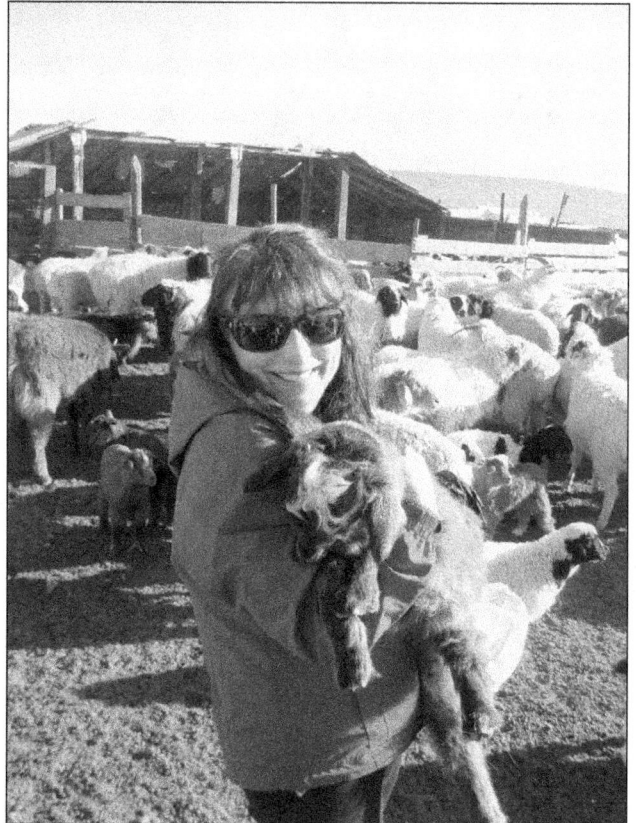

Dr. Sophia Papageorgiou, a native San Franciscan, Lowell High School graduate, veterinarian, and epidemiologist, is the daughter of immigrants George and Marika Papageorgiou from Limni, Evvia, Greece. She has a love of animals and passion for adventure, inspiring a veterinary career spanning three continents and working with wildlife and free-ranging animals in Tanzania, Mongolia, and across the United States. Pictured here in Mongolia, Sophia is enjoying time with some "kids." (Courtesy of Dr. Sophia Papageorgiou.)

Alexandra Apostolides Sonenfeld, founder of the Daughters of Penelope, was born on August 6, 1896, in Sokraki, Kerkyra (Corfu), Greece. One of nine children, she accompanied her father on a trip to the United States when she was 10 years old. She married Dr. Emanuel Apostolides, settled in San Francisco, and raised three children. After her husband's death, she married Howard Sonenfeld. (Courtesy of Mary Chicos.)

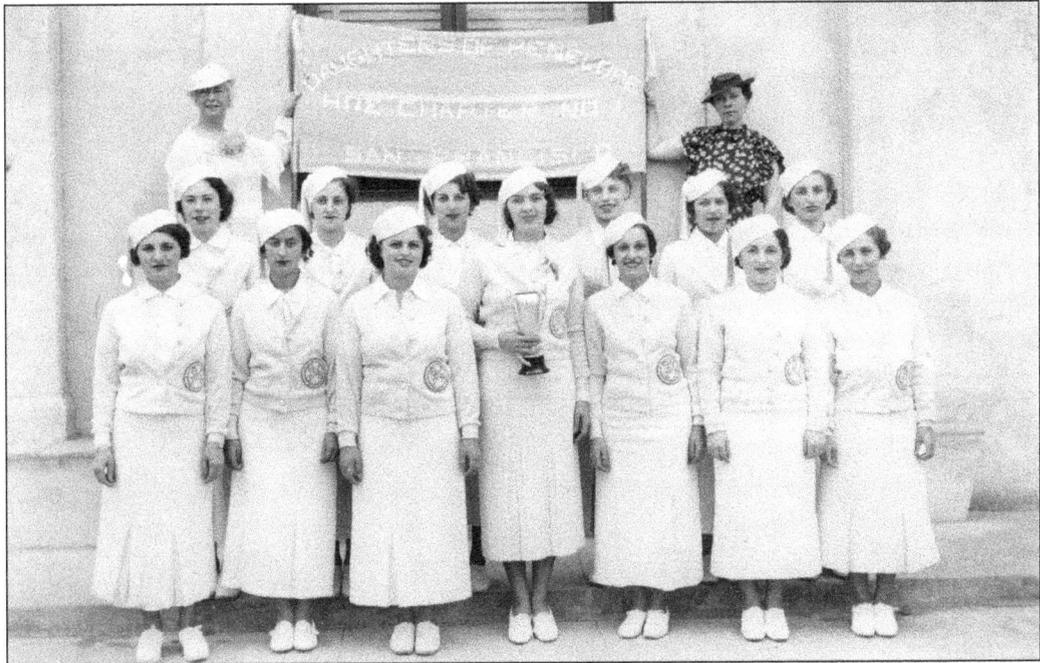

In 1929, Alexandra Apostolides opened her home to the wives of the members of the Order of AHEPA in San Francisco to discuss the formation of a women's auxiliary. The first chapter of the Daughters of Penelope, EOS No. 1, was established and, in 1931, was chartered as a California nonprofit organization. Over the years, it has grown to 390 chapters in the United States and Canada. (Courtesy of Mary Chicos.)

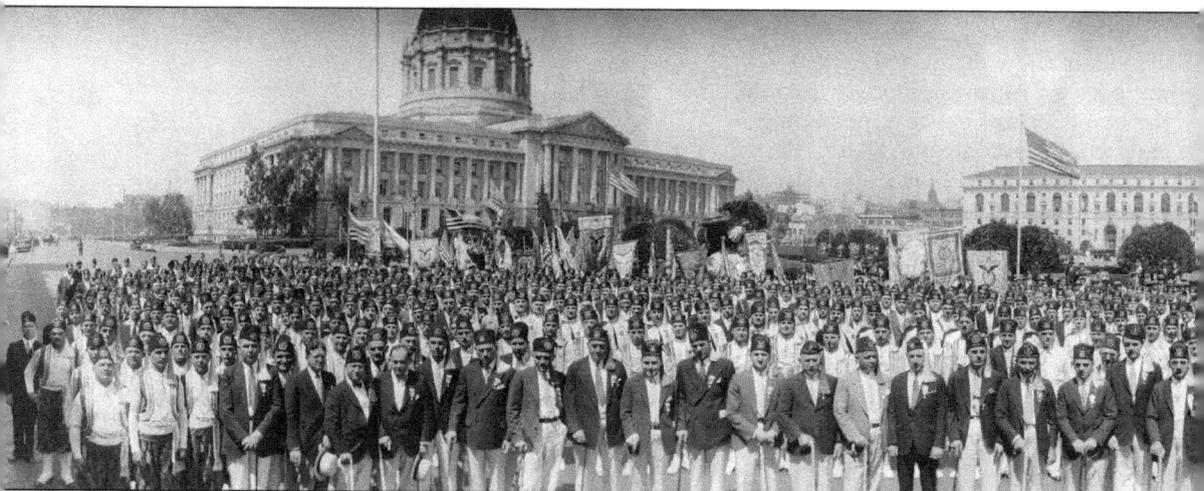

The Ninth Annual National Convention of the Order of AHEPA took place from August 24 to 31, 1931, in San Francisco. Convention headquarters were at the Whitcomb Hotel on Market and Eighth Streets. The Grand Convention Banquet took place at the Palm Court of the Palace

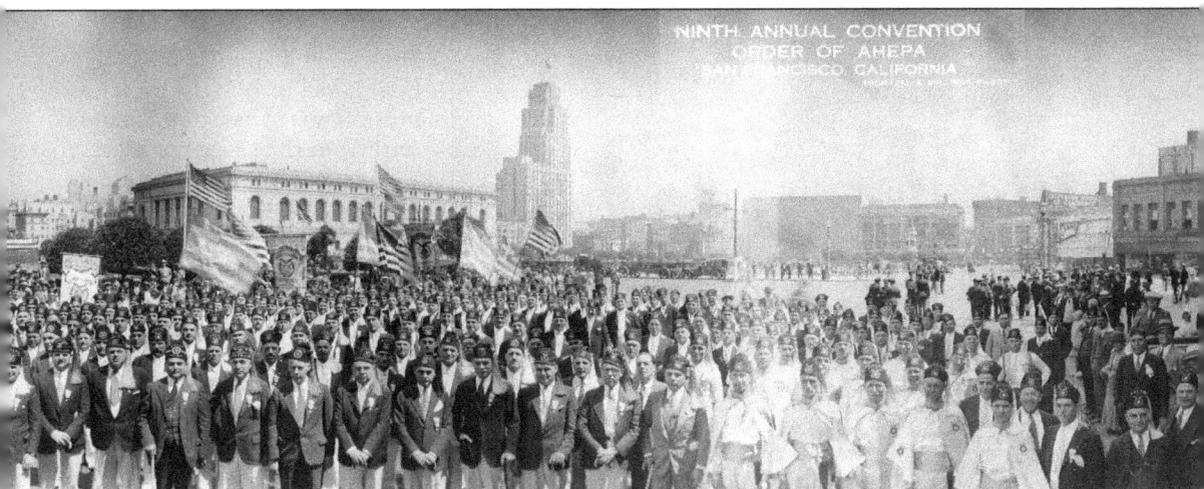

Hotel, and the convention met at the Civic Auditorium. Pictured here are the attendees assembled at the Civic Center. (Courtesy of the Ascension Cathedral Historical Society.)

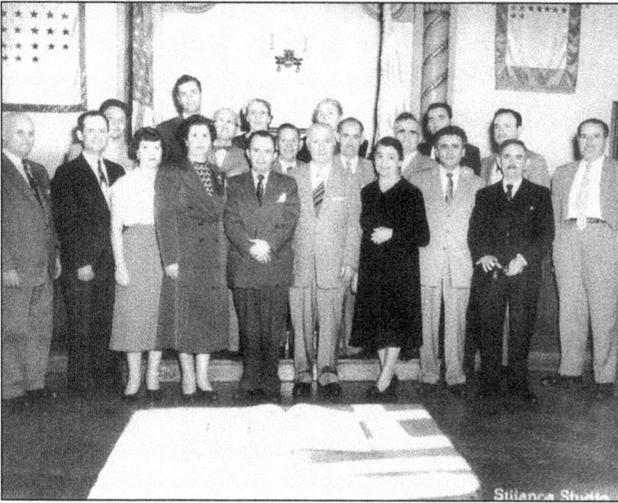

United Arcadians of San Francisco Chapter 35 was established in 1933. Its initial mission was to assist immigrants settling in their new homeland. The society was instrumental in raising funds for the Pan Arcadian Hospital in Tripolis, Greece, and other charitable endeavors. Greek community photographer John Stilanos, a 1907 émigré from Marmara, Turkey, captured many events, including this Arcadian Society photograph. (Photograph by John Stilanos, courtesy of the Greek Historical Society of the San Francisco Bay Area.)

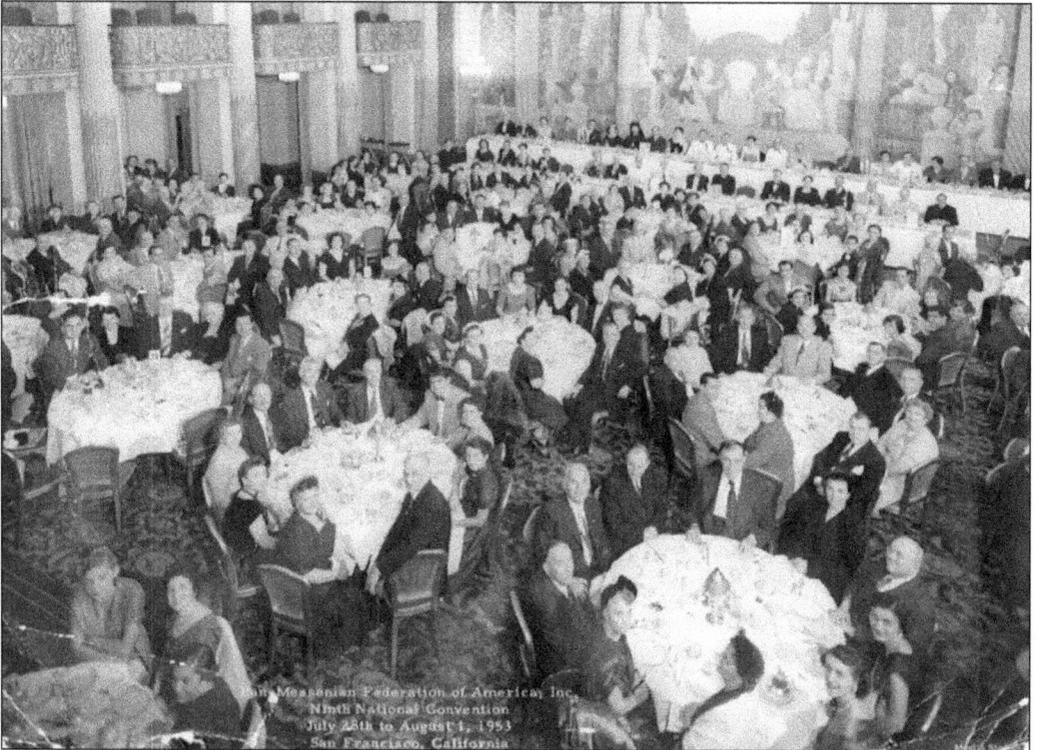

The Ninth National Convention of the Pan-Messinian Federation of America took place between July 28 and August 1, 1953, in San Francisco. The local Messinians of San Francisco and the Bay Area met in 1946 and formed the Navarino Messinian Society, which is a member of this federation. (Photograph by Moulin Studio, courtesy of the Antonia Kaplanis Bach estate.)

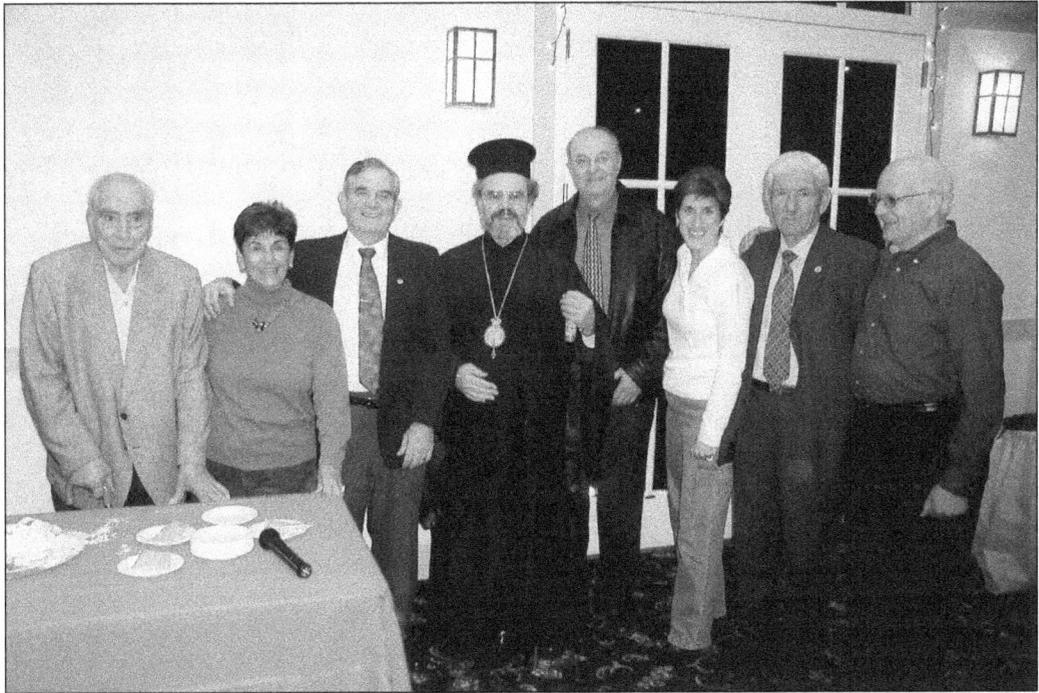

Pictured are past presidents of the Pan Cretan Association of America Epimenides/Ariadne Chapter. The organization contributes to local charities, medical research, scholarship programs, education, and churches. Antonios Kounalakis (second from right) was the recipient of the 2012 Oxi Day Greatest Generation Award for heroic service with the Cretan Resistance freedom fighters, who played an important role in defeating the Axis forces in World War II. (Courtesy of Diane Kounalakis.)

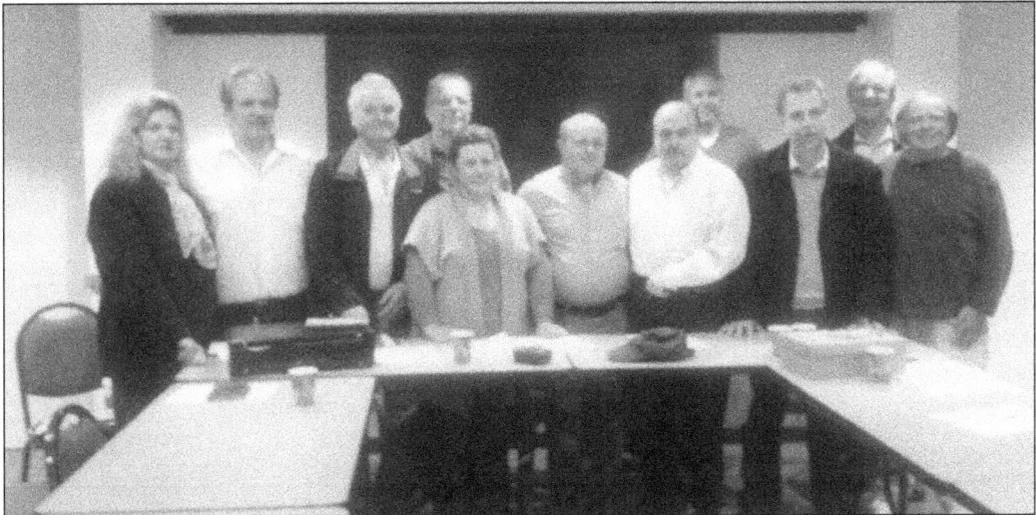

The Zakynthian Brotherhood, founded in 1935, is one of the oldest Greek organizations in the San Francisco Bay Area. Its primary mission was to assist new immigrants from the island of Zakynthos who were confronted with financial hardship during the Great Depression. Currently, the focus of the organization has shifted to charity work locally and in Zakynthos. The board is pictured in 2016. (Courtesy of Zakynthian Brotherhood.)

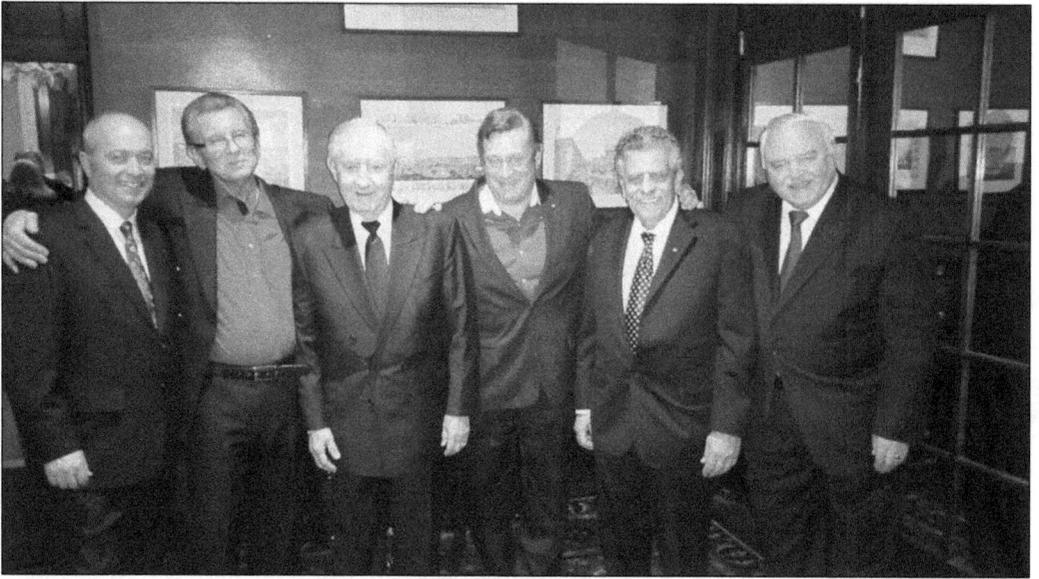

The Elios Society, incorporated in 1995, is a nonprofit organization whose mission is "to preserve and promote the spirit, values and ideals of Hellenic culture and heritage for the benefit of our youth, membership and Greek American community through a process of mutual enlightenment and fellowship." Pictured from left to right are founders John Gumas, George Marcus, Theofanis Economidis, Steve Padis, Dr. Kenneth Frangadakis, and Ted Laliotis. (Courtesy of Elios Society.)

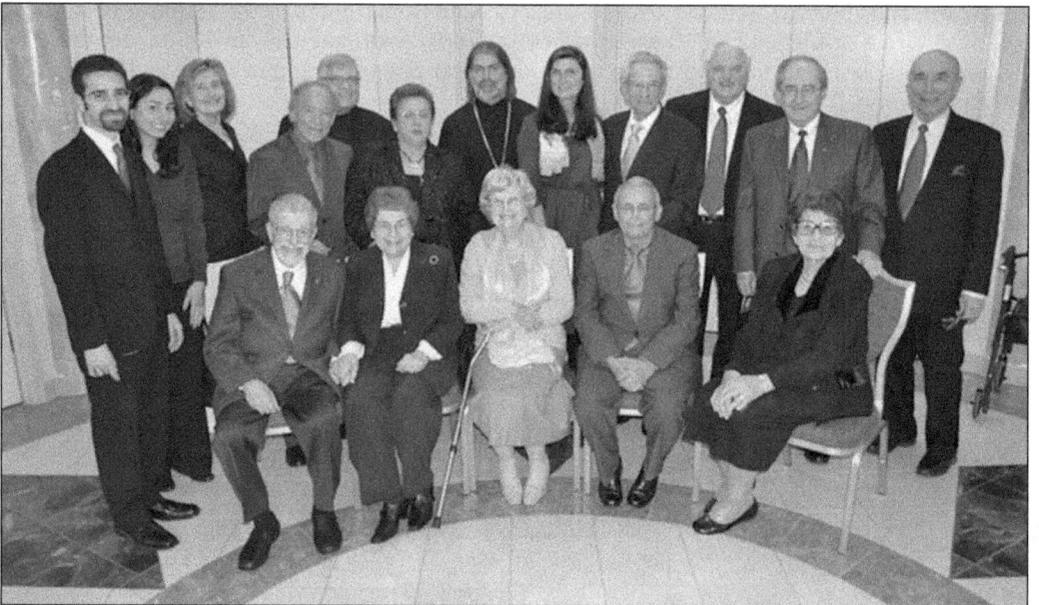

The Hellenic American Professional Society (HAPS) is an organization founded in 1960 to promote educational, cultural, social, and community ties among Greek American professionals in Northern California. HAPS programs include a scholarship program for qualified college or university students of Greek descent and the Axion Award, which acknowledges superior professional accomplishments contributing to the well-being of the Greek American community. Metropolitan Nikitas joins HAPS members in this photograph. (Courtesy of HAPS.)

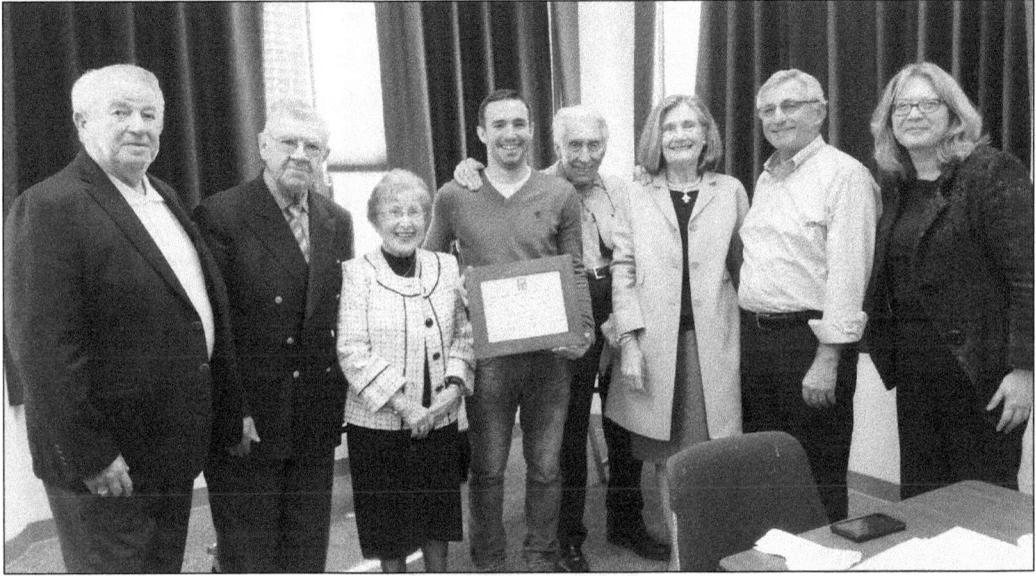

The Modern Greek Studies Foundation benefits the Center for Modern Greek Studies at San Francisco State University. Established in 1981, the center's purpose is to promote the study of modern Greek language, literature, history, and culture in relation to its earlier Hellenic and Byzantine civilizations. Pictured are Executive/Maskaleris Scholarship Committee members, including Prof. Martha Klironomos (far right) and Prof. Thanasis Maskaleris (fourth from right). (Courtesy of Prof. Thanasis Maskaleris.)

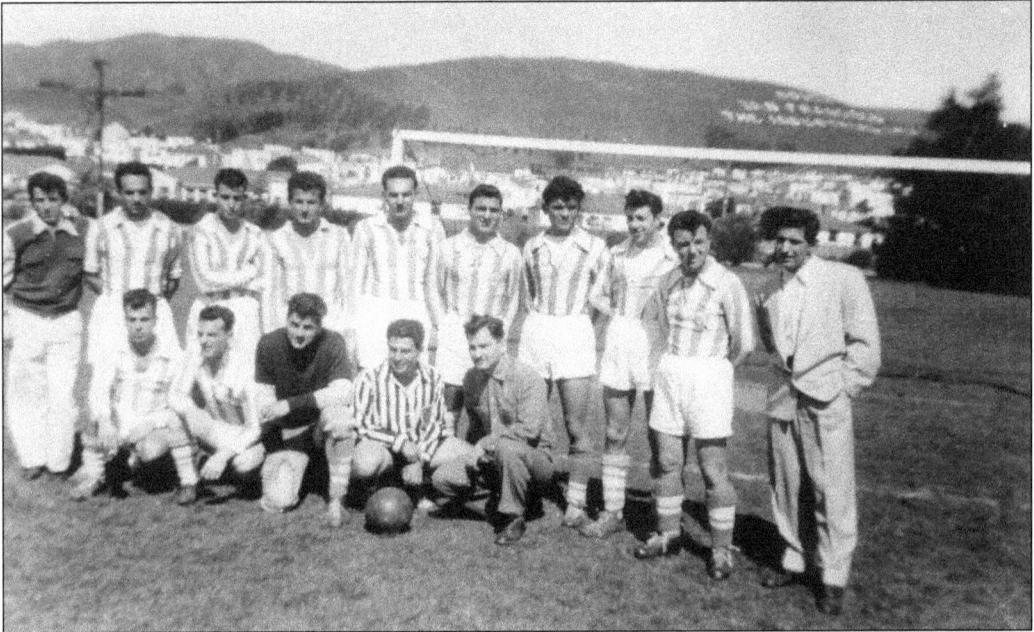

The Greek American Athletic Club was founded in 1949 by brothers John and Jim Rally. In its 56-year history, their soccer team advanced to the US Open Cup Final three times, winning in 1985 and 1994. The club was one of the most successful and prolific soccer teams in the United States, winning numerous local, state, and national championships. (Courtesy of Joan M. Peponis Rinde.)

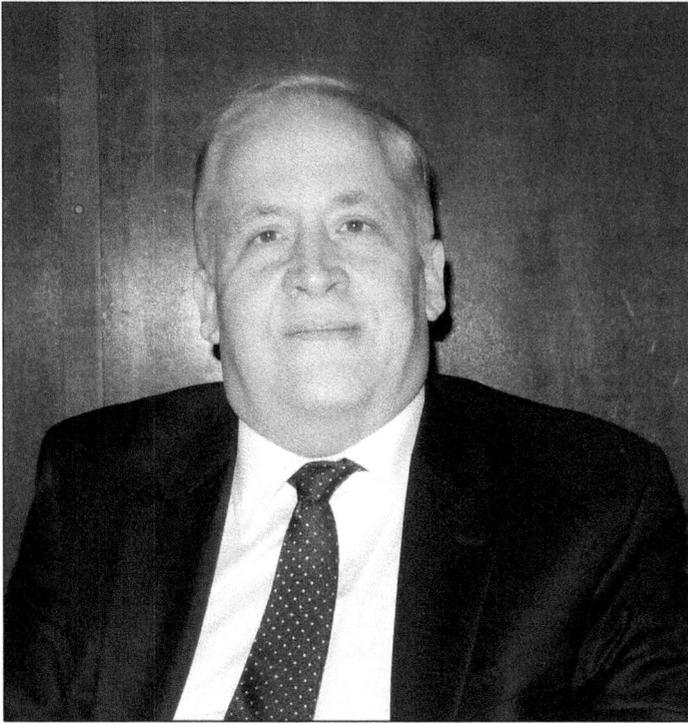

Jim Lucas is the founding president of the Greek Historical Society of the San Francisco Bay Area. He has chaired several Greek organizations, built websites for churches and fundraising drives, started sanfranciscogreeks.com, and manages community list servers. As a San Francisco Greek community historian, he has lectured on various topics and has written many articles regarding the history of the community. (Courtesy of Jim Lucas.)

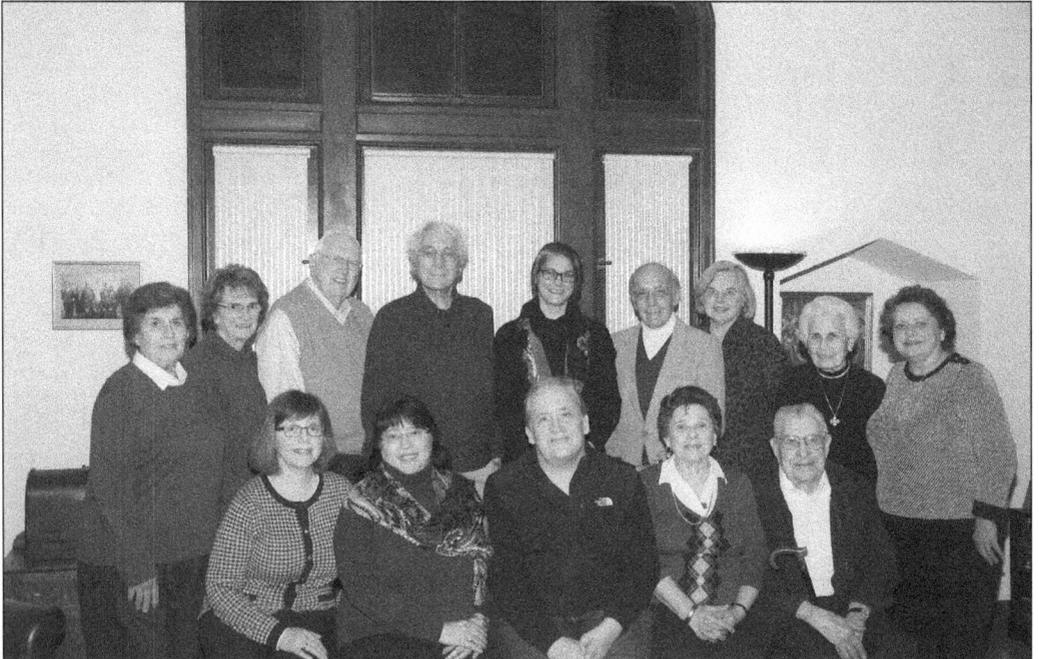

The Greek Historical Society of the San Francisco Bay Area was established in 2011 as a 501(c)(3) nonprofit organization dedicated to the preservation of local Greek history and culture. Its mission is to explore, document, archive, promote, and preserve the history of the Greek people in the San Francisco Bay Area. Pictured are its members with chairman Jim Lucas (first row, center). (Courtesy of the Greek Historical Society of the San Francisco Bay Area.)

Seven

TRADITION AND COMMUNITY

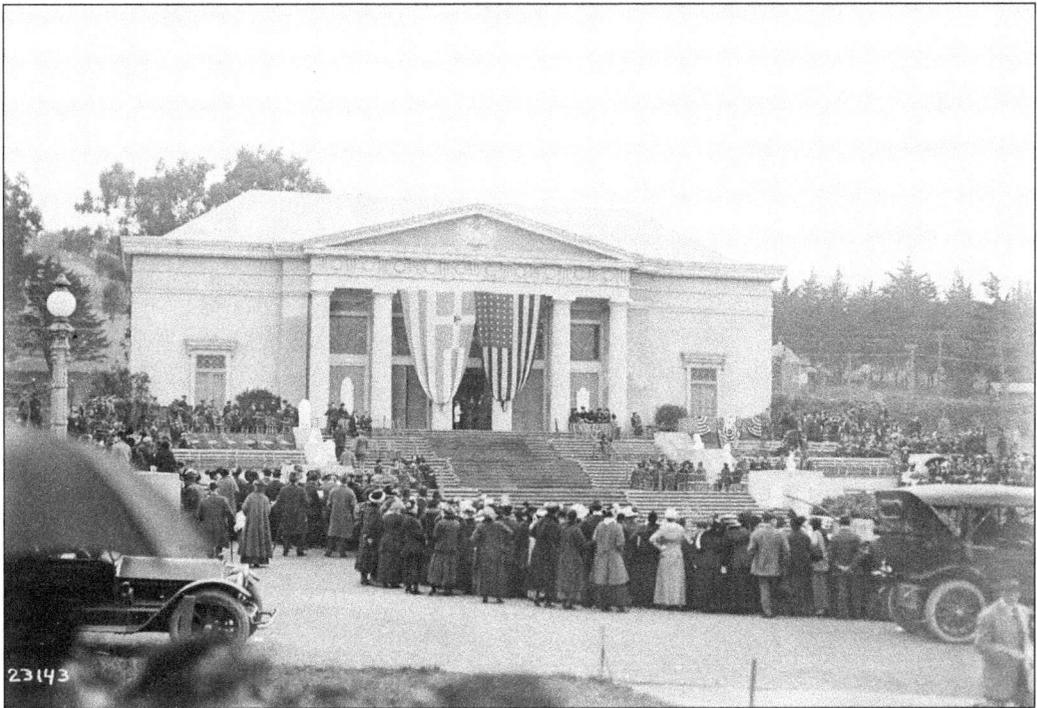

Pictured here is the dedication of the Greek Pavilion at the 1915 Panama-Pacific International Exposition. Prime Minister Eleftherios Venizelos of Greece replied to the invitation to participate with these words, "Your country deserves great credit, as well as the thanks of the world, for having corrected a fault of nature, in its construction of the Panama Canal." (Courtesy of the San Francisco History Room, San Francisco Public Library.)

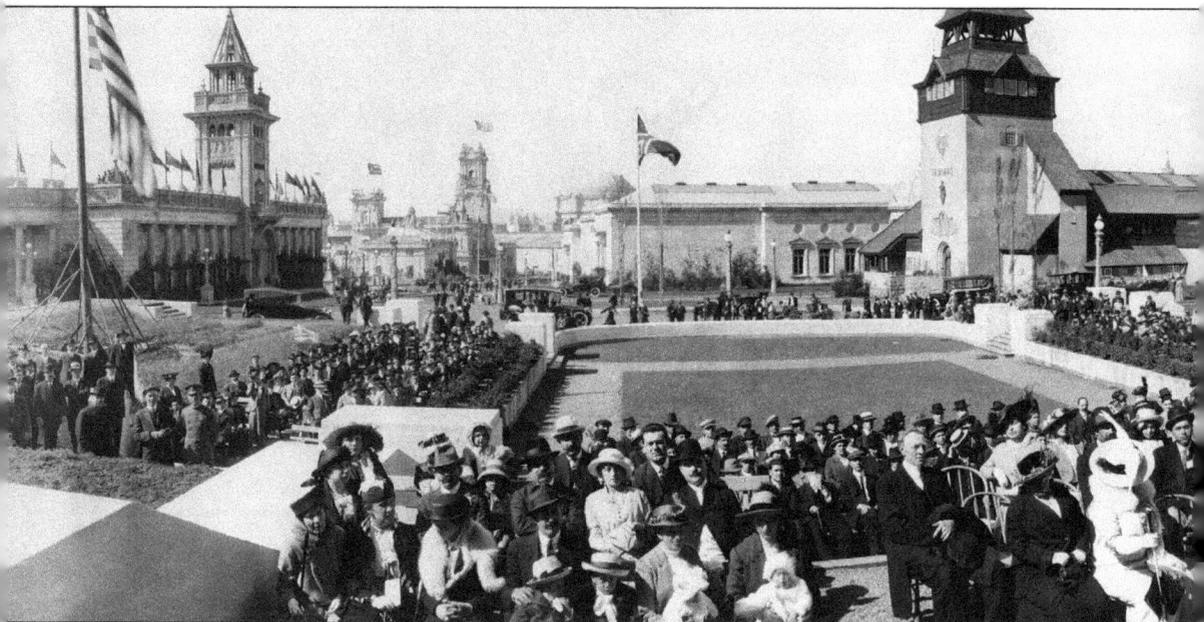

The central figure in this photograph, taken at the dedication of the Greek Pavilion at the Panama-Pacific International Exposition on June 9, 1915, is Fr. Constantine Tsapralis, the first priest to serve at Holy Trinity. To his right is Fr. Kallistos Papageorgopoulos, who also served

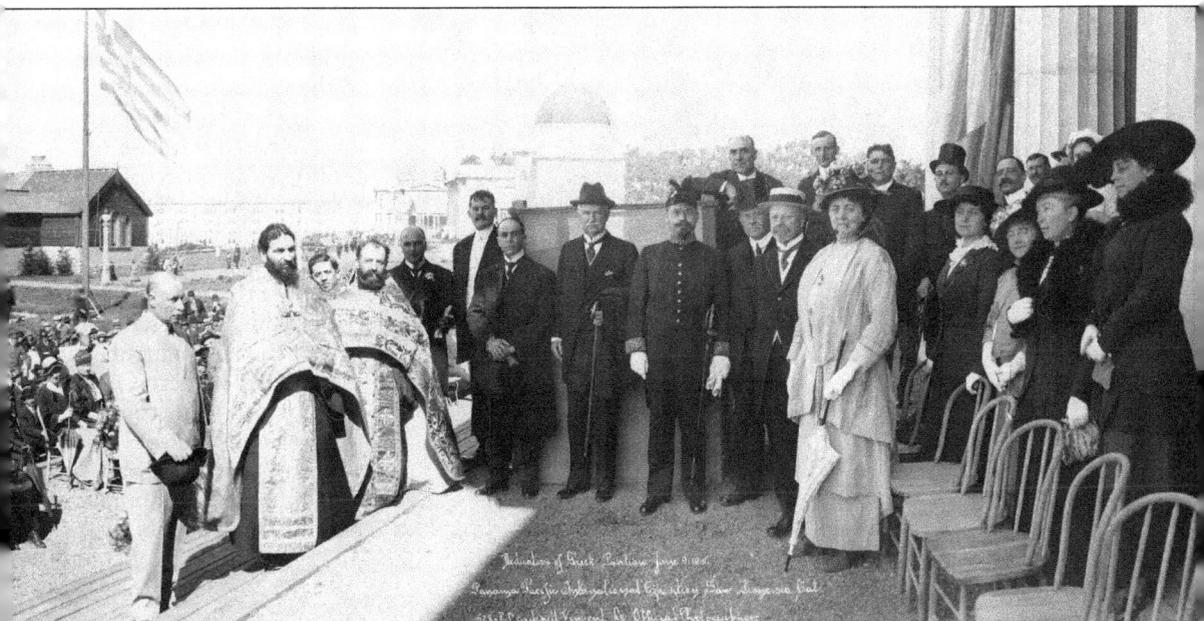

at Holy Trinity between 1910 and 1919. Father Kallistos would become the first bishop of San Francisco in 1927. (Courtesy of Ascension Cathedral Historical Society.)

The Greek Pavilion, located inside the Presidio entrance to the Exposition, was a neoclassical building with a three-tiered staircase leading to a portico of Doric columns and a pediment reminiscent of an ancient Greek temple. The main feature of the interior of the building was a sculpture gallery showing magnificent ancient and modern Greek works of art. (Photograph by Cardinell-Vincent Co., courtesy of the San Francisco History Room, San Francisco Public Library.)

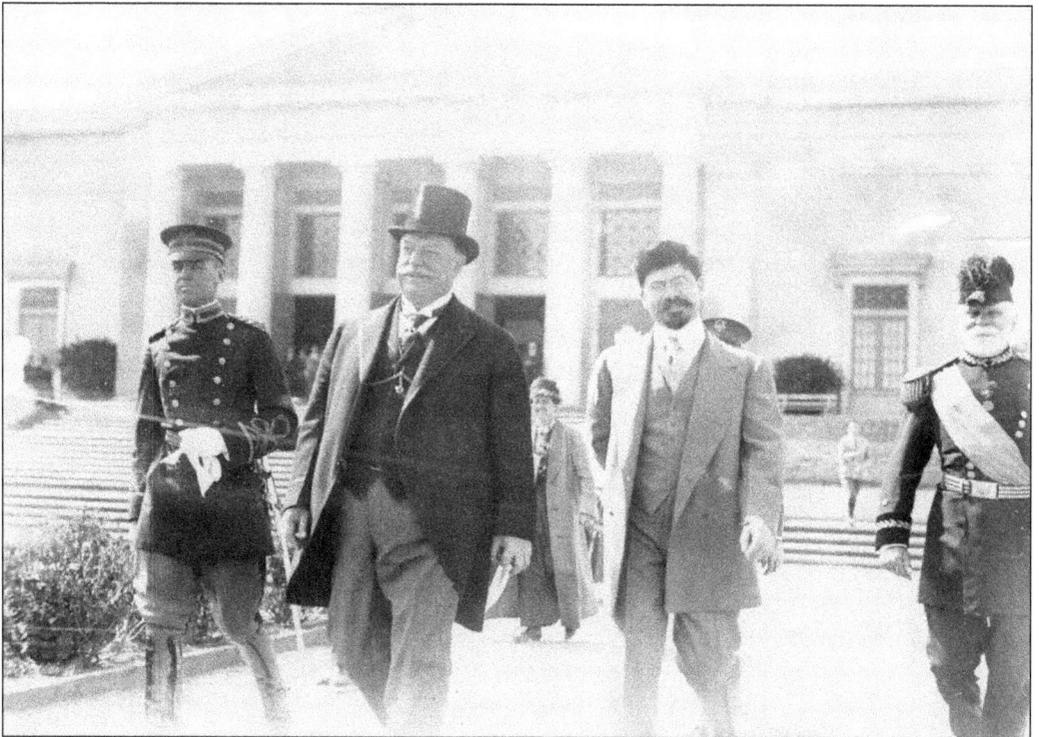

The 27th president of the United States, William Howard Taft (1857–1930), seen here leaving the Greek Pavilion on September 2, 1915, was also a jurist and statesman. He was appointed the 10th chief justice of the US Supreme Court (1921–1930) and is the only person to have presided over both the executive and judicial branches of government. (Courtesy of the San Francisco History Room, San Francisco Public Library.)

Shown here in 1917 is Jim George, born Dimitrios Georgopoulos. He was the son of Panagiotis Georgopoulos, one of Holy Trinity's founders, and Spiridoula Hlebakos. Jim started Pacific Oil & Gas Development Corporation. He purchased 2,000 acres in Sonoma County, creating the George Ranch. He was a benefactor of the Church of the Nativity in Novato and St. Nicholas Ranch and Retreat Center in Dunlap, California. (Courtesy of Peter B. George.)

Easter, 1917, is celebrated with the lamb on the spit at Chiotras Grocery at 858 Rhode Island Street, in Potrero Hill. The grocery was owned by Chris Chiotras. All of those pictured were from Bodia, Arcadia, Greece. Chiotras was an early Greek immigrant, and his grocery store served as a meeting place for fellow villagers from Bodia to help each other find work. (Courtesy of Jim Poulos.)

Pictured at far right is Michael Glafkides, owner of the St. Cloud Market at 164 Sixth Street, at the famous Sutro Baths with his swimming buddies. The Sutro Baths, created by Comstock millionaire Adolph Sutro, opened in 1894 and featured seven swimming pools filled with filtered and heated seawater, a museum, restaurants, tropical plants, promenades, and seating for thousands covered by 100,000 square feet of glass. (Courtesy of Katherine Glafkides Johns.)

Pictured from left to right are (seated) Giorgos Konstantiniadis; (standing) Louis Hontalas (1895–1972), Manolis Konstantiniadis (1885–1967), and Michael Hountalas. Louis opened Louis' Restaurant in 1937 just above the Sutro Baths. Manolis, after a short stay in America, returned to Greece, and in 1919, Michael leased a candy and tobacco stand inside the Car Barn, the western terminus for streetcars at Ocean Beach. (Courtesy of Tom Hontalas.)

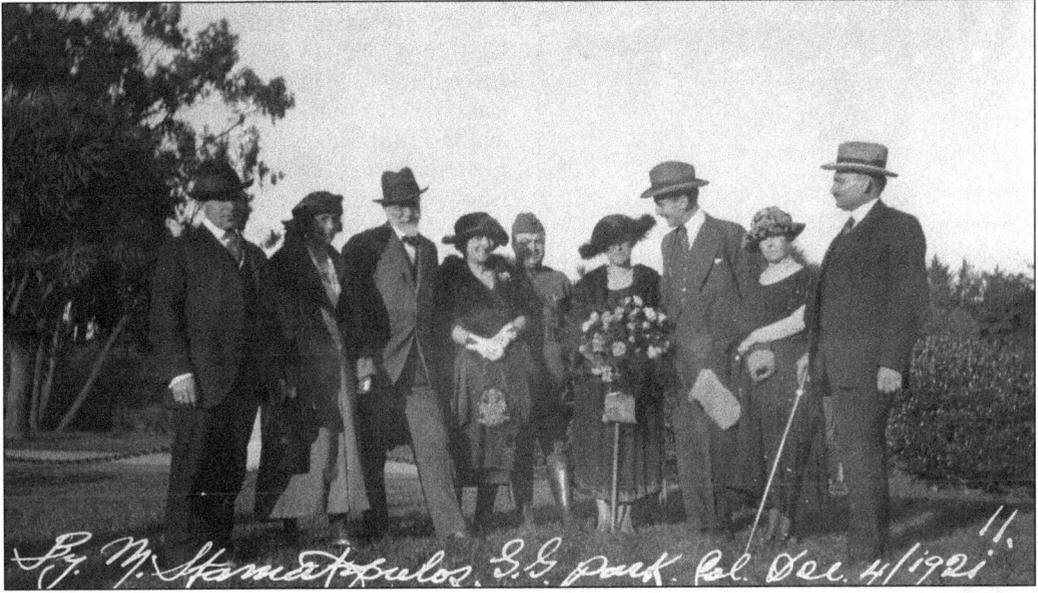

In 1921, former Greek prime minister Eleftherios Venizelos (1864–1936), third from left, visited California with his wife after leaving office. The St. Sophia community (later renamed Annunciation Cathedral) made arrangements to show him Northern California attractions, including Stanford University, the Mount Tamalpais gravity rail line in Mill Valley, and Golden Gate Park. (Courtesy of Art Andreas.)

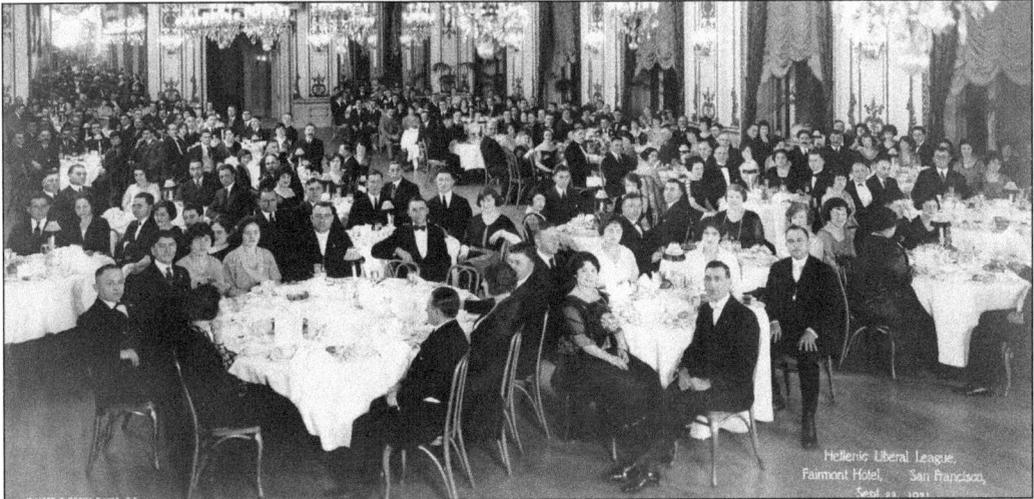

From 1915 to 1925, events in Greece had an impact on all Greek Americans. World War I and the conflict between Royalists and Venizelists created division within the Greek American community. The Hellenic Liberal League was a political and social organization supportive of former prime minister Eleftherios Venizelos. Pictured is the September 22, 1921, gathering of the Hellenic Liberal League at the Fairmont Hotel. (Courtesy of Annunciation Cathedral.)

Peter A. Deligianis operated the London Clothing Company at 42 Perry Street, specializing in men's furnishing goods, and was co-owner of the Calamata Grocery at 285 Third Street. He married Maria Elefteriadis and had two children, Hope (shown in this 1930 photograph) and George. Hope's son, Nick Peters, became a Baseball Hall of Fame award–winning sportswriter. (Courtesy of Lise Peters.)

In this 1936 photograph, taken shortly after they arrived in San Francisco from Sioux City, Iowa, are Tom (sitting) and, standing from left to right, Andrew, Olga, and Harry Banis. Tom owned several restaurants in San Francisco, including the B&K Restaurant, Palm Garden Grill, the Ship Ahoy across from the Orpheum Theater, and most recently, Pier One. (Courtesy of Andy Banis.)

94

This photograph, taken in the 1920s, is of the Meniktas family. From left to right are (seated) Maria (Anna's mother) and Anna (Gus's wife); (standing) Sophia Meniktas and Gus Meniktas. Gus opened the Texas Chili Parlor and served meals to longshoremen on the city's waterfront. He served as president of the Navarino Messinian Society. (Courtesy of Clare Meniktas.)

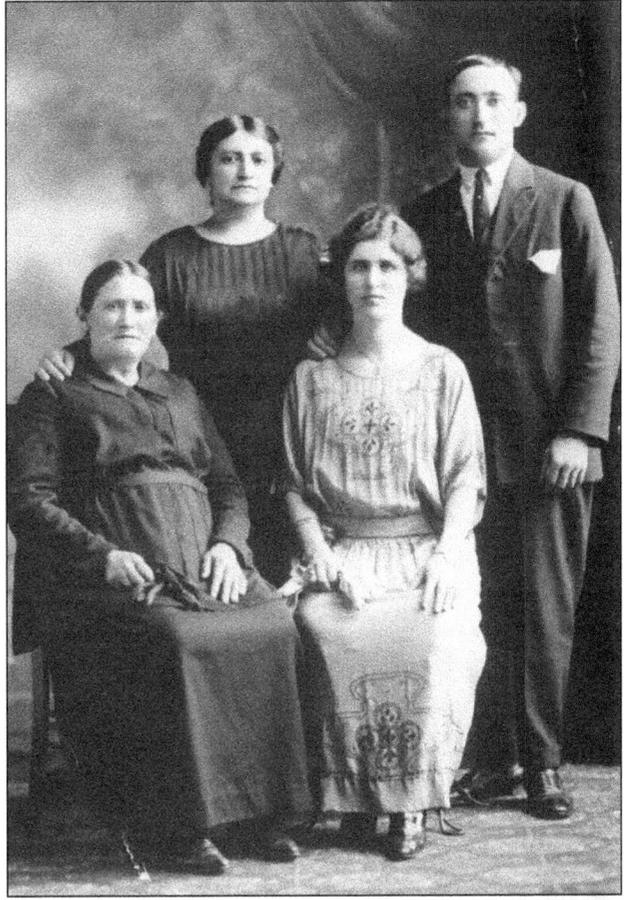

The James Psaltis-Mallary wedding took place February 4, 1923. Fr. Athenagoras Kavadas (1884–1963), second from left in the first row, officiated. Father Kavadas served at Holy Trinity from 1921 to 1927. He was born on the island of Kerkyra, Greece. He became bishop of Boston, dean of Holy Cross School of Theology and, in 1951, archbishop of Thyateira and Great Britain. (Courtesy of the Angelo and Anna Mountanos estate.)

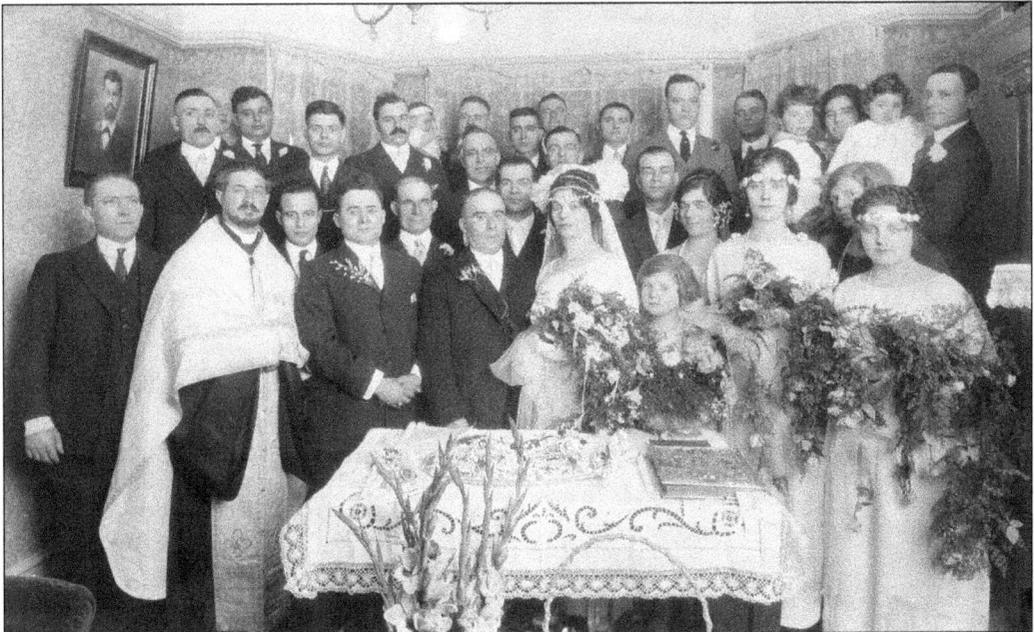

George and Fotini Peponis came from Levidi, Arcadia, Greece. George arrived in San Francisco in 1912. He traveled to Havana, Cuba, in 1929 to marry his picture bride, Fotini, in a civil ceremony. Their religious wedding took place at the old Holy Trinity on July 28, 1929. They lived and raised their three children in the Mission District. (Courtesy of Joan M. Peponis Rinde.)

Vassiliki Paisopoulos (1912–2015), a native of Kandila, Arcadia, Greece, married Michael Hountalas in 1931. Michael had been a part of the Ocean Beach business community since 1906. The couple acquired the Golden Gate View Coffee Shop next to the Sutro Baths in 1952. Their son Dan and his wife, Mary, continue the family tradition and operate the world-famous landmark Cliff House. (Courtesy of the Vassiliki Hountalas estate.)

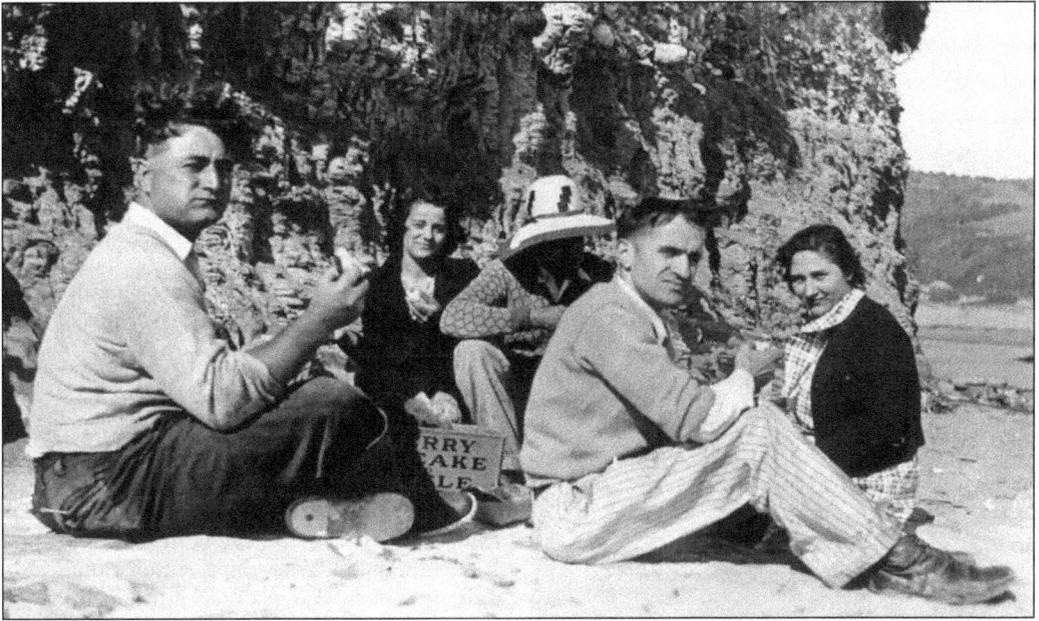

San Francisco's many beaches were a popular weekend destination for San Francisco Greeks to spend a relaxing afternoon. They also explored other beaches like Half Moon Bay to gather mussels and sea urchins. In this 1935 photograph are, from left to right, unidentified, Helen Loizou, Steve Glaros, and Peter and Eva (Gemela) Diaman are enjoying a seaside picnic. (Courtesy of Nikos Diaman.)

John Jerome, a native of Haraka, Greece, was a well-known San Francisco businessman who started an airline commuter service and a detective agency and was a successful strike breaker. He married Daisy Economakis, whose family came from Kyparissi, Lakonia, Greece, in 1937 at Holy Trinity Church. Daisy was known for her philanthropy. (Courtesy of Peter Lekas.)

Pictured are Julia and James Pappas of Pappas Brothers Nursery. It was established in the 1930s by brothers George, James, Bill, and Speros Pappas. They immigrated from Silimna, Arcadia, Greece, in the early 1920s. Starting with a small flower stand, they grew the business to include their nursery on Junipero Serra Boulevard in Colma and a florist shop in the San Francisco Financial District. (Photograph by Fireside Studio, courtesy of Bess Pappas.)

San Francisco's Greek American children, dressed in Greek national costumes in this 1950s photograph, are dancing to honor, remember, and celebrate Greek Independence Day at Civic Auditorium. The start of the Greek War of Independence on March 25, 1821, coincided with the Greek Orthodox Church's commemoration of the Annunciation of the Virgin Mary. (Courtesy of Joan M. Peponis Rinde.)

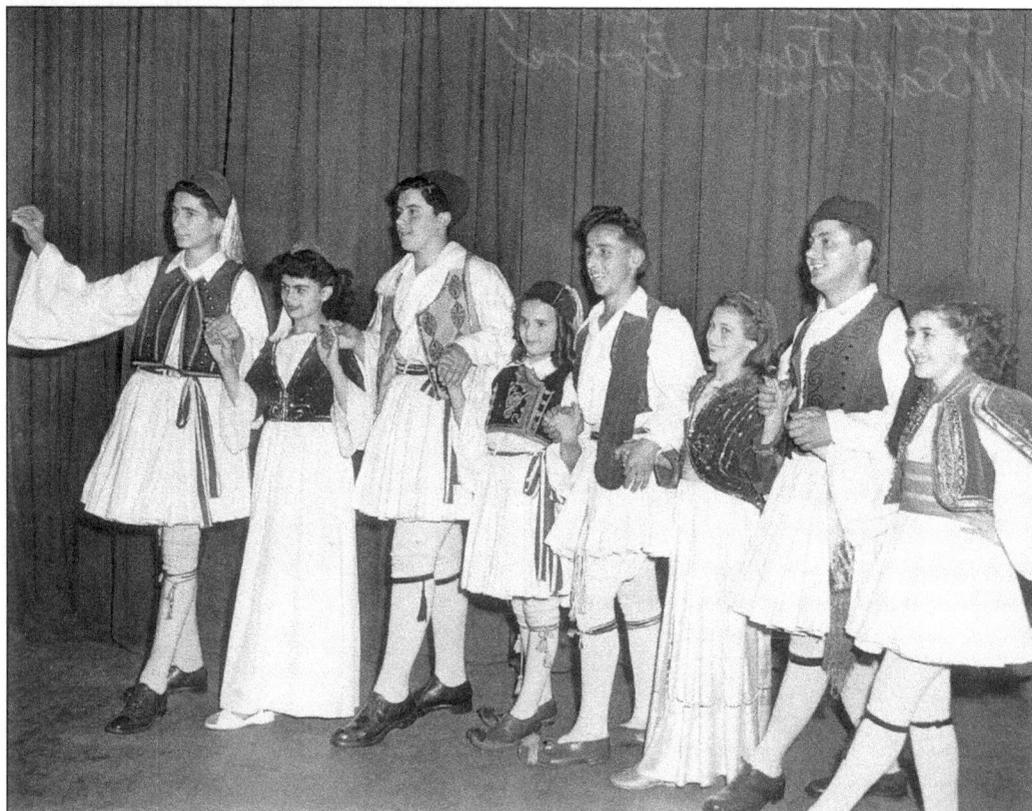

At the 1955 convention of AHEPA in San Francisco, Lou Phillips, president of the Sons of Pericles, is shown here carrying the torch from the steps of city hall as part of a relay of runners set to arrive at St. Ignatius Field, where the track competition of the AHEPA Olympiad was held. The Olympic torch he carried was used in the 1948 London Olympic Games. (Courtesy of John B. Vlahos.)

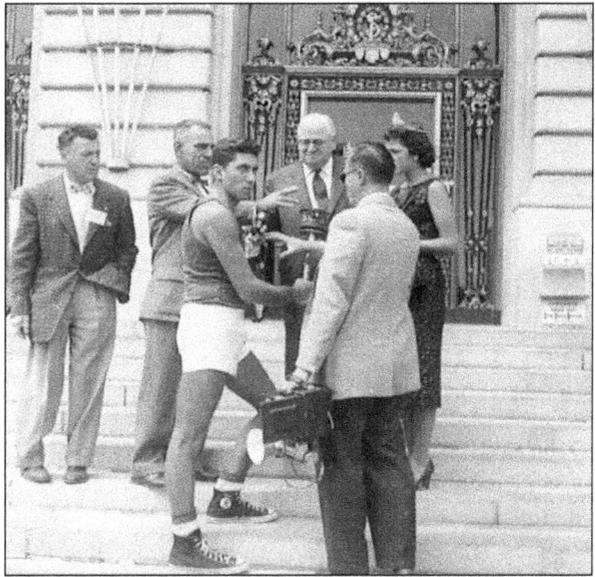

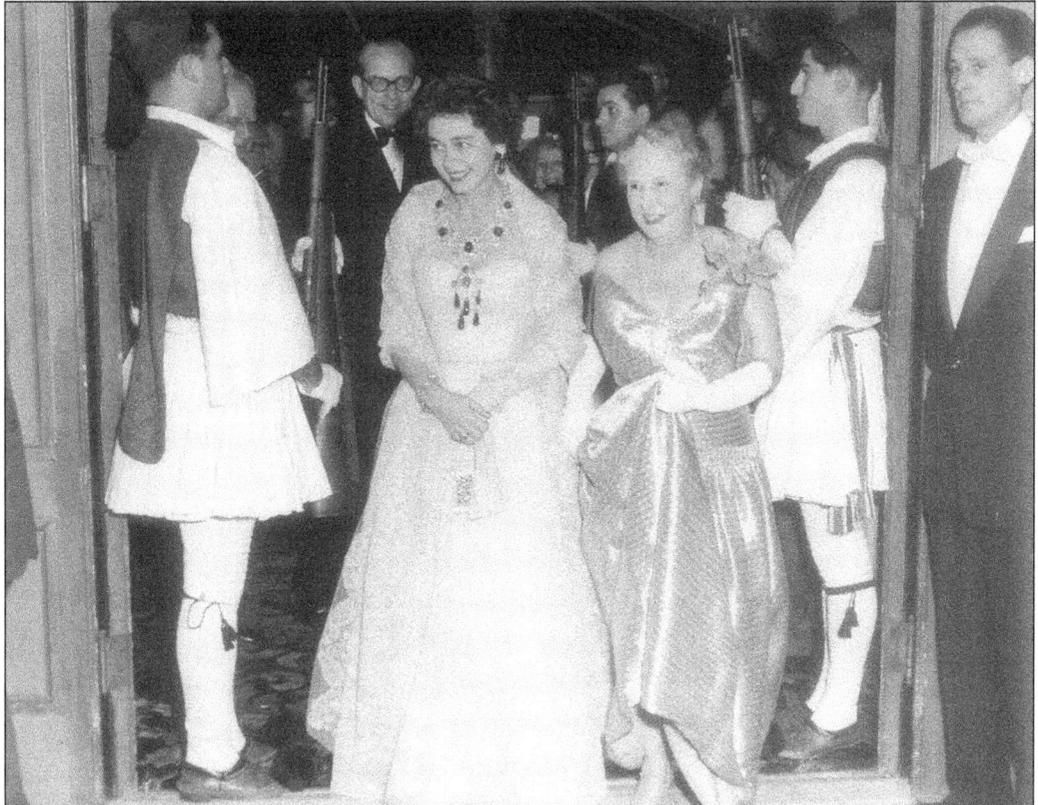

Queen Frederica and King Paul of Greece visited San Francisco in 1953. Pictured are King Paul, (behind the queen), Queen Frederica (left), and Lucretia Grady (right), wife of the former ambassador to Greece. During the queen's 1958 visit, a civic welcome at city hall was followed by a private reception hosted by Mayor George and Tula Christopher at the Palace of the Legion of Honor. (Courtesy of Dorothy Vasiloudis.)

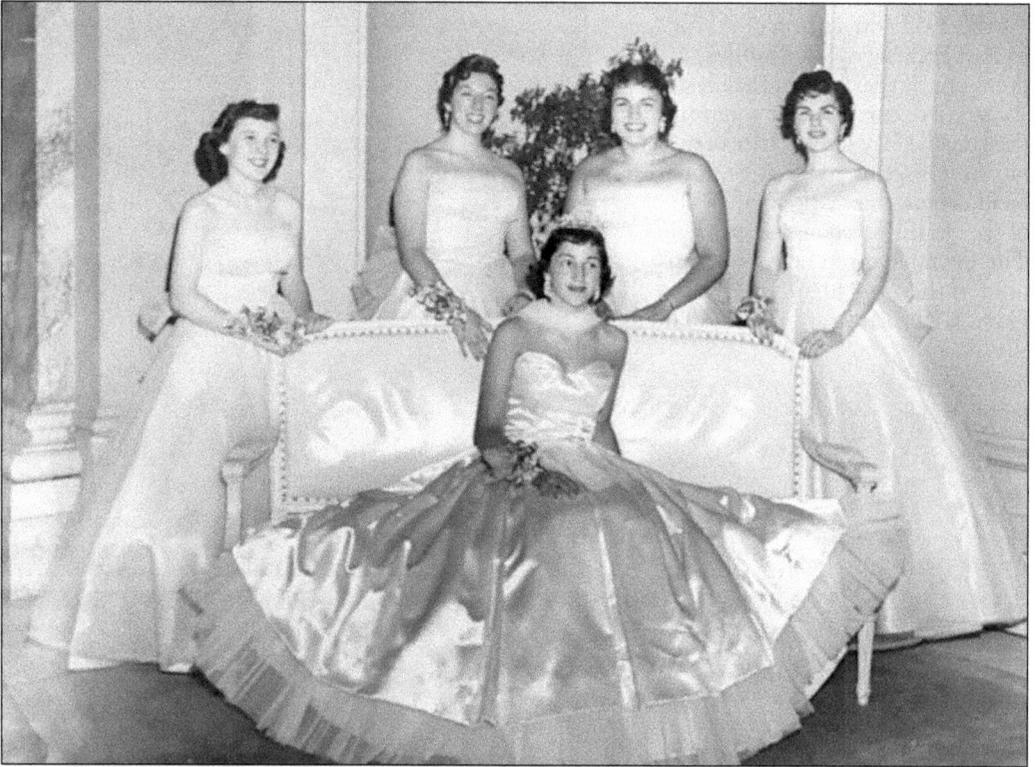

Pictured from left to right are Princesses Lula Tamaras and Elaine Sfaelos, Queen Tasia Vlahos, and Princesses Eugenia Economou and Angie Panagiotakis of the 29th National Convention of AHEPA, held in 1955 in San Francisco. Lula was president of the Maids of Athena, Antigone Chapter No. 95, San Francisco. (Courtesy of John B. Vlahos.)

Marion Hontalas and George P. Parashis were married on June 15, 1963, at the old Holy Trinity Church on Seventh Street, six months prior to the parish moving to the new Holy Trinity Church on Brotherhood Way. Marion served as president of the Daughters of Penelope EOS Chapter No. 1 from 2011 to 2013 and as chairwoman of the board from 2013 to 2015. (Courtesy of Marion Hontalas Parashis.)

Eight

MILITARY AND WARS

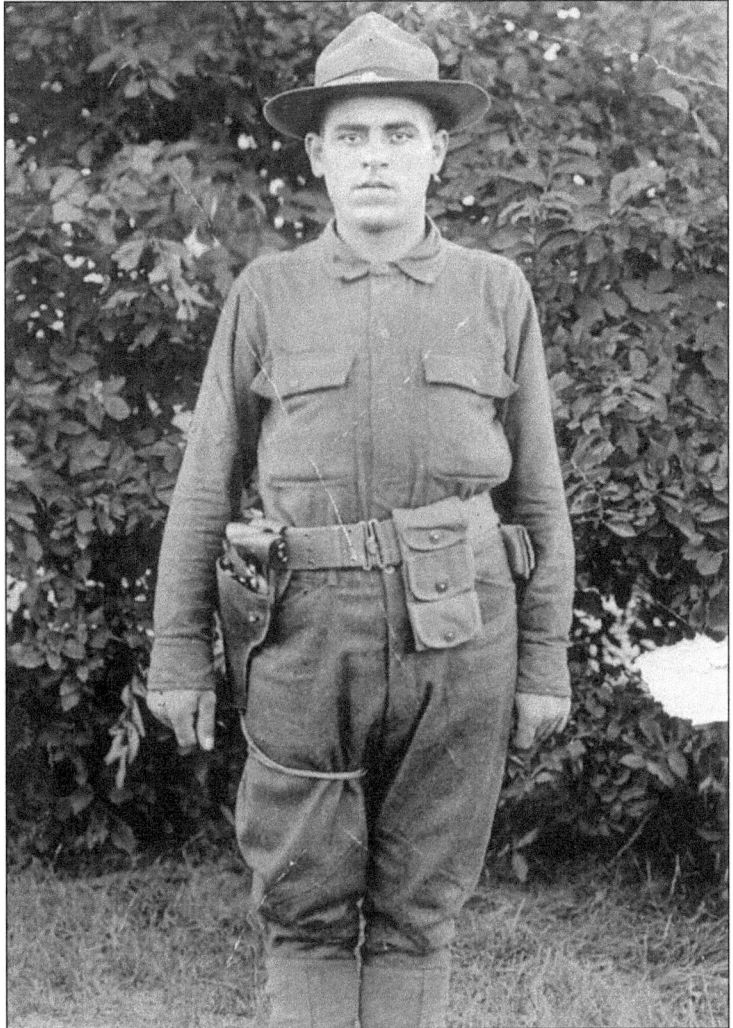

Sgt. Alexander B. Pethenos (1894–1972), a native of Skoupakia, Greece, enlisted in the US Army in 1916 and was assigned to the 2nd Infantry. He fought Pancho Villa in Arizona and, in 1917, was shipped to the Western Front in France. He received the World War I Victory Medal. He settled in San Francisco and was the owner of the Royal Novelty Company. (Courtesy of Sophia Pethenos Fonti.)

Basil P. George (1892–1964), son of Holy Trinity founder Panagiotis Georgopoulos, served in the US Army during World War I. Upon his honorable discharge, he partnered with John Jerome at the Associated Real Estate Company. He started a produce business headquartered in Petaluma supplying grocery stores in Marin, Napa, and Sonoma Counties. He married Chrisafo Kosta, daughter of Alexander Kosta, another Holy Trinity founder. (Courtesy of Peter B. George.)

James Anthony Sperow was born in 1893 on the island of Evvia. One of seven children born to Katherine and Anthony Sperow, he immigrated to America at 17 and enrolled at Heald Business College in San Francisco to learn the English language. He joined the Army, fighting in World War I. This photograph was taken in Germany on July 10, 1919. (Courtesy of Angeliki Sperow-Trujillo.)

Dr. Christos Abramopoulos (1887–1960) immigrated from Sabanaga, Greece, in 1904. He settled in Kansas City, Missouri, earned a pharmacy degree, enrolled in medical school, and graduated in 1913. He enlisted in the Army during World War I and served in a surgical unit in France. After being honorably discharged with the rank of captain, he settled in San Francisco, establishing his practice in the Phelan Building. (Courtesy of Art Andreas.)

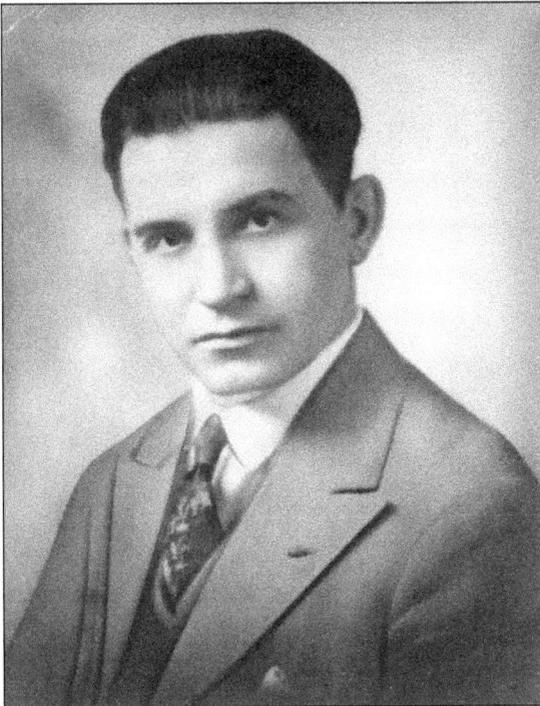

William Lambron (Cleomenis Balopoulos) arrived in San Francisco shortly after the 1906 earthquake. He served in France during World War I and was awarded the French Croix de Guerre and the Silver Star. He saw action at Aisne-Marne, St. Mihiel, Meuse-Argonne, Toulon-Troyon, Marbache, Limey, and Chateau Thierry. He owned the Busy Bee on Bush and Jones Streets during the 1950s. He bought struggling restaurants and revitalized them. (Courtesy of Michael Balopoulos.)

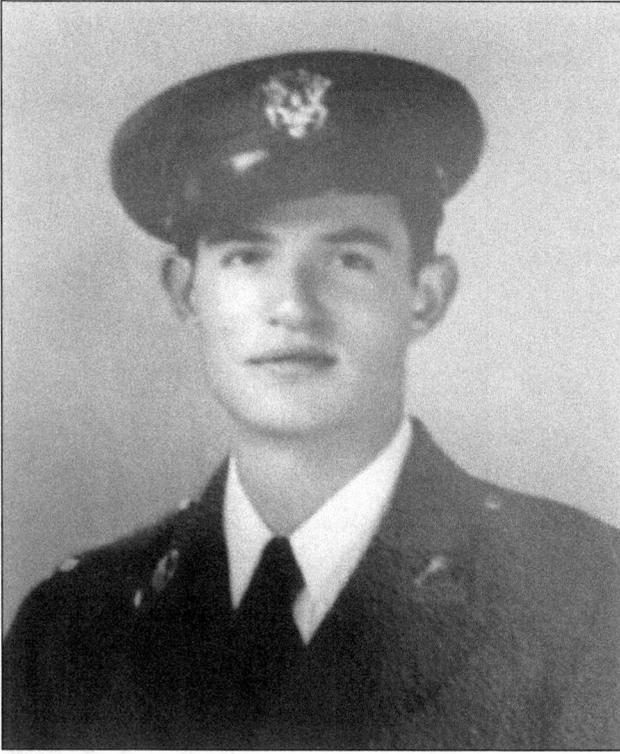

Sgt. Louis Paponis enlisted in the US Army Air Corps civil engineering program at the University of Minnesota in 1942. When the program was dissolved, he was reassigned to the Army's 44th Division as a mortar man in France until he was wounded. He received two Purple Hearts. After recovering from his wounds, he was reassigned to the US Army Air Corps. (Courtesy of Joan M. Peponis Rinde.)

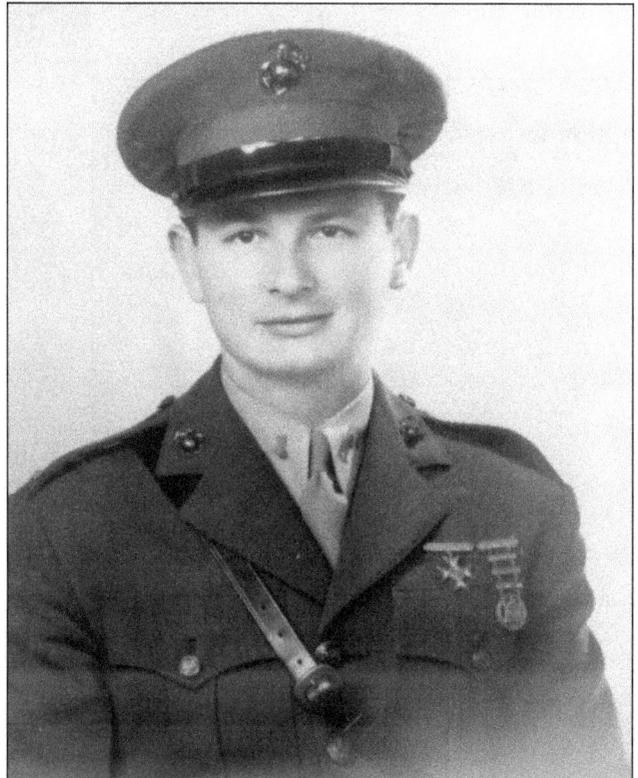

US Marine Corps second lieutenant James Paponis (1921–1997) was a veteran of World War II, seeing action on Guam and Iwo Jima. He received the Bronze Star and advanced through the ranks to retire as a lieutenant colonel in the 3rd Battalion, 9th Marines. He worked for Shell Oil as a senior accountant and was in the Marine Reserves until his death. (Courtesy of Joan M. Peponis Rinde.)

Sotirios "Sut" D. Chalios was a veteran of World War II, having served in the US Navy as a pharmacist's mate. He was injured during a Japanese air raid on Roi Island in the Marshall Islands. He received the Purple Heart from Rear Adm. D.B. Beary, USN, commandant of the Twelfth Naval District. (Courtesy of Mary Chalios.)

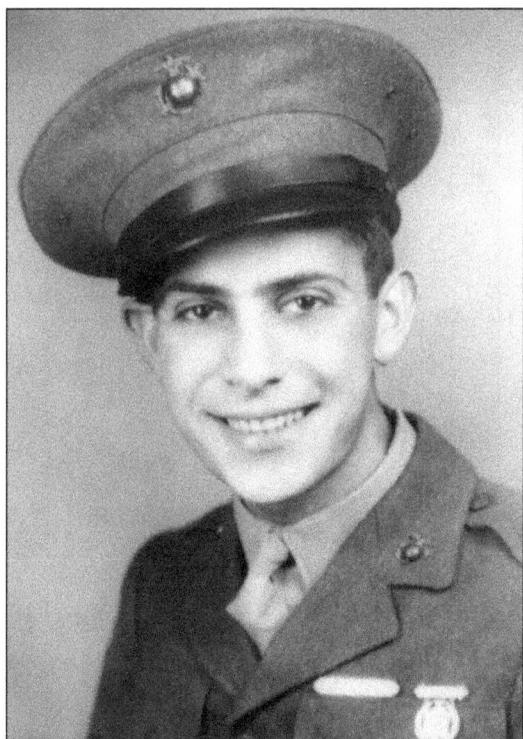

George Samoulides, former Holy Trinity Parish Council president and a veteran of World War II, served as a radio operator in the US Marine Corps from 1944 to 1946 in the Solomon Islands and Okinawa. On April 1, 1945, he landed on the beach in Okinawa with the seventh wave. At the conclusion of the war, he was sent to China's all-year seaport, Qinhuangdao. (Courtesy of George and Artemis Samoulides.)

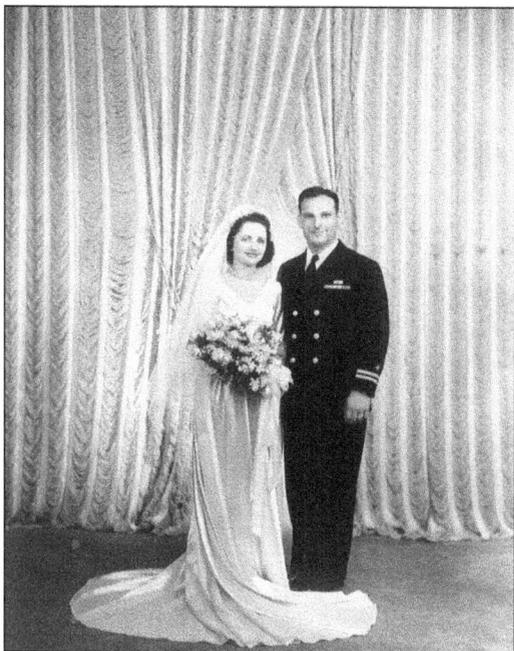

Tony Manuel was born in the Panama Canal Zone. He attended the University of San Francisco and later Northwestern University, where he earned his commission in the US Navy. He participated in the invasion of Normandy on June 6, 1944, and rose to the rank of lieutenant commander by the end of the war. He is pictured here with his bride, Lottie. (Courtesy of Tony Siacotos.)

PFC Arick J. Mathios, pictured with his sisters Sophie (left) and Mitsy, was a combat ranger with the 33rd Infantry Combat Division during World War II. He fought in New Guinea, Malukis Island, and the Philippines. He received the Bronze Star for rescuing a wounded comrade under enemy fire, thus saving his life. He also received the Purple Heart for injuries received during combat. (Courtesy of Marion Hontalas Parashis.)

Euclid Sperow was 22 years old in this 1953 photograph, taken in Yokosuka, Japan. He served during the Korean War as an electrician, third class, on a Navy ship based in Pearl Harbor. The ship patrolled the seas for North Korean mines. He was the only licensed barber on board. Upon returning home, he opened Uke Sperow's Barbershop at Forty-Second and Lawton Streets. (Courtesy of Angeliki Sperow-Trujillo.)

Gus (Konstandinos) T. Varellas joined the US Army in December 1942, as part of the 222nd Infantry Training Battalion. He was a technician, fourth grade. This rank was given to those who possessed specialized skills—in Varellas's case, cooking. He was honorably discharged in October 1945. Gus had previously served in the Greek army (1926–1928) before immigrating to the United States in 1929. (Courtesy of Carol Varellas-Pool.)

Chris Pallas graduated from Balboa High School and joined the US Army Air Corps in 1943. Based in Guam, he served as a radar operator on B-29 Superfortress bombers. After being honorably discharged, he started Pallas Brothers Radio and Television Repairing at 5000 Mission Street. He served as councilman and mayor of San Bruno. He was honored along with his brothers Harry and Ted with a Quilt of Valor. (Courtesy of Ruth Pallas.)

Andrew Pallas (1927–2009) served in the US Navy and then worked as a pressman for the *San Francisco Chronicle* for 40 years. Andrew and his four brothers—Chris, Gus, Harry, and Ted—all served their country in the armed forces with valor. They lived in the Third Street Greek community before moving to the Excelsior District. (Courtesy of Ruth Pallas.)

Gus Pallas (1931–1991) served in the US Army and also attended seminary for two years. He was one of five sons born to Michael and Irene Pallas. All five sons proudly served their country with valor in the armed forces. Michael Pallas owned the Pallas Barber Shop and gave a young George Christopher—the future mayor of San Francisco—his first haircut. (Courtesy of Ruth Pallas.)

Theodore Michael Pallas appeared on the front page of the nation's newspapers in November 1952. Drafted in 1951, Pallas served with the 52nd Field Artillery in Korea until wounded and captured. He was the first US soldier photographed in the war by fellow POW and AP photographer Frank Noel. He was imprisoned at a Yalu River camp on the border of North Korea and China. (Courtesy of Ruth Pallas.)

Helen Julius Ernst served as a lieutenant in the US Navy's Bureau of Aeronautics in Washington, DC (1942–1946). Her husband, Charles, served aboard the carrier USS *Monterey* in the Pacific theater from the Gilberts to the Philippines; the ship and its crew earned 11 battle stars. They are pictured here on their wedding day, December 30, 1944, at San Francisco's Fairmont Hotel. (Courtesy of Peter B. George.)

The occupation of Greece by the Germans in 1941 precluded delivery from the United States of money and supplies, and by the middle of 1941, the war relief drive ended. Some aid reached Greece through the Red Cross. The war relief drive was rekindled in mid-1944, when the German army pulled out of Greece. Pictured here is Tasia Vlahos Misthos carrying packages destined for Greece. (Courtesy of John B. Vlahos.)

Pictured are George Apostolopoulos (left) and George P. Zambukos (1896–1968), a native of Kounoupia, Arcadia, Greece, both of the United Arcadians of San Francisco Chapter No. 35. They participated in a parade to celebrate the end of World War II held at the old Kezar Stadium. (Courtesy of the Helen and Homer Coreris estate.)

Dena (Constandina) Bundros Sarris, born in Lafka, Corinthias, Greece, came to America with her mother, Eleni, in 1937. Dena is pictured in the second row at far left, holding her gift on her last day of work at the California & Hawaiian Sugar Refinery in Crockett, California (December 20, 1945). Dena was one of the first women to work at the refinery, replacing men fighting in World War II. (Courtesy of Joanne Sarris.)

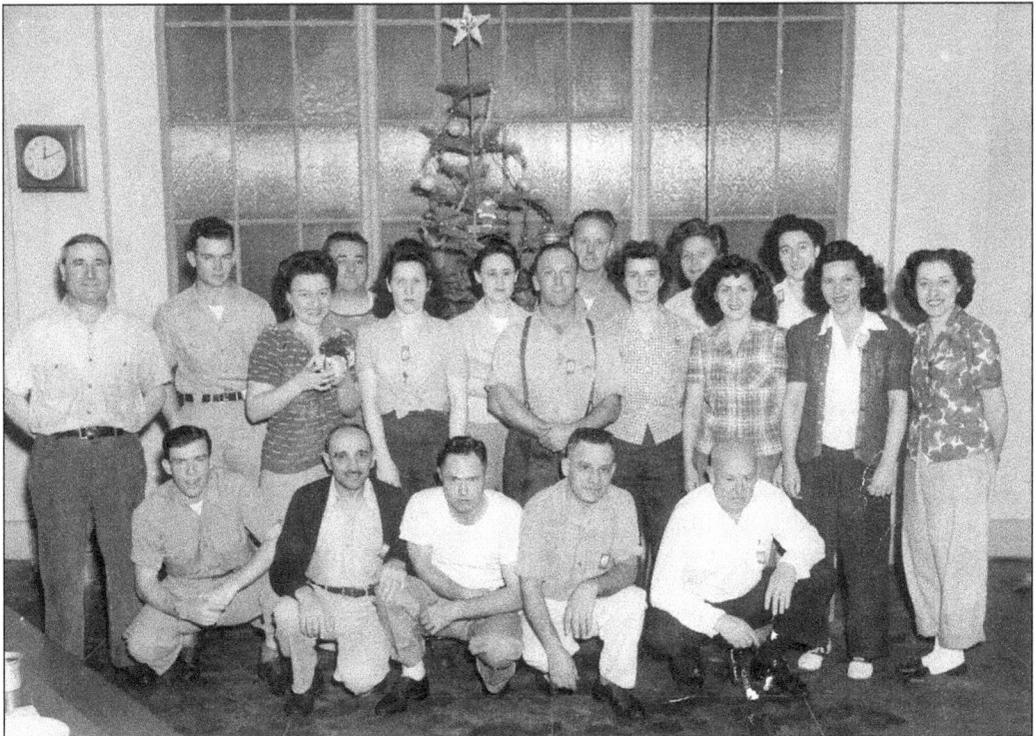

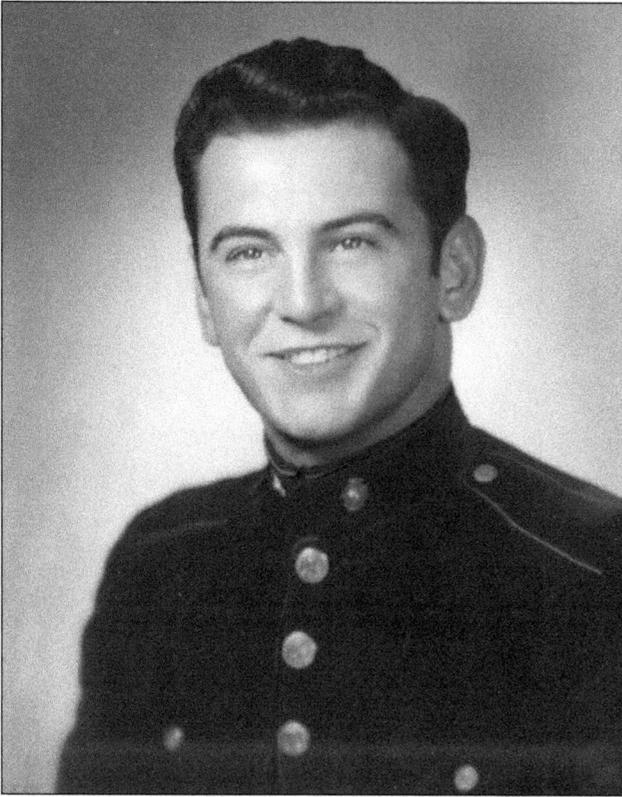

John Siacotos (1930–1998), the son of Charles and Katherine Siacotos, was born and raised in San Francisco. He joined the US Marine Corps following graduation from George Washington High School. After the Korean War, he attended Heald Business College and became an executive with a South Bay printing company. He married Anne Wolfe in 1957 and had two children. (Courtesy of Tony Siacotos.)

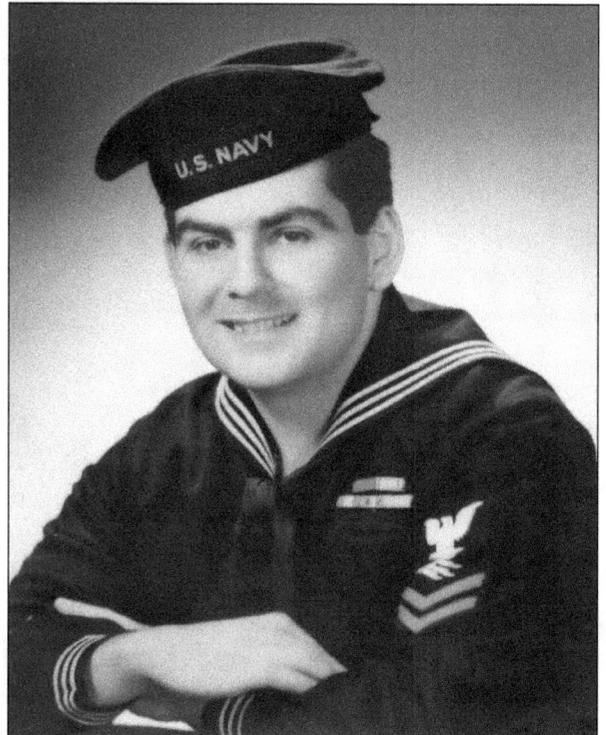

Sam G. Chicos, a veteran of the Korean War, served in the US Navy (1951–1954) as a radioman, first class. His tour of duty included the Far East; Middle East; Mediterranean; Guantanamo Bay, Cuba; and the Panama Canal. He received the Navy Occupation Service Medal, United Nations Service Medal, National Defense Service Medal, Korean Service Medal, and the China Service Medal. (Courtesy of Sam and Mary Chicos.)

John B. Vlahos, born in San Francisco in 1935, graduated from the University of San Francisco (USF) and enlisted in the US Army. Following an honorable discharge from the Army, he attended USF Law School and has practiced law in San Francisco and the peninsula for 35 years with his brother Eugene A. Vlahos. (Courtesy of John B. Vlahos.)

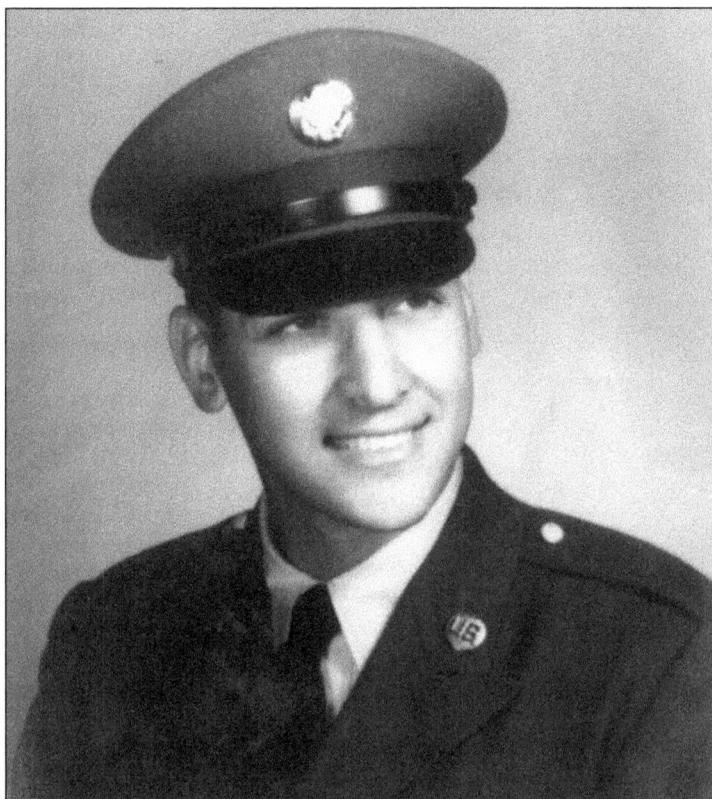

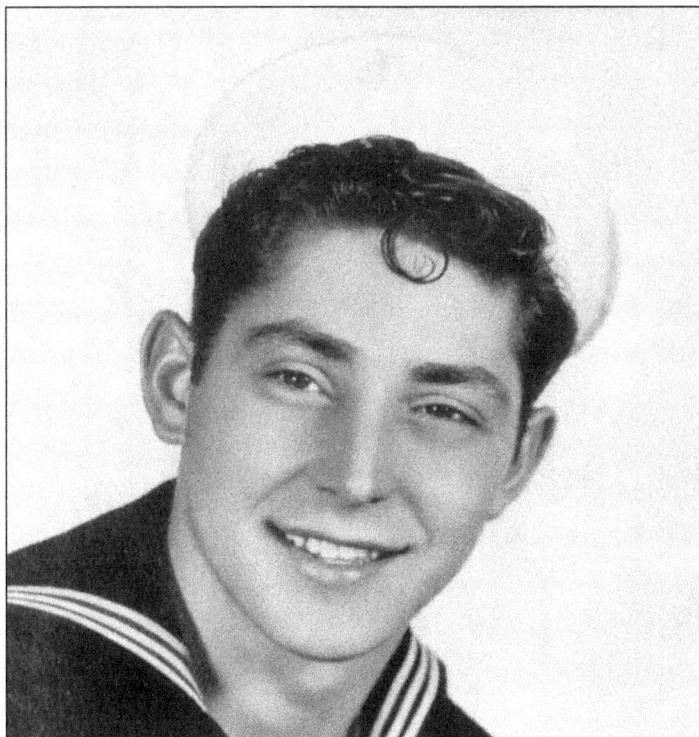

George Vlahos was born in San Francisco in 1936. Upon graduating from Lowell High School, he joined the US Coast Guard and served in Samoa and along the West Coast. Upon his honorable discharge from the service, he started the Food Circus Market on Clay Street and Van Ness Avenue. In 1982, he opened the famous Vlahos Orchard Fruit Stand at Pier 39. (Courtesy of John B. Vlahos.)

Lefty Karkazis served in the US Navy from 1955 to 1957. He was stationed aboard the destroyer USS *Radford*, serving in the Western Pacific and visiting Australia, Hong Kong, China, Midway, Guam, and the Samoan Islands. Upon his honorable discharge, he operated the Geary and Hyde Market (opened in 1947) at 798 Geary Street with his cousin, Gus Kanios, until his retirement in 1998. (Courtesy of Lefty Karkazis.)

Spiros Johnson (lower far right) joined ROTC in high school and upon graduation, he enlisted in the Navy. He transferred to the US Marine Corps, serving as an infantry medic in Okinawa, Japan, and the Philippine Islands (1984–1992). Upon leaving the Marine Corps, he returned to San Francisco and opened Twenty-Fifth & Clement Produce, a small "whole foods" market servicing the Richmond District of San Francisco. (Courtesy of Spiros Johnson.)

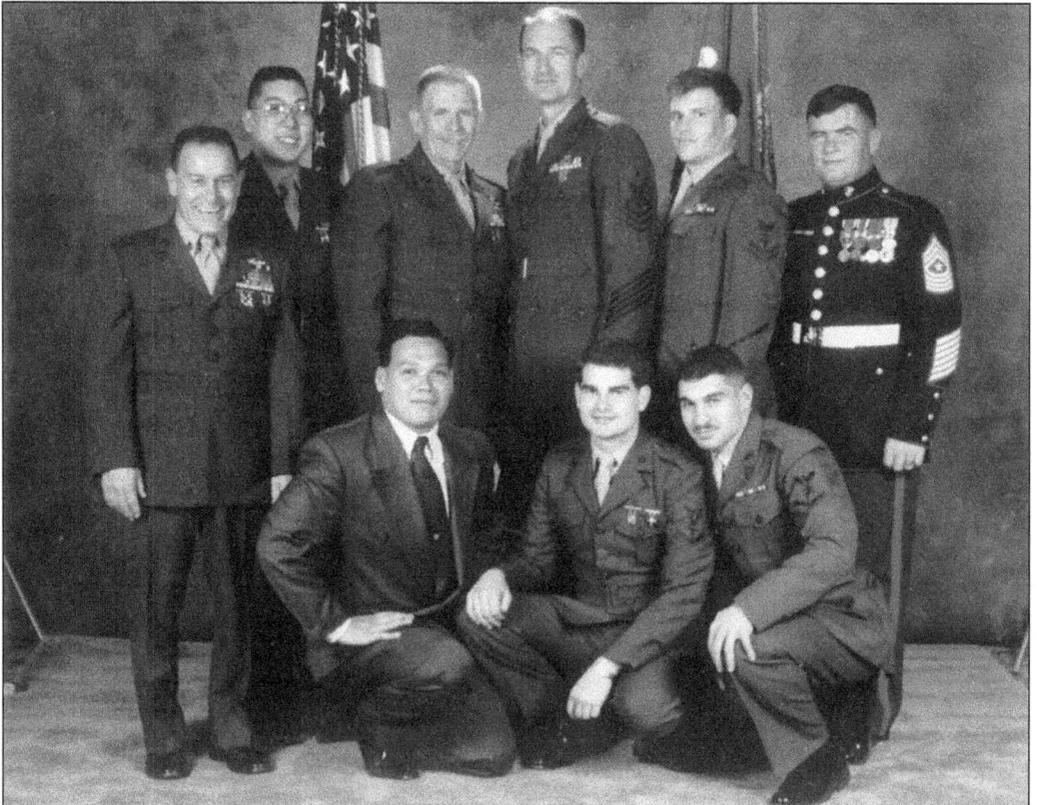

Nine

ARTS, MEDIA, AND ENTERTAINMENT

Virginia George Blight (pictured here in 1934) was born Despoina George (Georgopoulos), one of seven children of Peter George and Spiridoula Hlebakos. The George family had immigrated from Kyparissia, Greece, and Peter George was one of the founding members of Holy Trinity Church. Virginia became an accomplished businesswoman and award-winning artist. (Courtesy of Peter B. George.)

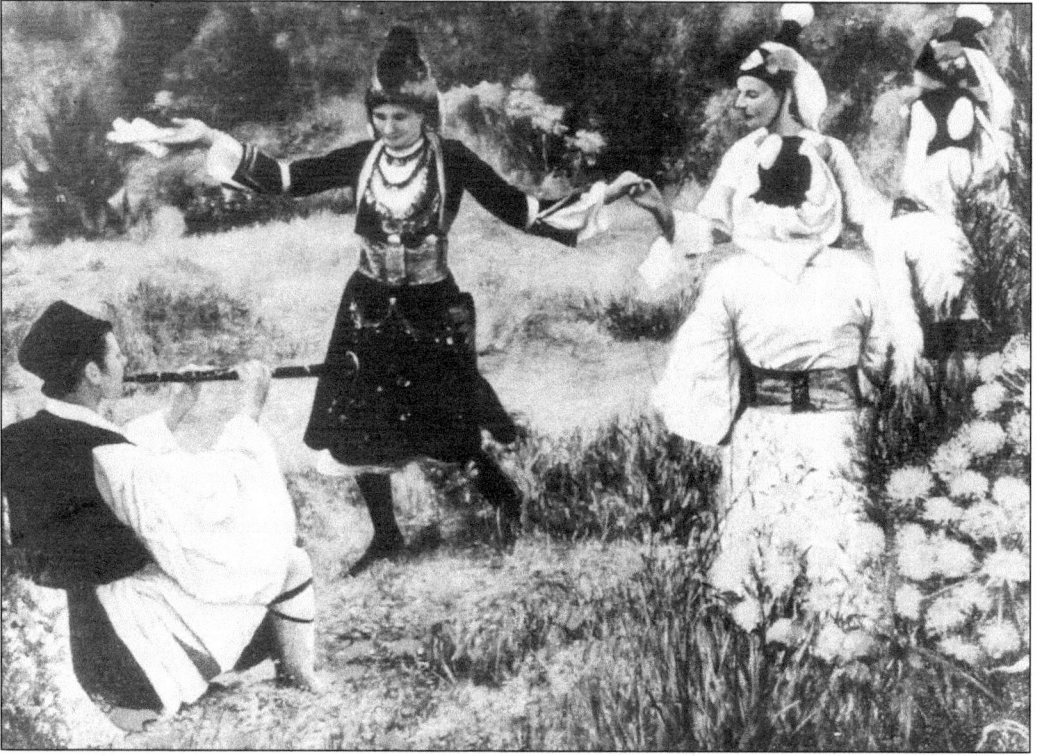

Gracia Bovis, a native of British Columbia, Canada, began her artistic career by studying fashion design in Toronto. She became an award-winning designer in British Columbia and continued her art education at San Francisco's Art Academy and with established artists throughout the Bay Area. Her work has been widely exhibited and earned many awards. (Courtesy of Gracia Bovis.)

Writer, artist, and videographer N.A. Diaman (Nikos Diamantides) was born in San Francisco on November 1, 1936, and has lived in the city most of his life. He is the author of 10 books published by Persona Press. *Athens Apartment*, a travel memoir, came out in 2009. (Courtesy of Nikos Diaman.)

In commemoration of the 60th anniversary of their founding in San Francisco, the Daughters of Penelope presented the M.H. de Young Museum with the Franklin Simmons statue *Penelope* on November 16, 1990. It is one of the finest examples of American neoclassical sculpture. Pictured is Mary Chicos (left), national chair of the 60th Anniversary Commemoration, and Alexandra Apostolides, founder of the Daughters of Penelope. (Courtesy of Mary Chicos.)

San Francisco Ballet's artistic director, Helgi Tomasson, is pictured with former San Francisco Ballet director of public relations Diane Kounalakis. A native San Franciscan, Diane worked with San Francisco Ballet from 1988 to 2001. She traveled extensively with San Francisco Ballet and helped grow it from a regional ballet company to one of the world's most renowned. Kounalakis is also active in the Epimenides/Ariadne Chapter of the Pan Cretan Association of America. (Courtesy of Diane Kounalakis.)

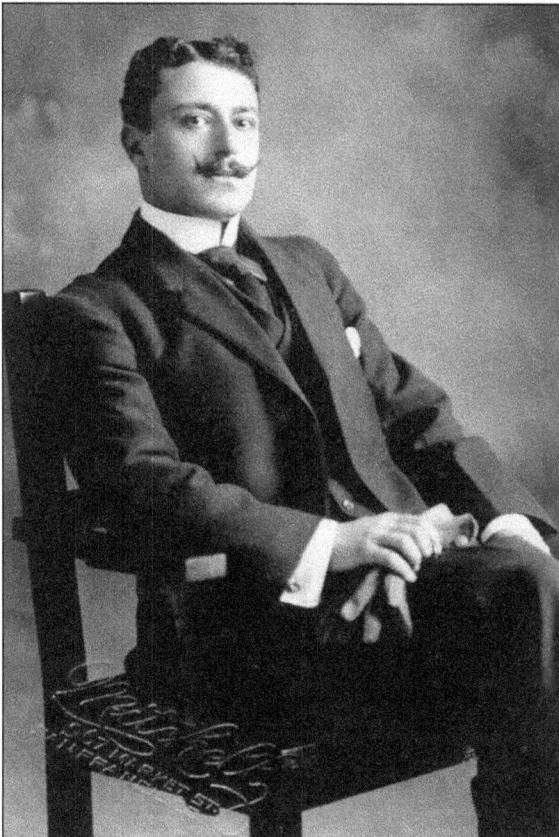

John Kosmas Skinas, a native San Franciscan born to Messinian immigrant parents, considers the greatest gift of his heritage to be the Orthodox faith. He writes books that help families embrace "the one needful thing." His publications include *Pictures of God: A Child's Guide to Understanding Icons*, *From God to You: The Icon's Journey to Your Heart*, and *Heaven Meets Earth: Celebrating Pascha and the Twelve Feasts*. (Courtesy of John Skinas.)

Alexander Pavellas, shown here in 1916, was a native of Nafplion, Greece. He came to San Francisco prior to the 1906 earthquake and fire, and he cofounded *Eirenikos*, the first Greek-language newspaper in San Francisco. He later cofounded a second newspaper, *Prometheus*, served as Greek consul, and presided over many local Greek community events. (Courtesy of Ron Pavellas.)

Anastasios B. Mountanos (1880–1966), a veteran of the Greco-Turkish War of 1897, immigrated from Mani, Greece, in 1906. After working in Washington, DC, and Houston, he arrived in San Francisco in 1907. He took over the publication of the *California* newspaper and operated it until it was sold to new owners in 1945. During the 1920s, he traveled the country in a Model T, soliciting advertisements and subscriptions. (Courtesy of the Angelo and Anna Mountanos estate.)

The *California*, founded by Basil Alonistiotis, George Chapralis, and Basil Rubogianois, was the second-oldest Greek-language newspaper in San Francisco. It was taken over by Anastasios B. Mountanos in 1907. The business was originally located at 340 Third Street (in this photograph) and later moved to 266–268 Third Street. The gentleman at the far right is George Meletis. (Courtesy of George and Sophia Fonti.)

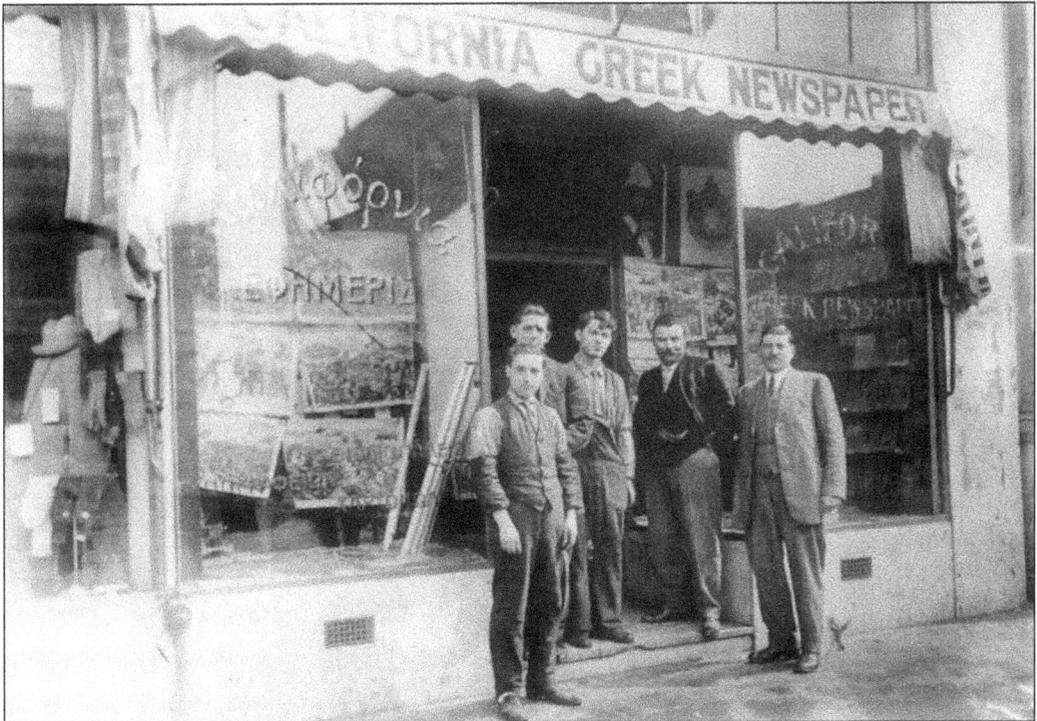

The *Pacific Coast Review*, published by Angelo Papoulias, was the definitive business magazine for those in the food, grocery, and beverage industry. Its offices were located at 43 Cleveland Street. Papoulias immigrated from Kalavrita, Greece. Greek businesses frequently advertised in the *Pacific Coast Review*. The magazine also featured articles about Greece and Greek food products. (Courtesy of Dorothy Vasiloudis.)

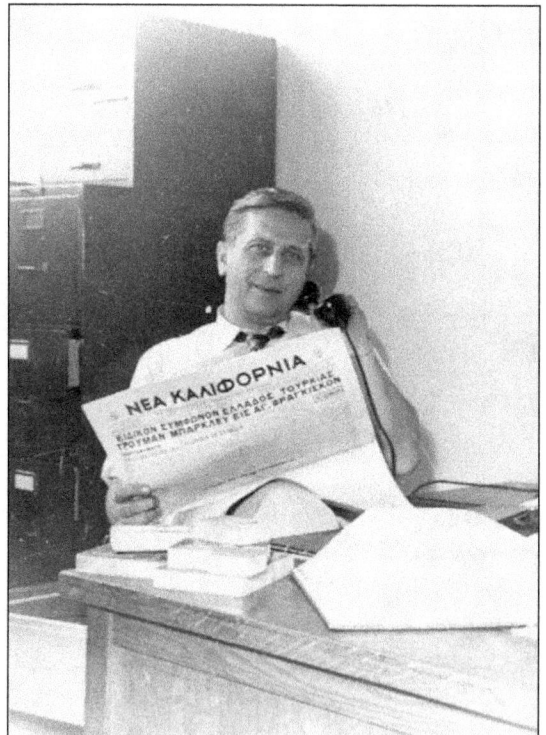

The *California*, a Greek-language newspaper, was founded in 1907. The newspaper was sold in 1945 and changed its name to the *Nea California*. Ted Kaplanis, pictured here in the offices of the newspaper, wrote many insightful articles about the Greek community, news, and events and was highly regarded by the Greek community. (Courtesy of the Antonia Kaplanis Bach estate.)

After serving as a captain in the US Army in World War II, Frank P. Agnost (1918–2000) became assistant to Charles Thieriot, publisher of the *San Francisco Chronicle*. He was appointed welfare commissioner by San Francisco mayor Elmer Robinson (who served from 1948–1956). In 1961, he opened Falcon Associates, Inc., a public relations, graphic design, and printing company. In 1975, he founded, published, and edited the *Hellenic Journal*. (Courtesy of Adrienne Verreos.)

Savas D. Deligiorgis, a native of Drama, Greece, arrived in San Francisco as a member of the Greek diplomatic corps. In 1965, he became proprietor of Hellenic American Imports at 2365 Mission Street and started a daily radio broadcast for the Greek community of Northern California, now in its 50th year. Deligiorgis is pictured interviewing Archbishop Makarios, the first president of the Republic of Cyprus. (Courtesy of Savas D. Deligiorgis.)

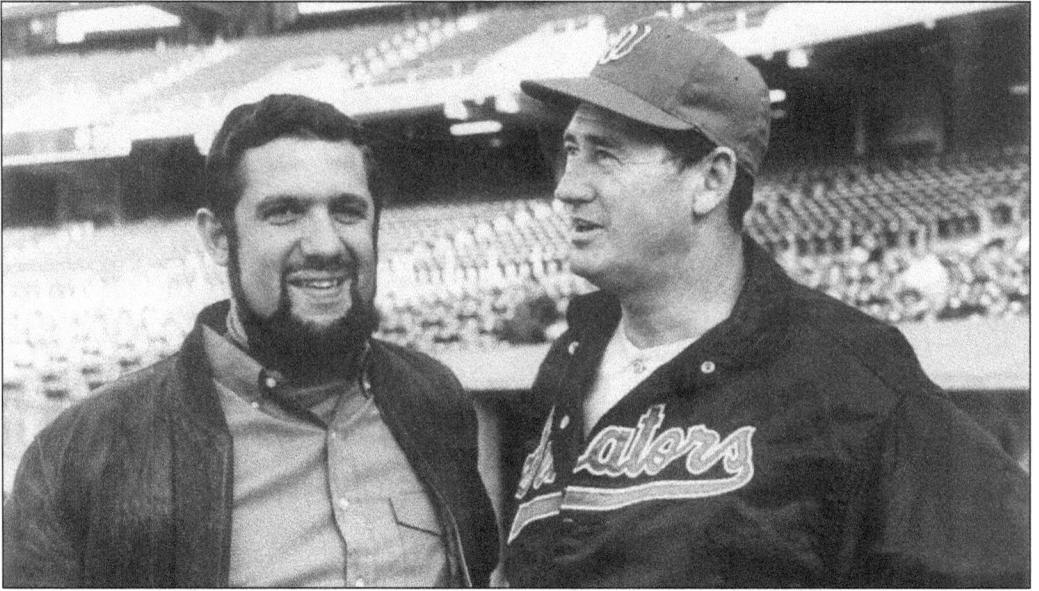

Pictured on the left is Nick "The Greek" Peters (1939–2015), the Hall of Fame baseball writer, with Hall of Fame baseball player Ted Williams of the Boston Red Sox. Peters, a native San Franciscan, graduated from San Jose State University, and spent the majority of his career covering nearly 5,000 Giants games for the *Oakland Tribune*, the *Sacramento Bee*, the *Berkeley Gazette*, and the *San Francisco Chronicle*. (Courtesy of Lise Peters.)

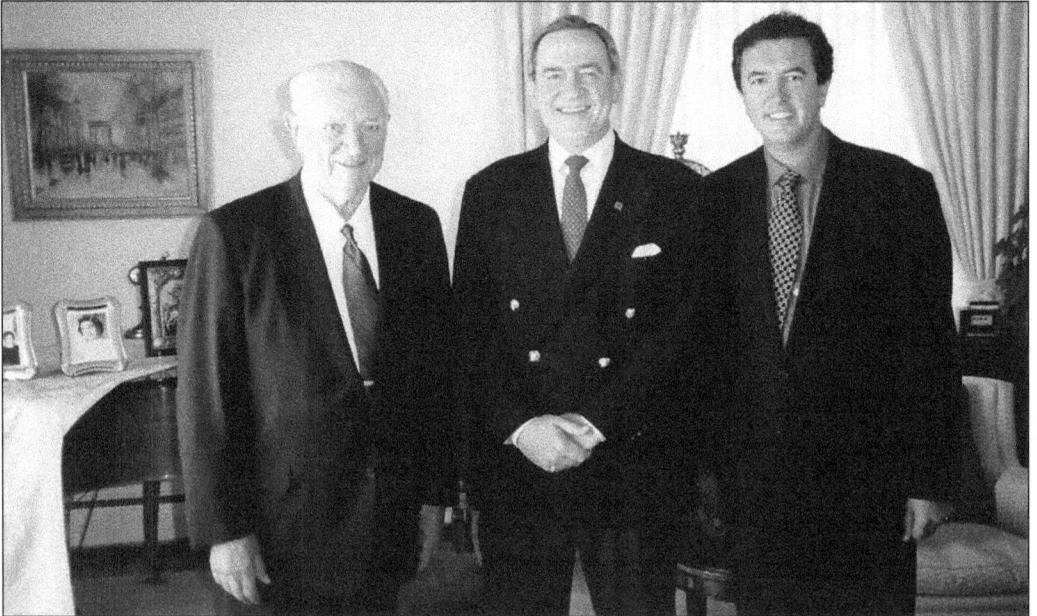

For 25 years, Dimitri Carapanos owned, produced, and hosted *Greek TV*, a weekly Northern California television program and one of the longest running ethnic TV shows in the United States. He is founder and chief executive officer of GreekTV.com, which serves the world online. The website offers a fresh, progressive perspective of Hellenism today. He is pictured here with former mayor George Christopher (left) and former king of Greece Constantine II (center). (Courtesy of Dimitri Carapanos.)

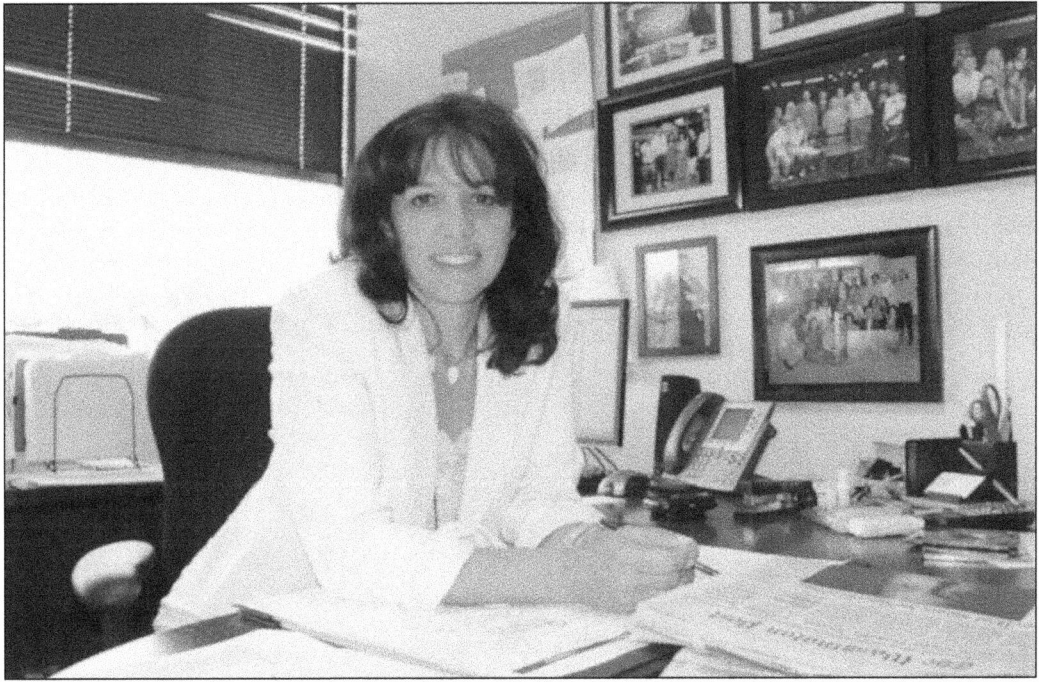

Francesca "Fran" Mires, a San Francisco native, graduated from San Francisco State University (bachelor's degree) and Northwestern University (master's degree) in broadcast journalism. Mires is an award-winning journalist with four Emmys, three Cines, and a New York Festivals award. She works for the federal government in Washington, DC, creating news programs in Arabic. Mires is married with three children. (Courtesy of Francesca Mires.)

Petrakos Films was founded in San Carlos, California, in 2003. It specializes in producing highly creative, cinematic short films. Clients include wedding couples, educational institutions, and special event venues, and it produces biographical films, website advertising videos, and many other productions. Kostas Petrakos is pictured left with Archbishop Demetrios of America at the 85th Anniversary Gala of Annunciation Cathedral on November 12, 2006. (Courtesy of Kostas Petrakos.)

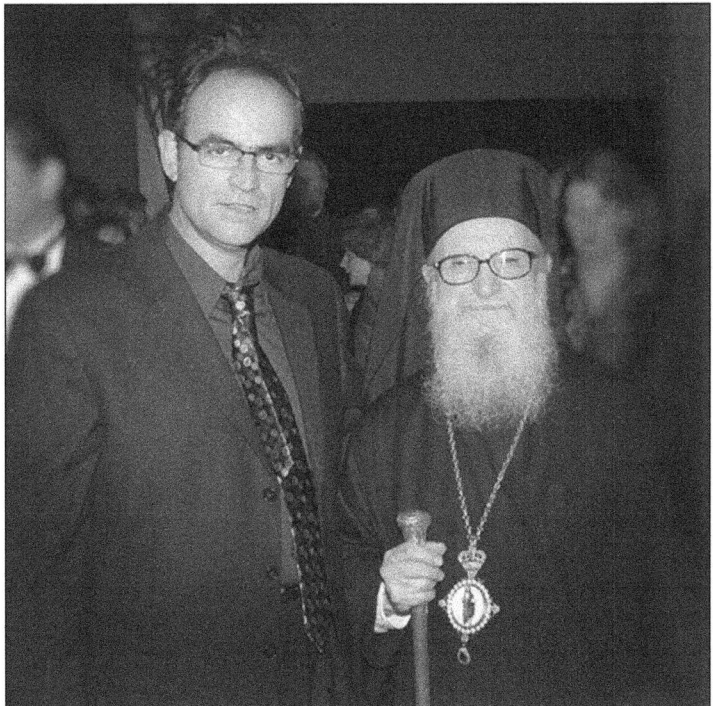

123

John C. Afendras (1897–1976) was born in Achladion, Evvia, Greece, and came to the United States in 1906. A classical violinist from childhood, he formed a continental Latin orchestra in the 1920s and led orchestras at San Francisco's historic luxury hotels and for Greek Independence Day celebrations for four decades. In 1956, Mayor George Christopher appointed him as the director and conductor of the San Francisco Municipal Band. (Courtesy of Cynthia Marcopulos.)

James H. Polos (1927–2006) was born in San Francisco and began taking clarinet lessons at age 11 from music professor John Geanacos. In 1942, he formed his own band, the Jimmie Polos Orchestra, playing at weddings and church dances. The Jimmie Polos Orchestra was the only Greek American band in the Bay Area for many years. After 2,324 performances, he retired the orchestra in 1978. (Courtesy of Cynthia Marcopulos.)

Nick Bardes was known as the Bay Area's finest trumpet player among big bands, marching bands, and jazz ensembles. The leader of the Knickerbockers Band, he served as president of San Francisco Musicians Local 6 for 17 years and in the US Army. Bardes worked with his immigrant parents, owners of the Calistoga Hotel and restaurant. He was married for 59 years and has five daughters. (Courtesy of Dawn Farry.)

Vasilios Glimidakis (far right), a native of Chania, Crete, came to the United States in 1960. He married Danish ballerina Christine Berenson in 1961. In 1962, he purchased the Minerva Café at 136 Eddy Street. The Minerva served great food in a taverna atmosphere, and Vasilios sang and danced with his band nightly. Over the years, he entertained mayors, governors, senators, judges, and celebrities. (Courtesy of Vasilios Glimidakis.)

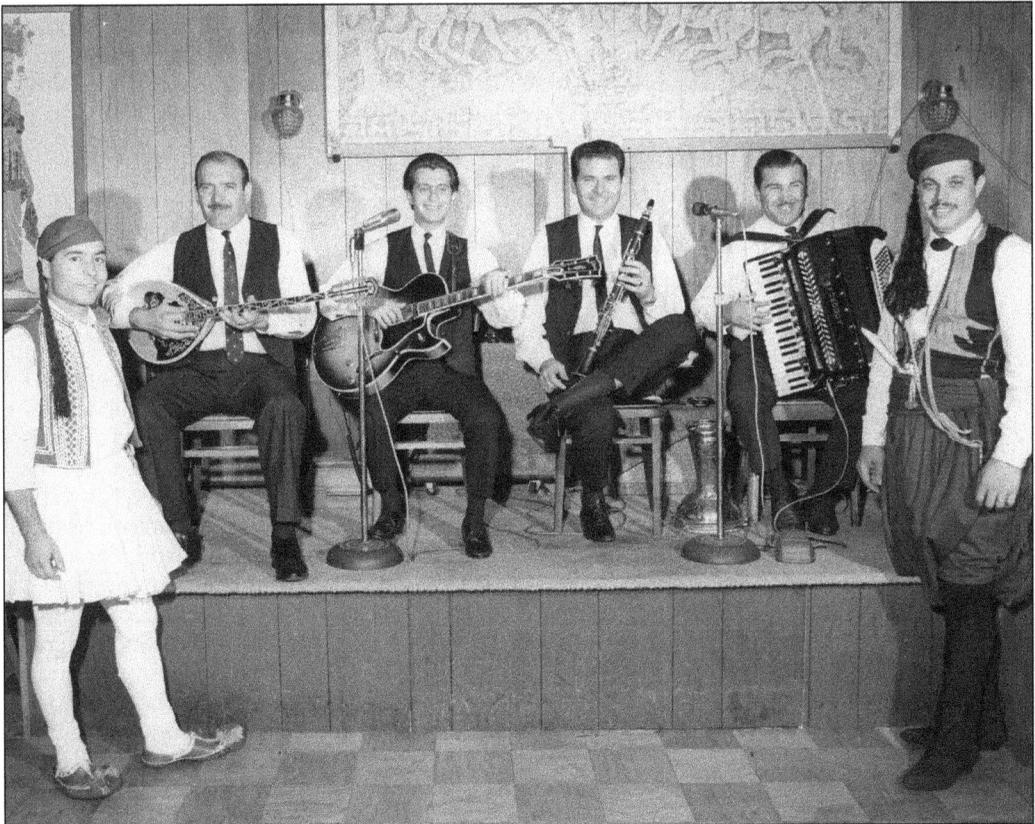

John Pappas (second from right), a native San Franciscan, plays the floyera, bouzouki, klarino, karamoudza, gaida, lavouto, baglamas, sandouri, and daouli. He formed the bands Meraklides in 1962 and Ta Adelphia in 1971. His current band plays music of Arcadia and other regions of Greece. They have performed all over the United States and have made several recordings, including four CDs of traditional regional Greek music. (Courtesy of John Pappas.)

The Yassoo Band of San Francisco was founded by Mike Kutulas and Themis Tjovenos in the early 1970s and lasted through different incarnations until 1985. The band played at Annunciation and Holy Trinity events, weddings, Greek organization events, Greek food festivals, and Calistoga's Macedonian Park. The band was unique in that all members were born in the United States. (Courtesy of Jim Frangos.)

About the Greek Historical Society of the San Francisco Bay Area

The Greek Historical Society of the San Francisco Bay Area, established in 2011, is a nonprofit 501(c) (3) organization dedicated to the preservation of local Greek history and culture. Our mission is to explore, document, archive, promote, and preserve the history and heritage of the Greek people in the San Francisco Bay Area. The society participates and exhibits annually at the San Francisco History Expo. It is working toward the creation of a Greek History Museum, as well as a library for research purposes. We actively seek members of our community for oral histories and to develop a video archive of interviews. We meet monthly and encourage anyone with an interest in Greek American history to attend our meetings and become a member. Our website is www.sanfranciscogreeks.com. Our e-mail address is sfghs@sanfranciscogreeks.com.

Visit us at
arcadiapublishing.com

www.ingramcontent.com/pod-product-compliance
Lightning Source LLC
Chambersburg PA
CBHW050628110426

42813CB00007B/1747